Art of Motherhood

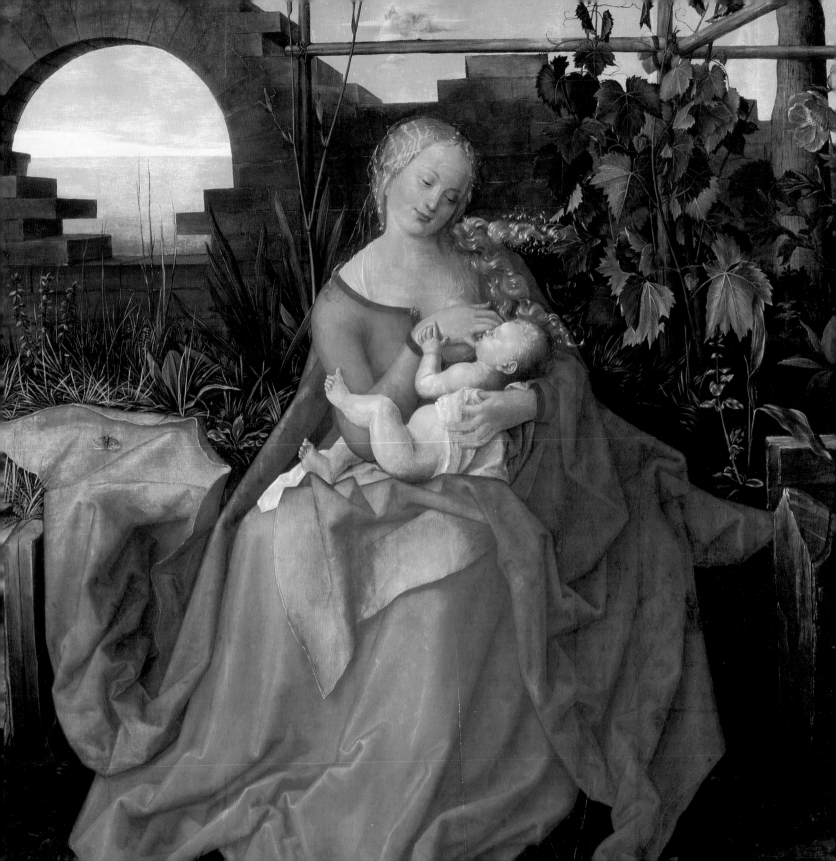

Art of Motherhood

Susan Bracaglia Tobey

ABBEVILLE PRESS PUBLISHERS
NEW YORK LONDON PARIS

For JRT

EDITOR: Amy Handy
DESIGNER: Molly Shields
PRODUCTION EDITOR: Sarah Key
PRODUCTION MANAGER: Dana Cole

Front cover: Mary Cassatt, *Maternal Kiss*. See plate 51.
Back cover: Raphael, *Madonna della Sedia*. See plate 95.
Page 6: Berthe Morisot, *The Cradle*. See plate 34.
Page 7: Jean-François Millet, *Baby's Slumber*. See plate 33.
Page 8: Georges de la Tour, *The Newborn Child*. See plate 14.

LIBRARY OF CONGRESS CATALOGING-IN-PUBLICATION DATA

Tobey, Susan Bracaglia.
 The art of motherhood / Susan Bracaglia Tobey.
 p. cm.
 Includes bibliographical references and index.
 ISBN 1–55859–105–2
 1. Mothers in art—Catalogs. 2. Mother and child in
art—Catalogs. 3. Art—Catalogs. I. Title.
N7630.T63 1991 90–14429
704.9′493068743—dc20 CIP

Third printing.

Contents

ACKNOWLEDGMENTS
6

INTRODUCTION
8

1
PREGNANCY
12

2
GIVING BIRTH
22

3
NURSING
36

4
BY THE CRADLE
56

5
MOTHER'S LAP
62

6
CLOSE BONDS
76

7
FIRST STEPS
88

8
MOTHERS AT WORK
94

9
MOTHERS AND CHILDREN
AT PLAY
112

10
OTHER MOMENTS
124

11
SPECIAL MOTHERS
138

12
THE FAMILY
154

NOTES
168

INDEX
172

PHOTO CREDITS
180

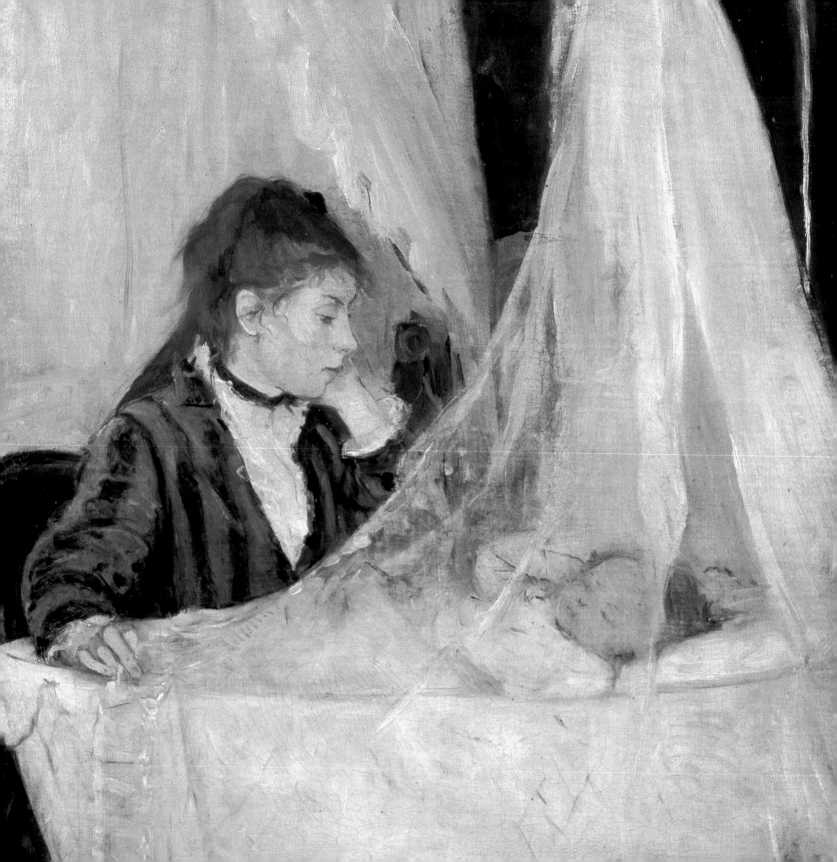

Acknowledgments

I am especially grateful to Alison Mitchell of Abbeville Press, who supported this project from the beginning and offered encouragement and thoughtful suggestions all along the way; to Mark Pendergrast, who edited portions of my original manuscript—his perception and intelligence helped shape the concept of this book, as well as refine its text; and to Marieta Tobey, who provided excellent research under severe time constraints with characteristic care and enthusiasm. I would like to offer special thanks to my editor, Amy Handy, who, like myself, completed her part of this book while pregnant with her first child. Her talents and congeniality, and the warmth we shared for the subject of motherhood, made our work together a pleasure. I am extremely grateful to Carol Haggerty for her proficiency in securing photography and permissions for artwork. Ann Shields's suggestions and encouragement, Amy Jacobus's research assistance, Giovanna Jager's design contributions, Eugenie Delaney's help with picture editing, Molly Shields's design, and Howard Pierce's generous computer assistance are all especially appreciated. Finally, I would like to thank James and Tasman Tobey for their love, support, and inspiration.

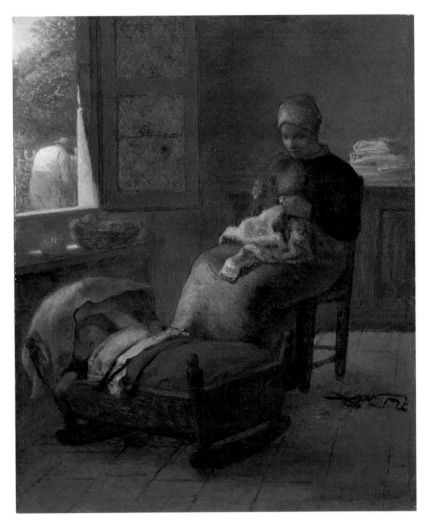

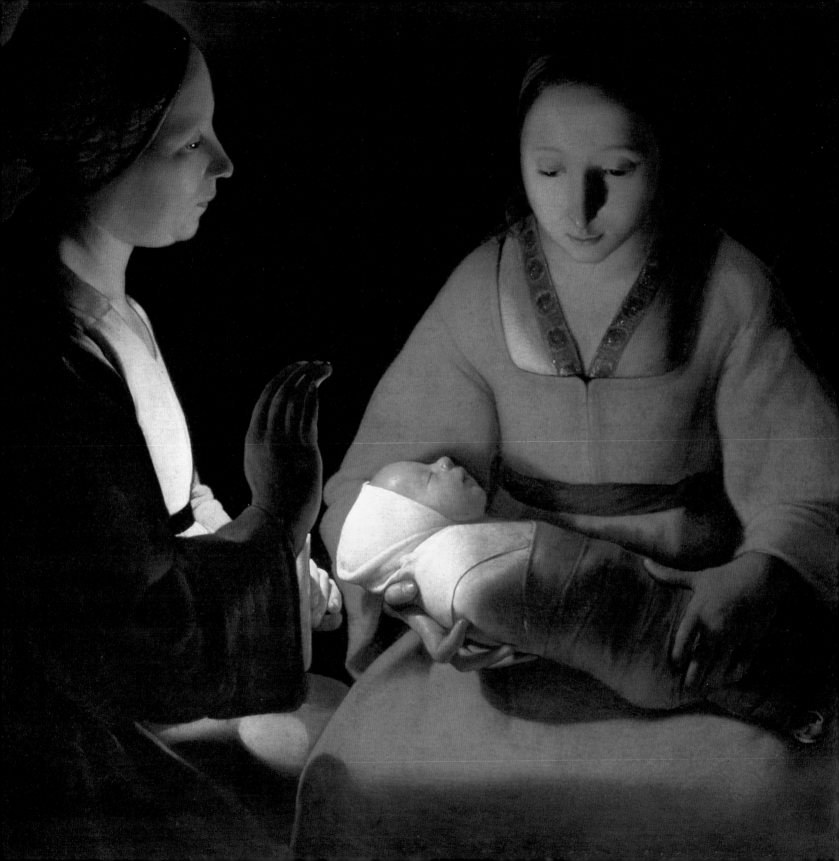

Introduction

The representation of woman as mother is one of the earliest and most prevalent kinds of images in the history of civilization. Four thousand years before the birth of Christ, the ancient civilizations of Cyprus, Egypt, India, the Near East, and Central and South America recognized the bond of mother and child in their art, and every culture since then has given the subject countless interpretations. It is therefore surprising that the subject of maternity in art has received so little attention.

I began my research in the spring of 1988, and my files were soon bursting with hundreds of images from all over the world, dating from the fourth millennium B.C. to the late twentieth century A.D. There were Mycenaean ivories, Egyptian wall paintings, Mexican stone carvings, Cycladic marble figurines, Athenian vase paintings, Indian terra-cottas, Chinese hand scrolls, African sculptures, Persian manuscript paintings, Japanese wood-block prints, Inuit stone carvings, as well as an abundance of masterpieces of Western art from the Renaissance through the present day, including hundreds of depictions of the Madonna and Child. The greatest difficulty became selecting a limited number of images from among so many splendid examples.

In beginning the process of elimination, I found great disparity in the way maternity has been treated. In the hands of some artists, the subject not infrequently distintegrates into the idealized, the saccharine, or the clichéd. Other artists, however, have created penetrating, movingly true-to-life examples that shatter the most binding stereotypes, clearly representing particular individuals rather than generalized notions of motherhood.

In conducting my research I was especially drawn to the work of women artists, imagining that their experience as women, if not as mothers, might yield particularly sensitive interpretations in comparison to artwork by men, which so often casts women according to stereotype as pure Madonnas or sensual, yielding odalisques. I did indeed find some wonderful notes of realism: Claudine Stella's seventeenth-century representation of that seldom-depicted task, the diaper change; Mary Cassatt's thoughtful portraits of distinctly individual mothers; Alice Neel's forthright depiction of a pregnant woman. There were also

poignant notes of emotion: Cecilia Beaux's knowing evocation of *The Last Days of Childhood*; Helen Turner's guileless, unadorned nursing *Mother and Child*; Paula Modersohn-Becker's earthy, primal connection between a mother and infant. But far from concluding that only a woman can break free of cliché and bring real insight and sensitivity to images of maternity, I struck upon many truly outstanding examples in work by male artists. There is the ever-compassionate Rembrandt's disarmingly human portrait of Mary in *Holy Family with Angels*, as well as his delightful, accurately observed drawing of a child's first steps; Kitagawa Utamaro's quietly humorous, real-life moments between mothers and their imperfectly behaved offspring; Sargent Johnson's heartrending *Mother and Child*; Milton Avery's abstraction of the intensity of the maternal bond; Henry Moore's moment of gleeful mother and child play; Daumier's serene mother of *The Third-Class Carriage*; Eishosai Choki's magical evocation of a mother and child catching fireflies, and much more.

In writing about these images, I chose to focus attention less on their art historical significance—with few exceptions, this information is readily available elsewhere—and more on what the lives of the women depicted as mothers might actually have been like in that particular time and place. This approach sheds a novel light on both familiar and unfamiliar works of art, enriching and deepening our experience of the works, and begins to suggest a multicultural history of the attitude toward and the experience of motherhood.

At times, however, these cultural insights were difficult or impossible to discover. There is little information, for example, on what life might have been like for a newly pregnant woman living in the third millennium B.C. on the dramatic, windswept islands of the Cyclades (see plate 1). While there is slightly more to be known about the life of the Mesoamerican woman using *metate* and *mano* in plate 56, and more still about the African mother in plate 82, or the eighteenth-century Chinese mother playing with her children in plate 69, conjecture is necessarily a component of many of the commentaries.

The mother most familiar by far to Western audiences, Christianity's Mary, appears selectively in this collection, as do other deified mothers from ancient Greek, Aztec, Egyptian, Near Eastern, Chinese, and Indian cultures. While representations of Mary, Isis, Demeter, and other mother-goddesses sometimes reveal beguilingly human stories, I chose to focus more attention on art history's ordinary mothers. Although it is fascinating to hear, for instance, of Queen Maya's experience of giving birth to the Buddha, or the special relationship

Indian goddess Parvati had with her elephant-headed son Ganesa, or of the contentious history of Church-supported veneration of Mary, we will find ourselves as mothers more readily in Alice Neel's *Margaret Evans Pregnant* (plate 2), Kano Hideyori's *Maple Viewers at Mount Takao* (plate 26), the tenth-century Indian sculpture *Mother and Child* (plate 46), the seated African mother of twins (plate 38), or Berthe Morisot's portrait of her sister Edma (plate 34).

In selecting and writing about this artwork, I was influenced by my own new experience of motherhood, which is how the book began in the first place. I started to consider images of mothers and children in art as a subject for a book as my husband and I contemplated the possibility of becoming parents in the spring and summer of 1988, and the book proposal was accepted about the time my son was conceived in the spring of 1989. I did much of the research and writing during my pregnancy, and completed the text over the first year of my son Tasman's life. Because of my own orientation, the organization of the book seemed inevitable: It begins at the beginning, with a chapter on pregnancy, followed by a chapter on giving birth. It moves on to nursing mothers,

mothers at work, mothers and children at play, and on through a variety of experiences of motherhood. Though the spectrum of cultures and time periods is purposefully as broad as possible, I was able to find myself in many of these images. Nevertheless, the experience of becoming a mother for the first time contains many surprises and a new world of feelings. There are challenges and adjustments, delights and difficulties for which no artwork, book, or even best friend can completely prepare you. Still, I hope that other new as well as seasoned mothers and grandmothers will find pleasure and recognition, as I did, in the timelessness of an unusually tender Picasso, the humor of Japan's incomparable Utamaro, the insight and emotion that the best of these images have to offer. Even more emphatically, I hope that this collection of images celebrating motherhood will affirm for women who have made this choice the enormous value of their role as mothers. In a culture that tends to assign more commendation and prestige to accomplishments outside of the home and family, it is vital that we not lose sight of the importance of mothering as a life-bestowing gift to our children and, ultimately, to society in our shared work of creating a better world.

1
Pregnancy

Pregnancy, as painter Alice Neel has noted, is a condition remarkably underrepresented in the pageant of human drama recorded in the visual arts. By far, the greatest number of images of pregnant women come from pre-industrialized cultures, where there was perhaps a greater reverence for—and less polite reticence toward—the magic and consequence of this essential human condition. The pre-Columbian artists of ancient Mexico, for example, seem to have been especially inclined toward images of pregnant women, often endowing them with raw physical power (see plate 3). If it seems incredible that so basic a human condition could be so largely ignored in the visual arts, it is more surprising still to remember that less than a hundred years ago in our own culture pregnant women did not dare appear in public.

The pictures in this chapter show pregnancy in various emotional facets. Alice Neel reveals its physical power, beauty, and vulnerability, Raphael its thoughtful solemnity, Chagall its magic, Vermeer its inner peace and tranquillity, our unknown Cycladic sculptor its mystery, and the Nayarit Indian artist its heroic natural force and power.

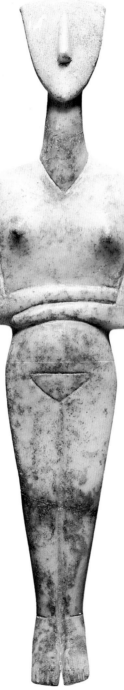

1. Cyclades, artist
unknown. *Canonical
Female Idol*,
c. 3000 B.C. Marble,
14½ × 4⅞ × 1¼ in.
(36.8 × 12.4 × 3.2 cm).
Courtesy The Menil Collection,
Houston, Texas.

Cyclades,
Canonical Female Idol

*T*his startlingly spare figure, some 4,500 years old, is testimony to the ancient human reverence for the mystery of motherhood. Apparently a young woman in the first few months of pregnancy, with strong shoulders and youthful breasts, she stands with arms gently curved over the secret of new life growing within.

Very little is known of the ancient civilization that produced this work, one of a cache of stunning marble figurines found buried in ancient tombs on the Cyclades. The figures, frequently called idols, are nearly all female. Most stand enigmatically, with arms folded like the one seen here, though a few are seated and hold cups in the attitude of a toast, or play woodwind instruments. Though their forms are simplified, the figures resonate with a mysterious eloquence that has fascinated viewers since their discovery. They are frequently compared to the modern abstract sculpture of Brancusi, and Picasso, who owned one, pronounced them "better than Brancusi. Nobody has ever made an object stripped that bare."[1]

The meaning of these graceful figures is a matter of conjecture. Since all were buried in tombs, they are probably connected to beliefs concerning an afterlife. Perhaps they represent goddesses of life and fertility exemplifying bright hopes for a world to come.

Alice Neel,
Margaret Evans Pregnant

*P*regnancy, the late portraitist Alice Neel observed, is an important part of life and has been seriously neglected in art. "I feel as a subject it's perfectly legitimate, and people out of false modesty, or being sissies, never showed it."[2]

False modesty cannot be attributed to any of this feisty artist's sharp, often startlingly uncompromising portraits. Remarking upon Cézanne's assertion that he loved to paint people who had grown old naturally, in the country, Neel countered: "I love to paint people torn by all the things that they are torn by today, in the rat race in New York."[3]

In her portrait of Margaret Evans, Neel seems acutely aware that pregnancy can be a psychologically vulnerable time in a woman's life, with feelings riding close to the surface. The great, swollen belly of late pregnancy is not decorously hidden or minimized, but featured front and center, and the portrait seems the very incarnation of physical and psychological vulnerability. The sitter's widened eyes, tight shoulders, and rigid arms betray her tension, and her hands grip her cushioned stool tightly, almost as if she expects it might eject her straight into the air. Yet despite this obvious tension and struggle, the portrait projects a note of triumph: Vulnerability notwithstanding, the subject holds herself erect and directs her gaze unblinkingly outward at the viewer, a discernable pride in her own forthrightness and the miracle her body carries.

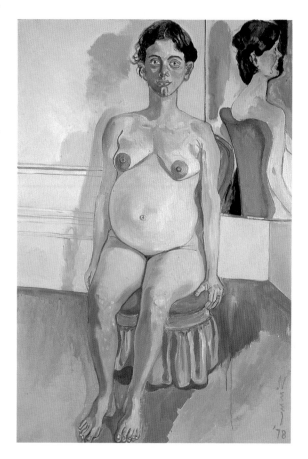

2. Alice Neel. *Margaret Evans Pregnant,* 1978. Oil on canvas, 57¾ × 38 in. (146.7 × 96.5 cm). Robert Miller Gallery, New York.

Mexico,
Standing Pregnant Woman

Two thousand years before Alice Neel's forthright depiction of pregnancy (see plate 2), a Nayarit Indian of the northwest coast of Mexico sculpted as bold and powerful an image of expectant motherhood as can be found in art. Hardly timid or vulnerable, this heroic, massively built woman has wonderful weight and presence. She looks to be experiencing the onset of labor: Her enormous legs take a wide, bracing stance, her hands grip her swollen middle, and her head is thrown back in a deep, open-mouthed breath.

Otherwise naked, this woman wears small bells on her ears and a ring through her nose. Her shoulders feature a decorative scarification that appears on other sculptures of this time. In spite of her eccentric features and proportions, there is a wonderful note of realism in this expectant mother's protruding navel.

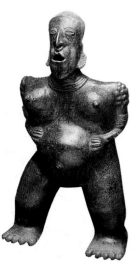

3. Mexico, artist unknown. *Standing Pregnant Woman,* c. 1st century A.D. Ceramic, 27¼ in. high (69.2 cm). Bruce Heath Rogers.

Raphael,
The Pregnant Woman (La Gravida)

Though the veneration of the Virgin Mary was common in Raphael's Florence, this sensitive, tender portrait of an anonymous woman is no tribute to idealized motherhood. Instead, Raphael has used an almost sculptural simplicity to portray a woman whose pregnancy is a simple fact of her existence rather than the reflection of a symbolic Madonna.

Despite this apparent simplicity, however, there is an enigmatic quality to this woman's face that recalls Leonardo's *Mona Lisa.* She seems pensive, with thoughts turned inward to the life she feels moving under her hand. At the same time, there is a touch of worry that most pregnant women near term know. Will the birth go well? Will my child have a healthy, happy life? Into what sort of world do I bring this new life?

She had good cause for worry. Throughout Renaissance Italy the infant survival rate hovered at fifty percent, and giving birth was itself not without serious risks for mothers as well. And though Florentines extolled Mary, they seemed to have real doubts about secular motherhood. It was not until the seventeenth century, with the discovery of the microscope, that women's biological contribution to procreation was understood. It was men, according to popular wisdom, who produced and planted a "seed" and to men, therefore, that children "belonged." Women simply provided a convenient place for a baby to grow.

Mothers' minimized role in the early lives of their children can be glimpsed in the practice, widespread among the city's middle and upper classes, of putting children out to a paid wet nurse from birth until the age of two, with the

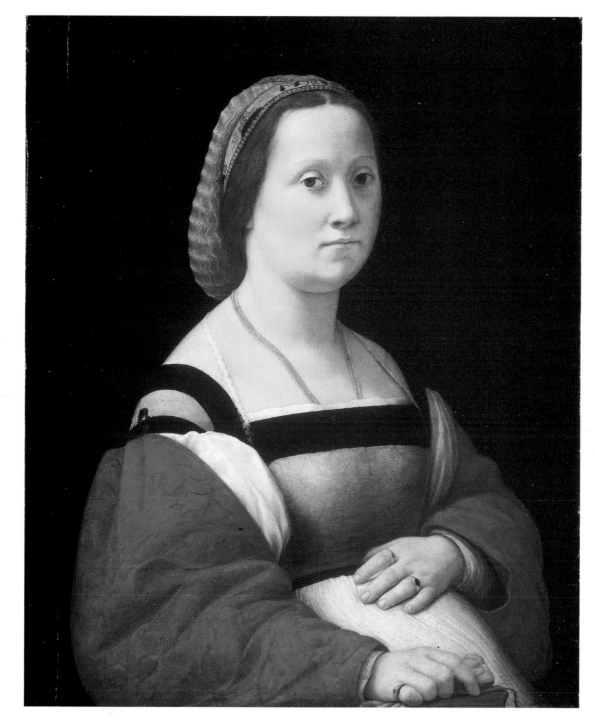

4. Raphael. *La Gravida*,
c. 1483–1520. Oil on
panel, 26 × 20½ in.
(66 × 52 cm).
Galleria Palatina di Palazzo
Pitti, Florence.

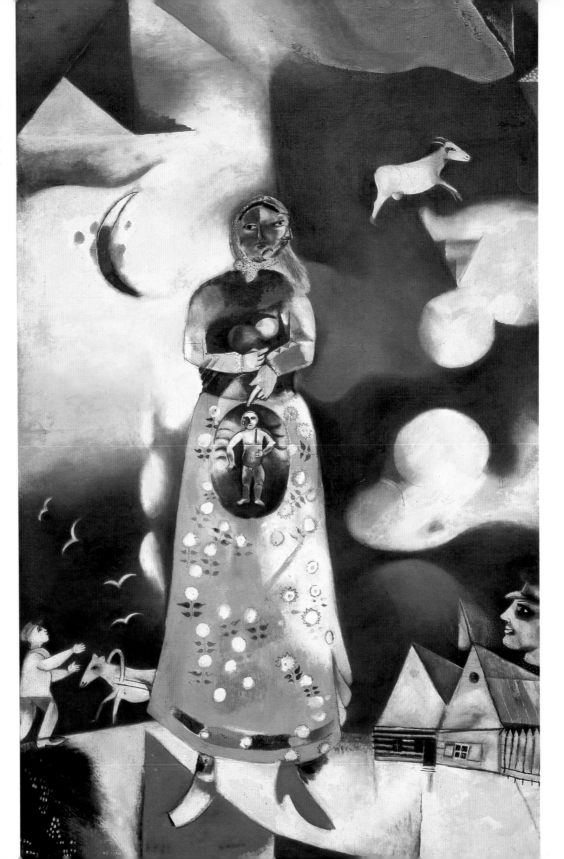

5. Marc Chagall. *Pregnant Woman,* 1913. Oil on canvas, 76 × 45¾ in. (193 × 116 cm). Collection Stedelijk Museum, Amsterdam.

father selecting the nurse and the appropriate time to wean. And since nurses often lived in a rural area some distance from the city, mothers and their newborn babies saw each other either infrequently or not at all during the first two years.

Marc Chagall,
Pregnant Woman

Chagall's paintings are characterized by fanciful, often joyful flights into the world of memory and imagination. Conventional forces such as gravity or visual perspective are suspended in favor of a highly personal, vividly colored dream world, where cows float over the moon, houses are built upon clouds, and lovers soar through space to meet for an enchanted kiss.

In this canvas, a portrait of a very dear friend's pregnant wife, Chagall hearkens back to his Russian childhood. The peasant cottages, farm animals, and wide sky suggest, as do so many of his paintings, the artist's small native village of Vitebsk. One might also suppose this image of motherhood to carry something of Chagall's feelings about his own mother, who always remained a source of cherished maternal warmth, security, and protection. Though her life was circumscribed, like that of other Russian women, by a subordination to men that was part of the Jewish faith, Chagall's

mother played a dominant role in the family. While Chagall remembered his father as a tired, silent, rather sad man beaten by the drudgery of peasant life, he remembered his mother for her sparkle and liveliness. Not only did she raise eight children, but she opened a small grocery store to supplement the income of her husband, who hauled barrels of fish at the local wharf. Most important, she created a safe haven to shield the rather timid, dreamy young Chagall from the impact of the harsher world beyond the family. This painting conveys a real sense of the snug, secure world of the child, literally contained within the mother, looking out in safety at the world beyond. Interestingly, a glimpse of the father can be seen in the bearded, masculine profile superimposed upon the mother's face.

Johannes Vermeer,
Woman Holding a Balance

Jan Vermeer was a master of quiet, well-ordered interiors where isolated women tranquilly sew, read letters, pour water from cool earthenware pitchers, or simply pause to glance out a window, mesmerized by a particular slant of pale sunlight. Vermeer's art evokes a gentle mood of stillness and reverie. The serenity of the pregnant woman in this painting mimics the delicate scale she gracefully holds: She radiates a sense of the

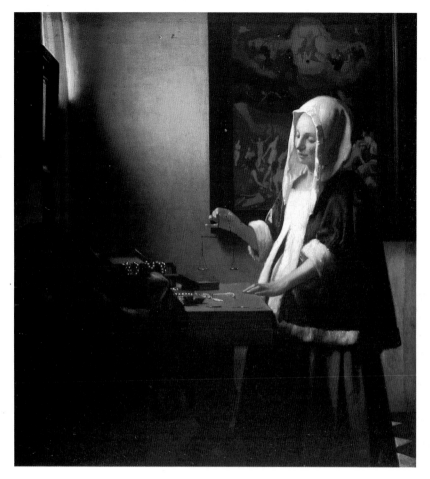

Threats of chemical or nuclear war, irreparable environmental harm, and knowledge of human suffering of every kind can easily, in the space of a particularly disheartening evening news program, overwhelm a contemporary woman. But her pregnancy signals an ultimate gesture of hope. Unwittingly or not, a pregnant woman affirms that, as bleak as things may look, there is yet the possibility of new life, a fresh start, a better world.

Käthe Kollwitz,
Pregnant Woman (Beim Arzt)

Käthe Kollwitz is widely known and admired for her compassionate portraits of women. Imbued from her earliest youth with her family's deep commitment to working against social and political injustice, Kollwitz sought to use her artwork to increase an understanding of these problems and demonstrate the need for social change.

In the last decade of the nineteenth century, Käthe married Dr. Karl Kollwitz, who set up his medical practice in a poor, working-class section of northeast Berlin. Her husband's crowded waiting room was often filled to overflowing, and desperate women would sometimes walk across the hall to claim Käthe's sympathetic ear. She saw firsthand their struggles with unemployment, hunger,

6. Johannes Vermeer. *Woman Holding a Balance,* c. 1664. Oil on canvas, 16¾ × 15 in. (42.5 × 38.1 cm). National Gallery of Art, Washington, D.C.; Widener Collection.

achieved balance of inner peace. While the painting behind her, a version of *The Last Judgment of Christ,* frames her in a cataclysm of finality and death, her beautifully pregnant form and tranquil expression emphatically assert the hopefulness of new life and fresh beginnings.

Any pregnant woman today can feel herself to be framed, like Vermeer's woman, by a world where hopefulness feels elusive indeed.

and illness, and dramatized their plight in sensitive portraits. "What moves me again and again," the artist stated, "and what has not been said enough, are the many quiet and loud tragedies of city life."[4]

Mother of two sons, one of whom was killed in World War I, Käthe felt her own maternal role with a passion that was not simply personal: She viewed motherhood as an all-important responsibility in the creation of a better world. Her many portraits of mothers and children reflect her own experience, which, as we know from notes in her journal, she treasured deeply.

This portrait is from a series called *Bilder vom Elend* (Portraits of Misery). This humble older woman, focused inward and filled with responsibility for the baby she carries, seeks help at the doctor's door, knocking with a large, gnarled peasant hand. Her somber, stricken demeanor underscores the "quiet tragedy" of poverty's particularly grievous effect on the lives of mothers and children.

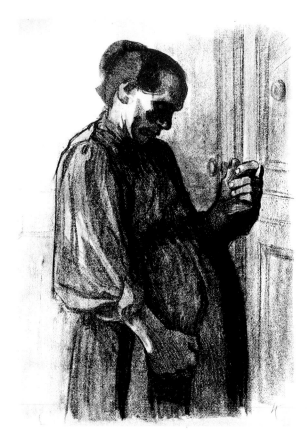

7. Käthe Kollwitz. *Pregnant Woman (Beim Arzt),* 1908. Charcoal, 23⅝ × 17⅝ in. (60 × 45 cm). Jewish National and University Library, Jerusalem.

Like depictions of pregnancy, images of giving
birth are rare in the history of art, and an air
of secrecy and taboo clings to this intimate,
essential process. In many cultures men are
ritually excluded from the event, and in our
own culture it is only one generation since
husbands were barred from the hospital deliv-
ery room.

In this chapter, then, we have few glimpses
of actual births. With occasional exceptions—
most notably the moving, naturalistic terra-
cotta from ancient Cyprus—we are treated
instead to representations of the extraordinary
births of mythological figures—the birth of the
Buddha, for example, or the Aztec goddess
Tlazolteotl giving birth to Centeotl—or to the
moments following an actual human birth,
represented with great fanfare in sixteenth-
century India at the birth of Prince Salim, and
with quiet intensity by Georges de la Tour in
the early seventeenth century. Judy Chicago's
Birth Trinity Mola, Q1 is all but unique in
contemporary art in making the monumen-
tal, unforgettable experience of giving birth
her subject.

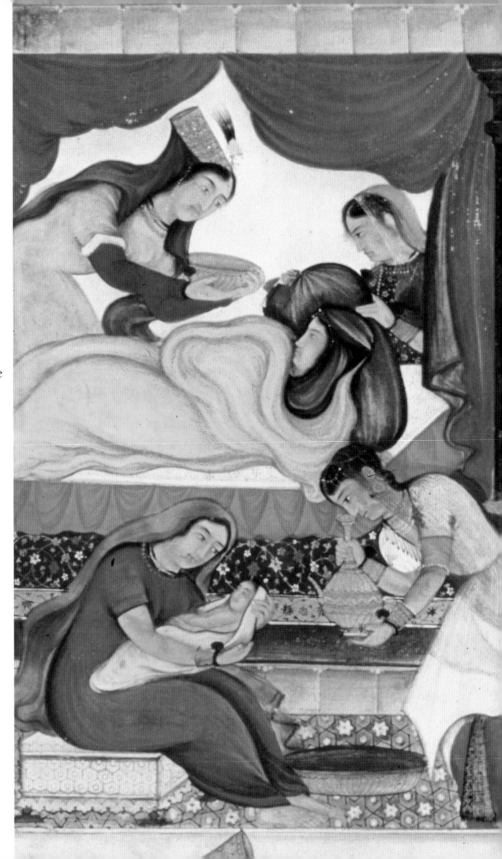

2
Giving Birth

Cyprus,
Birth Trinity

*T*his small sculpture group is quite moving in its intimate and accurately observed treatment of the act of giving birth. Two women assist a third; one holds the mother from behind, providing not merely physical support for her sitting position but the additional comfort of cheek-to-cheek proximity and encircling arms. The other woman takes her position in front, ready to assist directly in the imminent birth. While there is discernible pain crossing the exhausted mother's face, there is also an unusually sensitive grace and dignity about the three figures.

This piece was probably made for a woman as a votive offering to the goddess Aphrodite, who was much more than simply a goddess of love. She was also a mother goddess who had power over birth and death; she controlled the sea and she presided over love and marriage, pregnancy and childbirth. Like a number of other gods and goddesses in the Greek Pantheon, she had many names and many manifestations, and in her character of goddess of childbirth she was a divine midwife called Ilithyia. The women of Cyprus and mainland Greece would have appealed to Ilithyia—most likely with small offerings like this little sculpture—for protection and assistance during childbirth.

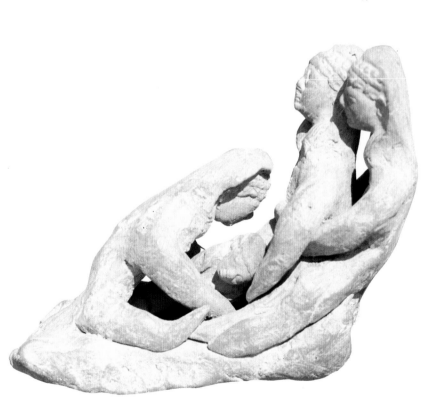

8. Cyprus, artist unknown. *Birth Trinity,* c. 6th century B.C. Terra-cotta, 3½ × 4½ × 2⅛ in. (8.9 × 11.5 × 5.4 cm). Cyprus Museum.

9. Greece, artist
unknown. *The Birth of
Erichthonius,* c. 5th
century B.C. Terra-cotta,
dimensions unknown.
Staatliche Antikensammlungen
und Glyptothek, Munich.

Greece,
The Birth of Erichthonius (detail)

This Athenian vase painting
illustrates a rather unusual birth.
Erichthonius was one of the first
kings of Athens, and, in a roundabout way, the
child of Athena, the Greek goddess of war and
wisdom. According to myth, Athena visited
Hephaestus, god of fire and craftsmanship,
to ask him to make her weapons and armor.
Hephaestus was purportedly filled with desire
for her, and though she successfully resisted
his advances, the goddess was left with some
of the god's semen spilled on her leg. The
disgusted Athena wiped the stain with a bit of
wool and tossed the rag to the ground. This
gesture impregnated Gaia, mother earth, who
produced a child that Athena accepted as her
own. In this painting Gaia is shown handing
the child up to Athena, who makes ready to
swaddle the child in her own garment, while
Zeus looks on.

One might be tempted to suppose that the
heroic women of Greek myth, and the power-
ful Antigones and Electras of Greek drama,

indicate a large domain for ordinary women in the classical Greek community. Clearly, though, ordinary women lived their lives on a far more restrictive scale. A cursory read through written law from 600 to 300 B.C., or the work of the poets and philosophers of the day, corroborates Aristotle's viewpoint that "as between male and female, the former is by nature superior and ruler, the latter inferior and subject."[1] Athena notwithstanding, a woman's sphere in ancient Greece was the home and the family, and marriage and motherhood were her most important achievements.

India,
Birth of Buddha

According to legend, the Buddha was born into a noble Indian family in 566 B.C. His mother, Queen Maya, was not only a dazzling beauty with "eyes like lotus leaves"[2] but was also a paragon of virtue and chastity. She vowed to her husband, King Suddhodhana, that she would "abstain from theft, intoxication and frivolous speech . . . from slander and from falsehood."[3] When Maya allowed that her vows included observing chastity, the good king respected her wishes.

The Buddha, then, was not conceived in the usual way. One night, Queen Maya dreamed that she was carried away to the divine lake Anava-tapta in the Himalayas, where she was bathed by the heavenly guardians of the four quarters of the universe. A lovely miniature white elephant appeared, carrying a lotus flower in his trunk, and entered her side. Immediately the universe was filled with miraculous occurrences. Musical instruments played without being touched, trees and plants were suddenly covered with blossoms, and rivers ceased to flow. Upon awakening, the puzzled queen called upon wise men to interpret this dream for her and was told that she had conceived a wonderful son who was destined to become a great emperor or universal teacher.[4]

This painting shows the moment of this miraculous birth. In what would be from a mother's viewpoint the quintessential "easy birth," the child emerges painlessly from his smiling mother's side, just where the little elephant entered in her dream. The child Buddha then precociously stands upright, a lotus

flower appearing where his foot first touches the earth, and takes seven strides. He is repre sented in this act by the small naked figure standing to the left of Maya.

Where other religions—notably Christianity, Hinduism, and Confucianism—attribute a sacred religious value to motherhood, early Buddhists viewed motherhood as limiting a woman's spiritual progress.[5] The religious aim of Buddhism in its dominant phase was to become liberated from suffering and pain— indeed, from all attachments to the material world—in order to follow a spiritual path that ultimately leads to enlightenment. Mothers, however, are inextricably tied to the material world simply by being mothers. A woman could attain the higher levels of spirituality by renouncing motherhood or, in a future life, being reborn as a man. Maya is spared this conundrum. She not only conceives in chastity and gives birth without pain, but dies "of joy," according to Buddhist scripture, seven days later, leaving the child Buddha to the devoted care of her sister Mahaprajapati.

China,
Birth of the Buddha

*H*ere we see a Chinese depic- tion of the Buddha's miraculous birth, rendered in a charmingly naive style. The baby Buddha seems about to

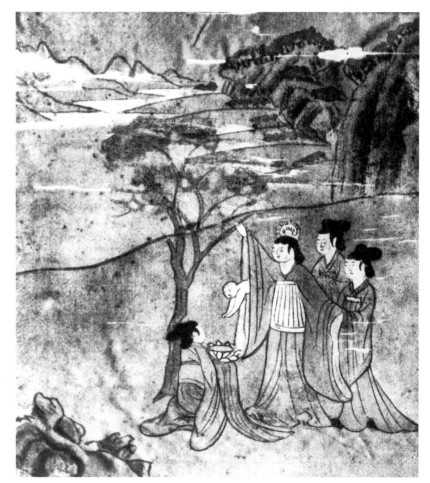

11. China, artist unknown. *Birth of the Buddha,* c. 618–907. Ink on cloth, 6⅜ in. wide (16.2 cm).
National Museum, New Delhi.

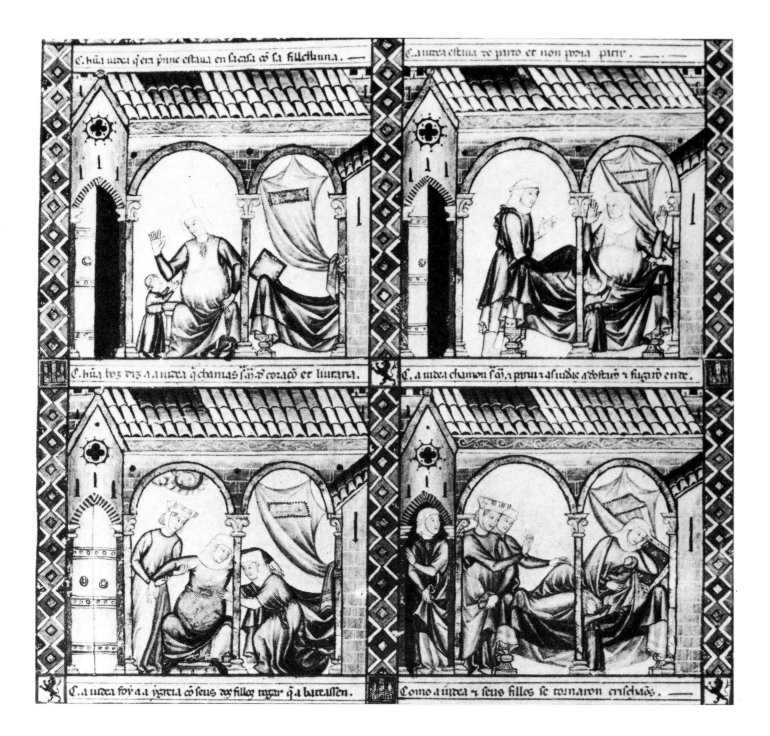

execute a graceful dive from his mother's sleeve directly into a waiting ewer.

Buddhism came to China from India along the ancient Silk Route, by way of central Asia, in the first or second century A.D. For women, Buddhism's effect may have been somewhat liberating, creating slightly broader options than the restrictive precepts Confucianism allowed. Nevertheless, Confucianism tended to continue to dictate social life and customs, and Tang dynasty women were still guided by the strictest rules of conduct. One Tang work, *Nu lunyu*, by Song Ruohua, admonished women: "When walking, do not turn your head; when talking, do not open your lips; when sitting, do not move the knees; when standing, do not move the skirt; when happy, do not laugh; when angry, do not shout out loud."[6]

Europe,
A Midwife Hands the Mother Her Baby
Spain,
Scenes of Childbirth

This engaging manuscript illumination portrays the happy moment of a midwife handing a smiling and obviously well-to-do mother her freshly washed and swaddled newborn. There is joy in this captured moment: The mother sits forward and eagerly extends her arms, and the midwife seems to fill a role of both trusted friend and capable attendant who shares the mother's happiness.

The second illustration gives us a much more sequential account of a noblewoman's experience of birth. In the first two frames we see her proceeding to her bed, appearing first to take leave of a small child. The third frame finds her attendants helping her into a squatting position, probably on a birthing chair, and by the fourth frame, mother and baby are resting comfortably in bed, to the smiles and well-wishing of the attendants.

Although medieval literature had much to say to women about the art of being a good wife, little mention is ever made of the role of the medieval woman as mother. Noted histo-

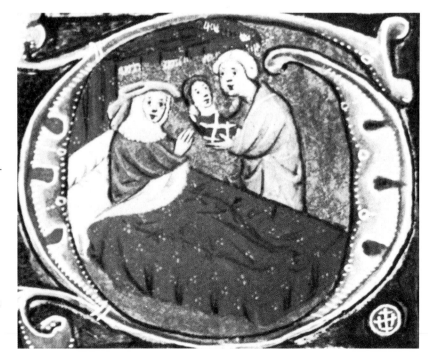

rian Philippe Ariès has gone so far as to say that the child had almost no place in medieval culture.[7] Vivid portrayals of children in the literature of the day are noticeably lacking, and in art children were almost invariably depicted as miniature adults. They were viewed with ambivalence even by the Church. "If you have children," one churchman wrote, "rejoice in them and raise them properly. If they die in childhood, accept your lot. Do not complain and do not regret it overmuch. Think of all the cares which you will spare yourselves."[8] The perennially pessimistic Eustache des Champs went much further. "Blessed is the man who has no children," he penned sourly, "for infants are nothing but wailing and smells, a source of sorrow and anxiety. They must be clothed, shoed and fed. There is always a danger that they will fall and injure themselves or sicken and die. When they grow up, they may go to the bad and be cast into prison. They can bring no happiness which can compensate for the fears, trouble and expense of their upbringing."[9]

If this gloom regarding children sounds excessive, the reality of childbirth and children in the Middle Ages must be considered: the infant mortality rate was alarmingly high for the nobility and the peasantry alike, and these sentiments, coldhearted as they sound to contemporary ears, may very well have been kindly intended to discourage parents from strong attachments to their children as a prudent way to avoid the very real possibility of future heartbreak. Even so, real mothers did not always suppress joyful feelings at the births of their children, as we can see in the faces of the two mothers shown here.

Georges de la Tour,
The Newborn Child

Here is a moment of wonder, a mother contemplating her newborn, perhaps holding the child for the first time. What is she feeling? The miracle of the child's birth? The fragility of a being just a few hours old? The magnitude of her responsibility for the vulnerable infant? Or simply a wellspring of love? In this painting Georges de la Tour has captured this mother's complex mixture of awe, reverence, and solemnity at the birth of her child. In a favorite device, the artist has set this quiet scene in the glow of candlelight, which illuminates all three faces and adds a feeling of intimacy to the hushed attentiveness of both women.

Seventeenth-century European women, whether ladies of the court or simple peasants, swaddled newborns in the very tight, constraining manner depicted here. Like the ancient Greeks, they believed that binding each limb separately, and then the infant's whole body, would protect the child from deformity, straightening his limbs and ensuring proper placement of each internal organ. Today, swad-

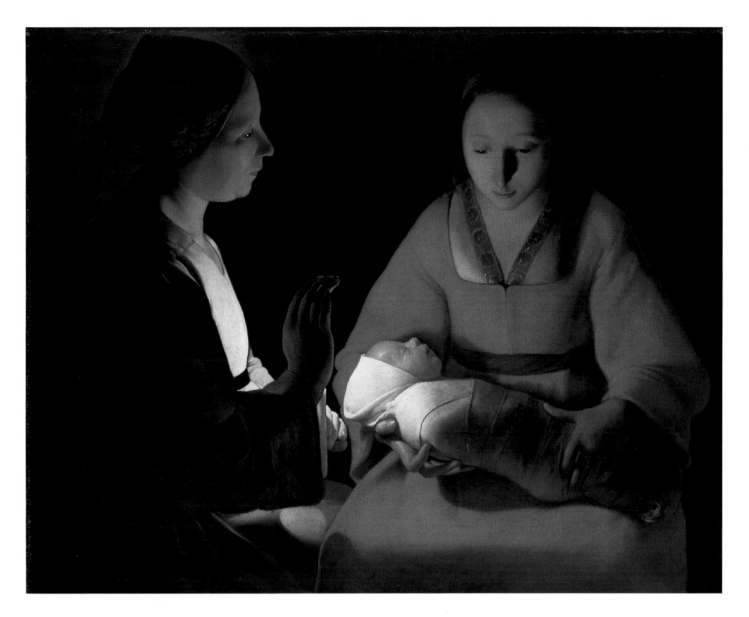

14. Georges de la Tour.
The Newborn Child,
1630. Oil on canvas,
30 × 35¾ (76 ×
91 cm).
Musée des Beaux-Arts, Rennes,
France.

dling an infant—albeit in a much modified form involving nothing more than wrapping a receiving blanket around the baby and tucking the corners underneath—is widely held by child-care experts to be soothing for newborns. The swaddling is thought to imitate the snug, enveloped feeling the baby must have experienced inside the mother's womb, making the transition to the wide-open spaces of the outside world a little gentler.

Judy Chicago,
Birth Trinity Mola, Q1

Contemporary artist Judy Chicago feels about the act of giving birth much as Alice Neel did about the condition of pregnancy: It is a subject woefully ignored in the history of art. "It was obvious,"

the artist stated, "that birth was a universal human experience and one that is central to women's lives." Why, she wondered, were there so few images?

Even more than pregnancy, birth itself is surrounded by an air of myth, mystery, and taboo. In Western culture, it was only very recently that husbands were welcomed into hospital delivery rooms to share the experience with their wives. Most of the extant images of birth come to us from ancient and preindustrialized cultures, where there existed a closer relationship to nature, and perhaps a stronger feeling of the significance of birth as a major drama of human life. In contrast, Western culture seems to have relegated giving birth to the category of female experience, largely extraneous to the preoccupations of men. Since Western art, perhaps in contrast to the art of ancient and preindustrialized cultures, came predominantly to reflect the values and experiences of men, birth became an inappropriate subject. In addition, the intimate and sexual aspect of birth runs counter to Western notions of propriety, limiting its forthright treatment in art and literature.

Chicago set out to create an image of giving birth that dispels some of the secrecy and taboo, yet honors its mythical power and primacy. She wanted the image to convey both the celebratory and the highly demanding aspects of the experience. Not a mother herself, she invited many other women to relate their expe-

rience of childbirth to her, and even attended several births. She chose to use the medium of needlework, a quintessentially feminine art form, to depict this essentially female experience. The result is a series of eighty images that make up *The Birth Project*. This stark, stylized image conveys intense concentration and effort, and a consolidation of power that speaks to many women's experience of natural childbirth.

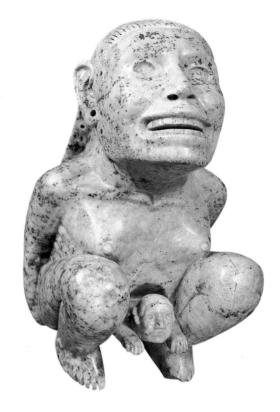

Mexico,
Aztec Goddess Tlazolteotl Giving Birth to Centeotl, the Corn God

This powerful sculpture of the Aztec goddess Tlazolteotl beautifully communicates the raw physical effort of the act of giving birth. In a classic squat—the traditional birth-giving posture before modern Western medicine popularized the supine position—the goddess grimaces and strains with the palpable effort of pushing out her remarkably adult-looking child, the corn god Centeotl. Arms outstretched, he seems ready to leap, pantherlike, from her body.

Aztec women and men sought the protection of a panoply of gods and goddesses who could intercede in most aspects of life. Pregnant women in the Aztec culture were protected by three or four different goddesses, including Tlazolteotl, a mother goddess who presided over fertility and childbirth and was also known for her ability both to stir up passion and to pardon sexual transgressions.[10]

During pregnancy, in addition to seeking the goddesses' help, an Aztec woman took a variety of precautionary measures to ward off evil, such as avoiding red objects, the view of which was believed to cause a breech birth.[11] She took healing hot baths, over which Tlazolteotl presided, and received massages from a midwife early in pregnancy. Finally, at the moment of birth, the midwife gave a lusty war cry to honor the mother. Directly after birth, a new-

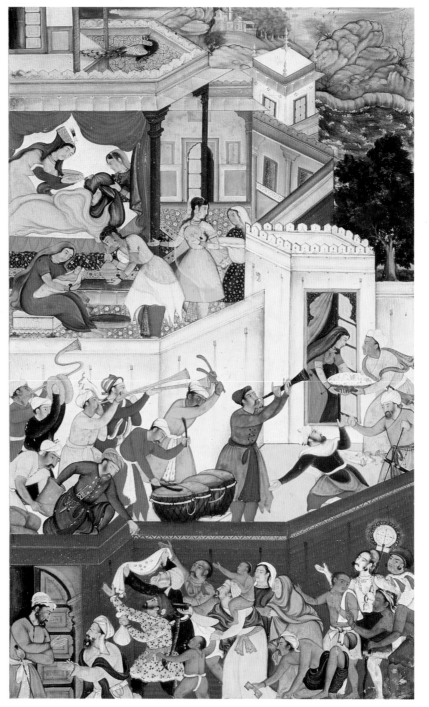

17. Dharm Das (design by Kesu the Elder). *Birth of Prince Salim,* from the *Akbarnama,* c. 1590. Watercolor on paper, Courtesy Victoria and Albert Museum, London.

born girl would be shown wool and a spindle to mark out her future occupation, and a boy would be shown weapons to guide him toward his vocation as a warrior.[12]

Dharm Das (design by Kesu the Elder), *Birth of Prince Salim*

This joyful celebration of the birth of a royal son belongs to the reign of the extraordinary emperor of sixteenth-century Mughal India, the great Akbar. Having inherited the throne at fourteen, Akbar went on to achieve lasting renown by uniting the entire subcontinent of India, bringing the warring Hindu and Muslim factions into a strong and lasting union. It was a time of idealism, even romanticism, and the arts flourished.

This wildly successful, energetic ruler had, it is said, only one grief: Of his reputed three hundred wives and harem of five thousand women, none had provided him with a son and heir. He had married the Hindu princess Jodh Bai in a calculated effort to seal his political alliance with the powerful Rajput clans. The marriage, nonetheless, had scandalized Akbar's mother and aunt, devout Muslims who believed that Hindu girls were fine as dancers and concubines, but a full-fledged wife was something else entirely. So it was with chagrin that Akbar's mother greeted the news of this less-than-favorite giving birth to the long-awaited heir.

Needless to say, Akbar was delighted. The event, as recorded here, was celebrated with all fanfare. We see the tired new mother in the topmost reaches of the zenana, or women's quarters of the ruler's castle, surrounded by attendants who hover at her bedside and swaddle and bathe the infant. At a lower level, horns blare, kettle drums boom, and, in a mood of general bounty, alms are distributed to those gathered outside the palace walls. Overcome with joy, an ecstatic Akbar decided he could not do less than build a new capital city to celebrate the event, and Fatehpur Sikri was duly completed a few years later.

Women of such courts led lives of inactivity and seclusion. Bearing children, especially boys, formed their main duty and was the source of their relative stature. Any of Akbar's wives or harem women who gave birth to a son would immediately have been elevated above the throngs of other women and been given special living quarters, prestige, and authority over the others. As a mother, however, she would have handed over much of the daily responsibilities to a wet nurse and other maidservants, and would have been separated from her son rather early, so he could begin an appropriate education and conditioning in a society that observed strict separation of men and women.

In contrast to pregnancy and giving birth, the act of nursing has been a favored subject of many artists, who seem to have been fascinated by this unique physical and emotional connection. These frequently idyllic images can make for a romanticized ideal at odds with the experience of real mothers, so it is especially satisfying to find images that counter the prevalent visions of dreamy perfection. While idyllic moments like those seen in plate 23 do exist, it is in the less typical nursing images by Utamaro (plate 24), Hideyori (plate 26), and Helen Turner (plate 27) that women are more likely to recognize their own experience.

Images of a mother giving her child a bottle are exceedingly rare (see plate 29). While historically the more common solution for non-breast-feeding mothers was the wet nurse, bottles have been in use for hundreds of years. The ancient Greeks used a clay bottle shaped like a small jug. As late as the nineteenth century, glazed earthenware, pewter, brass, or blown-glass bottles were shaped like toy boats. Some early bottles featured nipples made of chamois, leather, parchment, linen, even ivory, until the rubber nipple was patented in the United States in the mid-nineteenth century.

Though often registering somewhere between Gauguin's island serenity (plate 28) and Bernini's perilous tumult (plate 31), the experience of feeding a baby is a special give-and-take, an essential act of love.

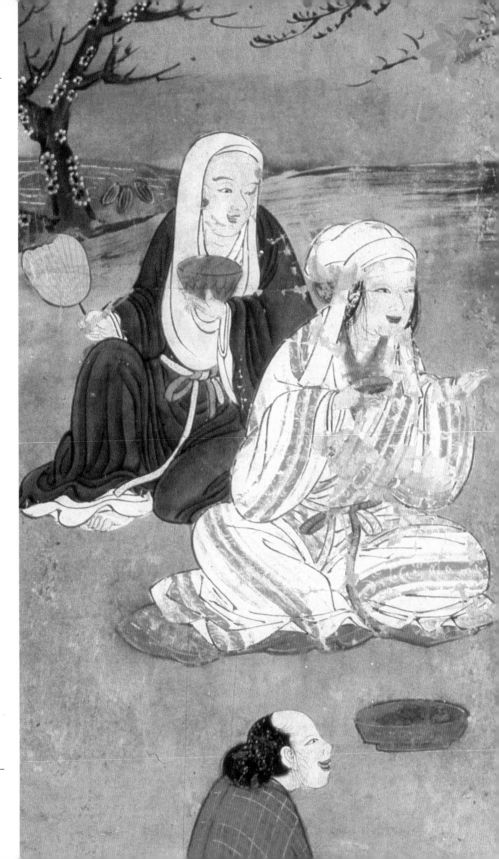

3
Nursing

Mexico,
Pre-Columbian Nursing Figure

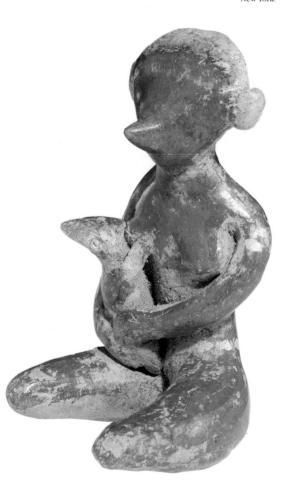

The triangular face of this tiny sculpture from Mexico is all but featureless and hardly naturalistic, giving it the austere look of modern abstract sculpture. Despite this, however, there is a naturalism in the mother's round, heavy breasts and in the child cradled in protective, curving arms.

This figurine is one of hundreds found in the extraordinary shaft tombs of southern Nayarit, which contained many objects, including pottery vessels, cooking tools, mirrors, whistles made of seashell, and small clay models of birds and animals. These objects undoubtedly related to a vision of the afterlife, where they would have been intended for real or symbolic use. Because so many of the figurines depict pregnant women, nursing mothers, and family groups, it is tempting to believe (though impossible to be certain) that this ancient Mesoamerican culture placed a high value on motherhood and the family.

Roman,
Nursing Deity

The ancient Greeks placed an enormous value on children, regarding them as an assurance of eternal life for the family and for Greek culture

at large. Raising children was therefore a primary responsibility of every citizen, and those who remained celibate or childless were held in contempt, sometimes even punished for their failure to contribute to the future welfare of society.[1]

For assistance with such important functions as giving birth and raising children, Greek, and later Roman, women appealed to the *kourotrophoi,* or nursing deities. These goddesses— usually represented, as in this elegant Roman marble, as a mother holding or nursing an infant—probably originated in pre-Hellenic times in Cyprus and Crete and spread to mainland Greece. Flourishing through late Roman times, they were immensely popular, but more as a religious undercurrent than a primary cult like that of Athena or Aphrodite.[2]

Greek and Roman women and men honored these goddesses in many different ways to enlist their protection in matters of childbirth, nursing, and successful child rearing. Women made offerings of small terra-cotta representations of the goddess, or of themselves as mothers, as a way of enlisting help. To secure a safe delivery, for example, a woman might offer a statuette of a birth trinity, such as the one from Cyprus (see plate 8). Such gestures as abstaining from wine or the wearing of colorful dresses could also secure the goddess's favor.[3]

The *kourotrophoi* seemed to have had a very lively following. Feasts and festivals for the

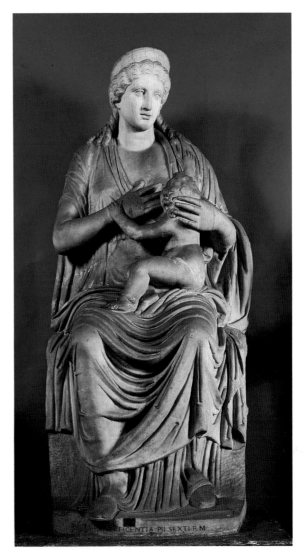

19. Roman, artist unknown. *Nursing Deity,* end of 1st century B.C. White marble, 64 in. high (162.6 cm). Museo Chiaramonti, Vatican Museums.

kourotrophoi included processions of mothers and children, banquets, and night dances. These activities must have fulfilled the important social function of bringing mothers together, providing emotional support for their shared experience of motherhood.[4]

Egypt,
The Goddess Isis with the Child Horus

This sculpture of the supreme Egyptian goddess Isis nursing her son Horus has unusual charm and humanity. Here the imposing, sometimes intimidating sovereign, "whose nod governs the shining heights of Heaven,"[5] and whose single teardrop causes the mighty Nile to flood annually, is shown as a voluptuous young mother who, with a small but eloquent smile of pleasure, offers her fat-tummied, Buddha-like babe a full, heavy breast.

Isis is the Egyptian manifestation of the culturally ubiquitous mother goddess, prominent in so many early civilizations. Egyptian scriptures read: "In the beginning there was Isis, Oldest of the Old. She was the Goddess from whom all becoming arose."[6] As the creator and mother of all things, she gave birth to the sun, Horus. The many ancient images of Isis with Horus might well be the foundation of later Christian Madonna and Child images.[7]

The existence of a supreme mother deity in Egypt and other early civilizations is often supposed to have grown out of these cultures' perception that women, not men, were endowed with the miraculous ability to create life by giving birth. It then follows logically that the creator of the universe would be female as well. Margaret Mead, among others, speculated that men's role in the birth process, since not

readily apparent, was probably unknown. It is not surprising, then, that the ancient Egyptian throne was inherited not by sons but always by the queen's eldest daughter, whose husband then became pharaoh.[8] An early visitor to Egypt tantalizingly suggested even more: Herodotus of Greece, who traveled to Egypt in the fifth century B.C., wrote that Egyptian women went to the market and occupied themselves in business while their husbands stayed home and wove.[9]

Giorgione,
The Tempest

A sense of mystery clings to this famous painting by the celebrated Venetian painter Giorgione. No one knows the identity of this woman in a stormy landscape, or that of her soldierly companion standing off to one side. She has been variously identified as a gypsy, a Madonna, or the heroine of some arcane classical poem. Yet the atmosphere of this painting tells its own story: Stormy skies notwithstanding, this is an Arcadian idyll, a vision of a harmonious world where nature, not the intellectualizing minds of men, reigns supreme.

Unlike much Florentine painting, in which figures dominate the field and landscape is merely an emotive backdrop, landscape in all its grandeur plays an important role here.[10]

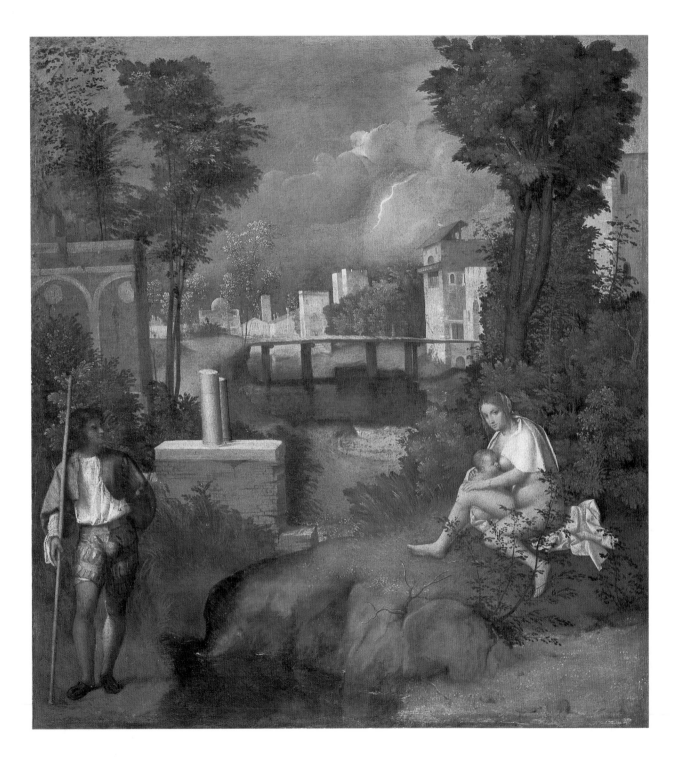

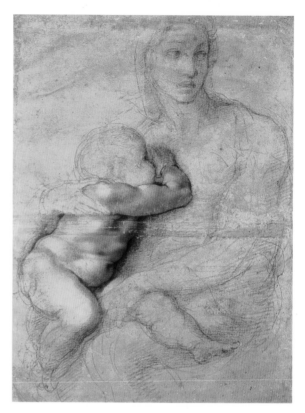

Awash in a magical light, it speaks of a natural order that includes this contemplative nursing mother.

Like the poet Tasso and others in the pastoral movement in Italian literature, Giorgione was expressing the Renaissance yearning for a golden age more serene than modern life in the great Renaissance capitals could offer,[11] and for a guileless, more natural world of harmony and tranquillity. Regardless of her identity, this mother perfectly exemplifies this vision: In the act of nursing her child she demonstrates her own harmonious accord with nature. Though the storm may rage, her child will be safe, suckled, and warm.

Michelangelo,
Madonna Nursing the Baby Christ

Michelangelo's exhaustive treatment—in drawings, paintings, and sculpture—of the Madonna and Child theme exhibits a common thread: The mother looks away from, not at, her son.[12] This beautiful, unfinished drawing, with its delicate lines and masterful sculpting of the infant, is no exception. While the child nurses energetically, the Madonna gazes distractedly into the distance with a troubled, perhaps startled, aspect, clearly immersed in her own thoughts. Though experienced mothers might chalk up Mary's remove to the inescapable tedium of nursing, and Christian theologians to Mary's premonition of future events in the life of her son, Michelangelo's consistent favoring of this representation of Mary as distant and almost oblivious to the child in her arms has led others to speculate that the artist was expressing in his art his own troubled feelings about motherhood.[13]

As was the common practice in moderately well-off urban families, the artist's mother sent each of her five sons off to the care of a wet nurse immediately after their births and—except for an occasional visit—did not see

them again until the time of their weaning at about two years of age. Michelangelo returned, then, at age two to a mother who was a stranger, and since she died when the artist was six, his experience of mothering was limited.

Michelangelo had at least one good thing to say of his experience with his nurse. His sixteenth-century biographer, Condivi, recalls the artist declaring that "it was no wonder the chisel has given him so much gratification," since his nurse was the daughter as well as the wife of a stone mason.[14] It appears Michelangelo shared the popular belief that a baby absorbed character traits from the mother's or nurse's milk.

Albrecht Dürer, *Madonna of the Iris*

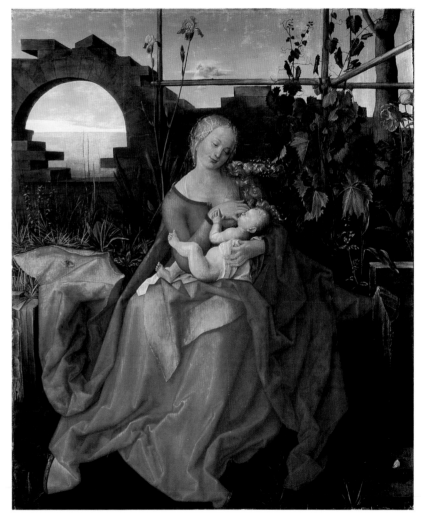

23. Albrecht Dürer
Madonna of the Iris,
1508. Oil on panel,
58¾ × 46⅛ in.
(149.2 × 117.2 cm).
National Gallery, London.

*T*his golden-haired madonna presents a sharp contrast to Michelangelo's drawing. Where Michelangelo's madonna appears discomfited, this mother is serene and completely absorbed, gazing at her nursing child with singular devotion, a peaceful half smile lighting her face. Baby's contentment is evident in his small hand on mother's wrist and big toe playing against mother's arm.

This radiant, albeit saccharine, depiction of motherhood speaks to the best of the nursing experience: a mutual delight in the elemental

attachment of a mother and an infant. As any bottle- or breast-feeding mother will recognize, however, it also presents a contrast to ordinary day-to-day experience; if only feeding times always took place in such tranquil circumstances. More often they are sandwiched into a busy day at home, or around a schedule of work outside the home, or on the run, anywhere from a hastily parked car to a department store fitting room.

Kitagawa Utamaro,
A Young Woman Arranging Her Hair and Nursing Her Distracted Child

This wonderfully humorous print effectively demonstrates how real life contrasts with the Renaissance painter's maternal ideal; compare the tranquillity depicted in plate 23. Here, an obviously harried mother attempts simultaneously to nurse her child and complete, with both hands, a complicated coiffure as she sits before her mirror. Following his busy mother's example, the child is also doing three things at once: nursing at one breast, playing with the other, and reaching for a toy a second woman rather misguidedly offers.

Utamaro is famous for his many portraits of women caught during spontaneous, intimate moments in their day-to-day lives. His remarkably sensitive chronicles of women arranging their hair, emerging from bed or bath, nursing a child, reading a letter, or simply lost in thought are somewhat surprising in view of the woman's role in Japanese society during his lifetime. In late-eighteenth-century Japan women were seen primarily as adjuncts to men, subservient to their husband's whims.

It is in this restrictive cultural context that we appreciate the achievement of Utamaro. His many sensitive and convivial portraits of mothers and children are as fresh and true as any we are likely to find in the history of art (see also plates 65, 79, and 101). These mothers, as they experience the midnight disturbances of sleep, a winsome child's interruption of any and all everyday tasks, or, as in this example, the sometimes comic frustrations of attempting to do two and three things at once, speak with humor and recognition to any contemporary mother.

Mir Sayyid'Ali,
Nomadic Encampment (detail)

This delightful detail of a Persian miniature is part of an illustration to famed twelfth-century Persian poet Nezāmī's epic romance, *Leyla and Majnun*, a tale of tragic love analogous to *Romeo and Juliet*. The illustration, however, doesn't conform to any of Nezāmī's verses.

What we see can hardly represent a genuine

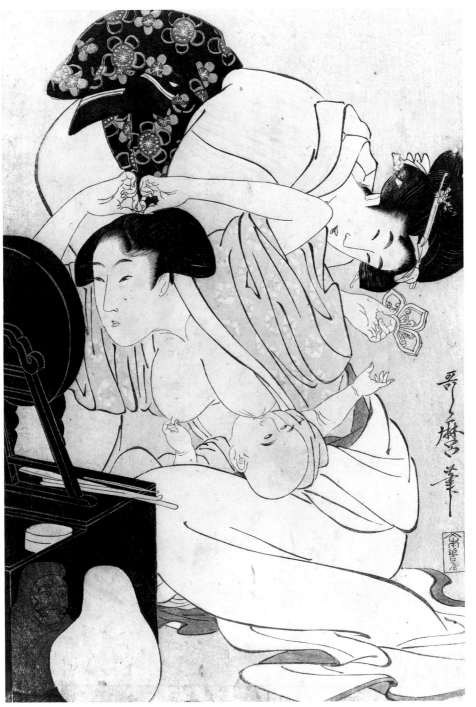

24. Kitagawa Utamaro.
*A Young Woman
Arranging Her Hair
and Nursing Her Dis-
tracted Child*, n.d.,
dimensions unknown.
Bibliothèque Nationale, Paris.

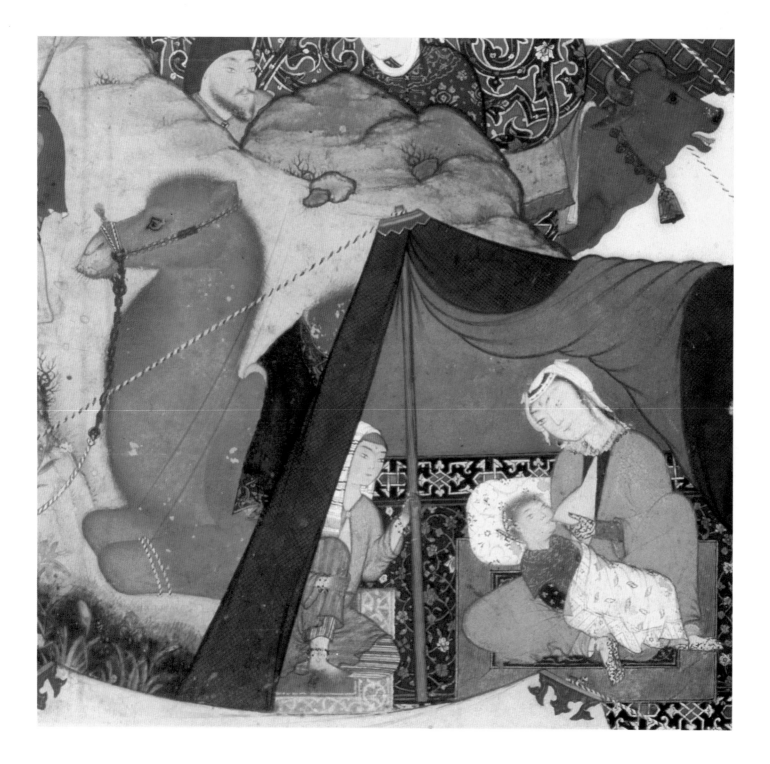

nomadic encampment. The general opulence of the scene, with its richly embroidered tents and textile hangings and the fashionable dress of some of the women, suggests instead a collection of royals on an outing, playing at a lifestyle not their own as a break from the tedium of life at court.[15] To ensure the comfort of the entourage all manner of servants are included, beautifully painted in bright colors and charming detail. Such aristocratic amusements find an eighteenth-century parallel in Marie Antoinette, whose royal parties in the gardens of Versailles enjoyed similar rusticity.[16] This nursing woman was probably the wet nurse of one of the more privileged women of the entourage;[17] the simpler design of her robe seems to indicate that she was of the servant class.

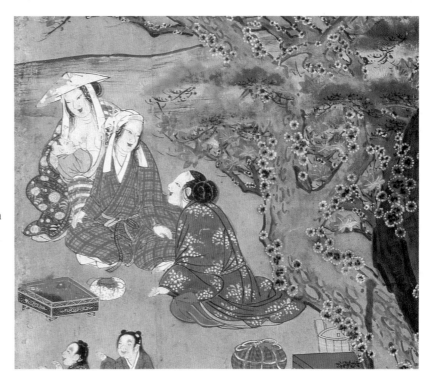

Kano Hideyori,
Maple Viewers at Mount Takao

This pleasant scene seems almost contemporary in its evocation of feminine friendship during an autumn outing in the countryside. These three women are actually part of a larger, rather sumptuous landscape of bright trees, a cloud-filled sky, and soaring geese spread over six panels of a folding screen. The panorama is dotted with other picnickers, including some male companions who sit just a short distance from these smiling women.

This painting anticipates the brilliant Momoyama period (1573–1615), when graceful, refined representations of nature and religious imagery gave way to freewheeling, grandiose depictions of the everyday life of ordinary people. Loosely painted and brilliantly colored, these paintings were made for the pleasure of a new middle class enjoying the country's newfound peace and prosperity. The taste of these nouveaux riches ran not to subtle refinements, but to large, dazzling screen paintings like this one, which celebrated their own amusements and pleasures.

These women are probably ordinary housewives, enjoying the autumn foliage and, from

25. Mir Sayyid' Ali. *Nomadic Encampment* (detail), c. 1540. Opaque watercolor on paper, 11 × 7½ in. (28 × 19 cm) (miniature only).
Courtesy The Arthur M. Sackler Museum, Harvard University, Cambridge, Mass.; Gift of John Goelet.

26. Kano Hideyori. *Maple Viewers at Mount Takao*, c. mid-16th century. Folding screen, paint on paper, 58⅜ × 143⅜ in. (149 × 364 cm).
Tokyo National Museum.

their animated expressions, some lighthearted gossip as well. Both the nursing mother, set slightly apart, and her companions appear happy and relaxed, perfectly complementing the bright landscape that surrounds them.

Helen Turner,
Mother and Child

*I*t is easy for a real mother to feel surfeited by too many male artists' flowery, idealized images of contented mothers nursing cherubic infants. The down-to-earth humanity of Helen Turner's vision of maternity is therefore particularly refreshing.

This artist was not one to see life in ideal terms. Raised in New Orleans, she found her life dramatically altered by the events of the Civil War. She was just a child when her eldest brother was killed, her family houses were burned to the ground, and her father's profitable business was ruined. By thirteen she had lost both her mother and father, and was raised by an uncle. Turner never married, but devoted her life to art. She supported herself with teaching, one of the few respectable vocations for a woman at that time, and eventually made her way to New York City, where she studied at the Art Students' League, Cooper Union, and Columbia University.

In this painting we find no saintly Madonna or serene beauty in a secluded garden, but an ordinary mother. Her features are less than beautiful, her face slightly careworn; she is not young. In this quiet interlude of nursing, her half smile and tender gaze tell us that in spite of the trials an ordinary woman's life may offer, there is yet this remarkable moment, this satisfaction in the special relationship of a mother and child. The pair's eyes are locked together and their fingers intertwined. Their connection is further emphasized by the downward angle of the lines of the mother's body and the stripes of her dress. Colors and patterns are muted to suggest the intimacy of a domestic interior and of this captured moment.

Paul Gauguin,
Maternity II

*T*his painting gives us a sense of the stature and grace Paul Gauguin perceived in the island women of Tahiti. By painting them in the dazzling light and colors of the open air, holding fruit and peacefully nursing an infant, the artist has placed them symbolically close to nature. Like Giorgione's painting from the fifteenth-century, Gauguin's image of women in harmony with nature suggests the artist's vision of a lost ideal.

Unlike many other artists, Gauguin actually acted out his own philosophy, abandoning a wife and children in Europe to pursue a purer, simpler life in the tropics—a life of "ecstasy,

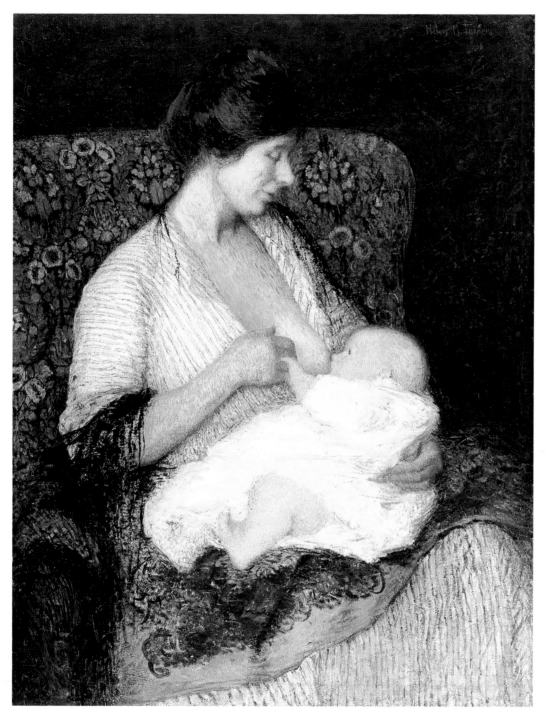

27. Helen Turner.
Mother and Child,
c. 1908. Oil on fabric,
40 × 30⅛ in. (101.6 ×
76.5 cm).
Collection Akron Art Museum;
Bequest of Edwin C. Shaw.

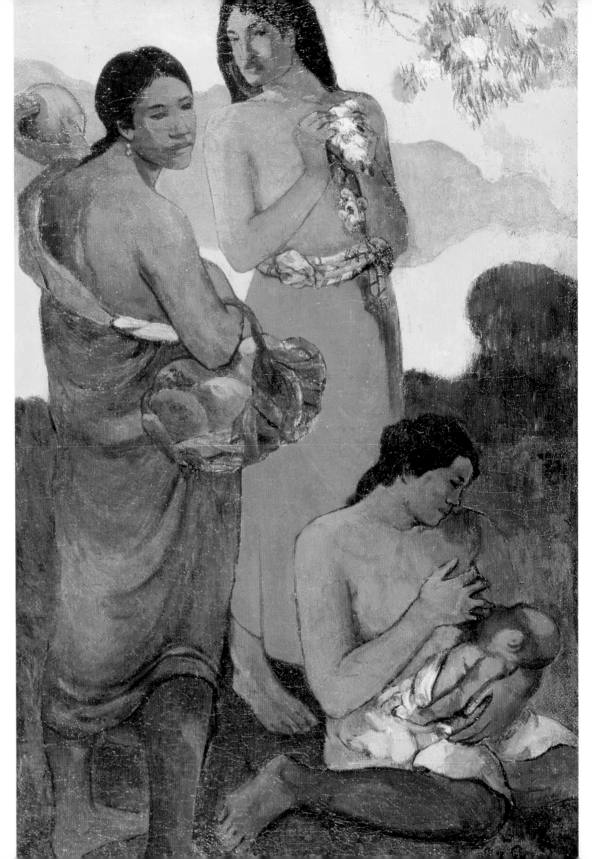

28. Paul Gauguin. *Maternity II,* n.d. Oil on canvas, 36⅝ × 23⅝ in. (93 × 60 cm). The Barbara Piasecka Johnson Collection, Princeton, N.J.

calm, and art," far from "the European struggle for money."[18] He finished his life in Tahiti, producing a large oeuvre of bold, brilliantly colored paintings.

Gauguin recorded his impressions of the island in his journal, published as *Noa Noa*; he found the Tahitian women to be endowed with a dignity of bearing that he found awe-inspiring. He noted that there was "something virile in the women, and something feminine in the men."[19] All worked together at the same tasks and rested with the same sensuous luxury. They were, he said, "comrades, friends rather than lovers, dwelling together almost without cease."[20]

European women compared unfavorably, according to Gauguin: "Thanks to our cinctures and corsets we have succeeded in making an artificial being out of woman. . . . We carefully keep her in a state of nervous weakness and muscular inferiority, and in guarding her from fatigue, we take away from her possibilities of development." Where European aesthetics demanded slenderness and fragility, Gauguin notes that in Tahiti "the breezes from the forest and sea strengthen the lungs, they broaden the shoulders and hips,"[21] giving the women a beauty that defied the European ideal.

Yet Gauguin's glorification of the Tahitian woman as a lost ideal of "natural" femininity can be seen as part of a late-nineteenth-century backlash against the rise of feminism in France.[22] As women began to pursue options other than their traditional roles as wives and mothers, making gains in education and employment, a flurry of art and literature appeared that extolled a "natural" femininity in which maternity was a woman's proper vocation.[23]

Camille Pissarro,
Mother and Child

Camille Pissarro, known primarily for his Impressionist landscapes, rarely painted portraits. When he did, he most often chose family members or close friends for his subjects. This painting is of the artist's wife, Julie, and their fifth child, Rodolphe.

The year this portrait was painted was not an easy one for the Pissarros. Desperate for money, Camille spent a good part of the year in Paris trying to generate sales. Pregnant with Rodolphe, Julie was left at home in Pontoise, on the Oise River in the Ile-de-France, to manage as best she could. While the landlord continually demanded the overdue rent and creditors of every kind pressed at her door, she cared for their three sons, aged fifteen, ten, and four, the eldest of whom was seriously ill. (Another child, a daughter, had died four years earlier.) Hardworking and thrifty, she fed the family with vegetables from her own large garden and with the chickens, rabbits, and pigeons she raised herself.

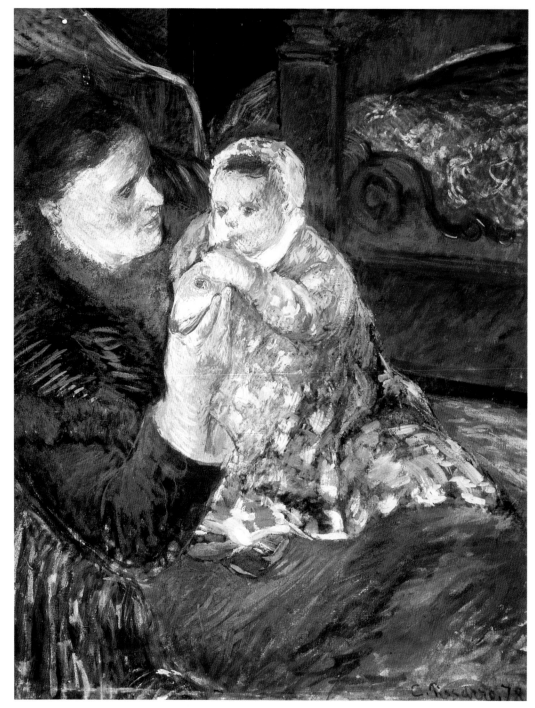

29. Camille Pissarro.
Mother and Child, 1878.
Tempera on canvas,
31⅞ × 25½ in.
(81 × 64.8 cm).
Alice F. Mason.

The ruddy-complexioned Julie appears here as a figure of strength and dependability. The explicit right angle of her solid figure, clothed in tones of warm brown, echoes the line, color, and sturdy mass of the wooden bedstead behind her. She gazes into the face of her son with a mixture of concern and fatigue as she feeds him from a boat-shaped bottle, which probably contained a homemade "formula" made of cow's milk, sugar, and cereal. Though bottles had been in use for hundreds of years—clay examples, shaped rather like teapots, survive from ancient Greece—it is rare to find them represented in art.

Pablo Picasso,
Nursing Mother

Picasso was fond of saying that he was born with the ability to draw like Raphael, but spent an entire lifetime learning how to draw like a child. It is indeed the artist's seemingly untutored inventiveness and whimsy that give this relaxed drawing its considerable charm.

The mother here is all curving lines that gracefully envelop a nursing child. Like the artist's line, she appears relaxed, with a sleepy indolence to her lifted arm and crossed legs. Though fingers and toes, eyes and mouth are summarily treated, as in a child's stick-figure drawing, this mother nevertheless has the

weight and solidity of sculpture, and the proportion and scale of an earth mother. Her colossal breast and hips contrast playfully with her tiny head, but as in the artwork of children, these inconsistencies simply add to the drawing's appeal.

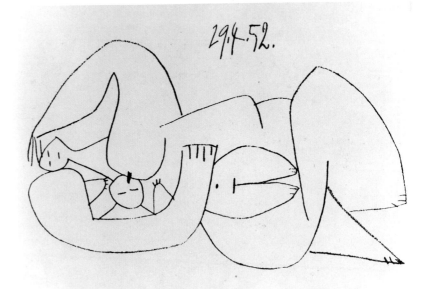

Giovanni Lorenzo Bernini,
Charity with Four Children

Bernini's ability to transform marble into wonderfully convincing theatrical figures delighted his contemporaries. Something of a child prodigy, Bernini carved his first sculpture at the age of eight, and his immense success during a lifetime spent in Rome was a natural sequel to such an auspicious beginning.

30. Pablo Picasso. *Nursing Mother,* 1952. Drawing, dimensions unknown. Private collection.

31. Bernini. *Charity with Four Children*, c. 1627–28. Terra-cotta with traces of gilding, 15⅜ in. high (39 cm). Biblioteca Apostolica Vaticana.

In this work the sculptor has given us a heroic image of motherhood that speaks as clearly to overburdened contemporary mothers as it must have to the women of Rome in the late Renaissance. Here is a mother who divides herself between the needs of four children, one hungry, one in tears, and two cavorting around her feet. With an almost magisterial calm she manages to hold one hefty child to her breast while simultaneously turning to tend to the tearful one at her side, nimbly avoiding toppling over the two at her feet.

This is not a seventeenth-century vision of ordinary motherhood but, rather, the Renaissance version of the "supermom" who meets extraordinary challenges with ease. She is the virtue Charity, meant to encourage viewers to imitate the lofty qualities she personifies. This sculpture must have been compelling: Charity's spiraling motion effectively brings us into her world. Her calm dedication to these small charges, even as they appear to overwhelm, enlists our empathy, and her grace and capability our admiration.

Scott Prior,
Nanny and Max

Scott Prior's paintings are astonishingly realistic, almost photographic in their careful delineation of every object within the scope of the artist's

view, from single blades of grass in a landscape
to a supermarket price sticker on a bunch of
bananas in a still life. This unwillingness to
edit reality enhances the sense of an actual
moment captured in time.

This painting has just this sense of a frozen
moment. It is a portrait of the artist's wife,
Nanny, and child, Max, in the yard of their
Northhampton, Massachusetts, home. Nanny
hardly seems posed; she looks as if she has
just dropped into a chair to nurse her infant.
As baby suckles with closed-eyed abandon,
mother's unfocused gaze suggests she has
turned her thoughts inward. The slight crease
in her brow and the set of her mouth suggest
mild annoyance, or perhaps preoccupation,
fatigue. In an added note of realism, she is not
unaware of the painter who works before her.

The moment captured is an ordinary—not
idealized—one in the day of a young mother.
The magical quality of light gives the painting
its poetry and lets the viewer participate for a
few moments in just that time of day, the mild
warmth of slanting sunlight on bared arms, the
coolness of deep shadow. The element most
palpable to mothers might be the recognition
and memory of just that size infant cradled
just so in one's lap with such lovely, peaceful
abandon.

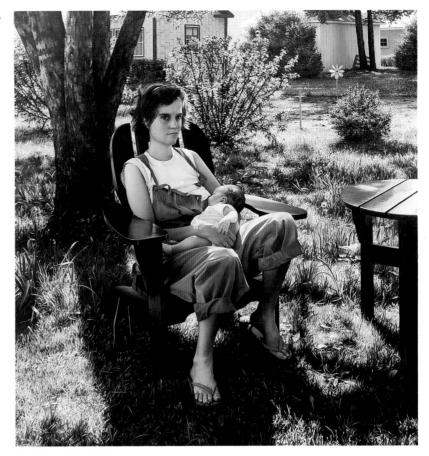

32. Scott Prior. *Nanny
and Max,* 1984. Oil on
canvas, 58 × 54 in.
(147.3 × 137.2 cm).
Courtesy Maxwell Davidson
Gallery, New York.

4
By the Cradle

Every mother has had the pleasure of observing her healthy new baby sleep the fitful sleep of infancy, as well as the anxiety of watching a little one's more uncertain slumber. Here are three artists' representations of these contemplative mother-and-child moments.

Rocking the cradle with her foot and busy with her mending, Millet's mother suggests contemplative repose, a peaceful interlude in a busy round of peasant farm labor. Berthe Morisot's genteel mother, whose wealth would have allowed her far greater leisure than Millet's and Rembrandt's peasant mothers could enjoy, takes full advantage of her freedom: She appears transported by reverie as she gazes at her sleeping child. Rembrandt, characteristically incisive, endows his portrait of the Virgin Mary with a humanity rare in depictions of the Madonna. Her anxious absorption allows us to see her as a new, somewhat unsure young mother instead of a saintly ideal.

Jean-François Millet, *Baby's Slumber*

33. Jean-François Millet. *Baby's Slumber,* c. 1855. Oil on canvas, 18¼ × 14¼ in. (46.4 × 36.2 cm). The Chrysler Museum, Norfolk, Va.

When Millet left his family farm in Normandy for the bright lights of Paris in 1837, he was part of a much larger trend. Country people were pouring into the city at an unprecedented rate, looking for the jobs that the Industrial Revolution had so lately created. Yet in his art Millet nostalgically hearkened back to the farm life he had left behind. Although the peasants Millet depicted have a heroic presence and power (leading one contemporary to describe Millet as one who "in the sabots of a peasant, treads in the footsteps of Michelangelo"[1]) he never edited out the less picturesque details of roughened faces, coarse features, worn shoes, or shabby clothing.

Like the peasant men, Millet's women are never idealized, and rarely are they idle. They are distinguished by physical strength and fortitude as they harvest buckwheat, shear sheep, card wool, churn butter, bake bread, plant potatoes, and haul water, or bend under the burden of faggots in a winter landscape.

The peasant woman shown here rocks her sleeping child with one foot while focusing industriously on her mending. She embodies strength in repose, perseverance, and capability that see her through all the demanding tasks of motherhood and farm labor. Yet there is still a mood of quiet reverie that speaks of

Millet's memory of the peace and tranquillity of life in the country. The soft colors and hazy light give the painting an intimacy and spirituality not unlike Rembrandt's Holy Family (see plate 35).

Berthe Morisot,
The Cradle

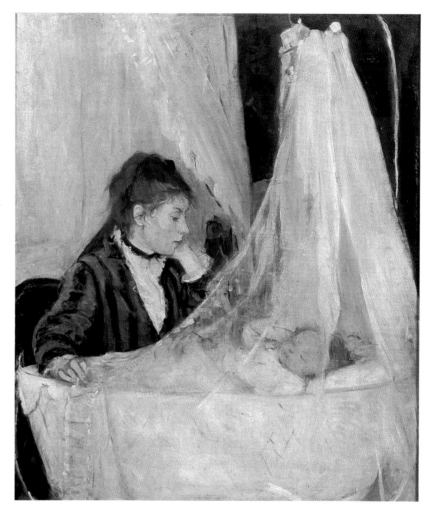

34. Berthe Morisot. *The Cradle*, 1872. Oil on canvas, 22 × 18⅛ in. (55.9 × 46 cm). Musée d'Orsay, Paris.

This mother, though immediately set apart from those depicted by Millet and Rembrandt (see plates 33 and 35) by the trappings of wealth, leisure, and privilege, is similarly caught in a moment of tranquillity. Her infant, sheltered in a filmy canopy of gauze and lace, inspires in her mother a long, dreamy gaze in which we can read both devotion and wonder.

The idealized moment portrayed here reflects some of the changes in the lives of women in the late nineteenth century. At the time of this painting, new prosperity had created a middle class able to afford the homes, food, clothing, servants, and child care previously reserved for the wealthiest elite. Freed from the necessity of earning wages and from the heaviest work of running a household, these middle-class women had new leisure time. They were encouraged to fill it with an elaborated, expanded conception of motherhood previously impossible. Like this mother in Morisot's painting, mothers had time for greater involvement with their children and for dreamy interludes like this one.

This is Berthe Morisot's portrait of her sister Edma with her baby, Blanche. The artist and her sister were very close; Edma can be found in a number of Morisot's paintings. Edma was also an aspiring artist but gave up painting after her marriage, while her sister went on to

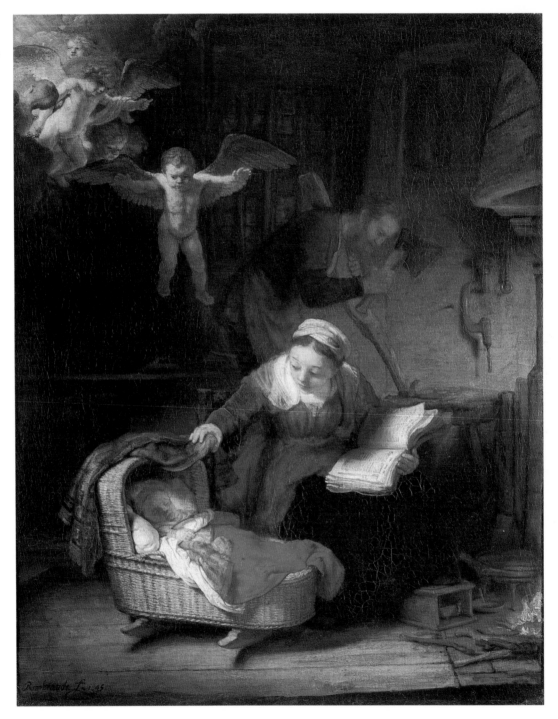

35. Rembrandt. *The Holy Family with Angels* (detail), 1645. Oil on canvas, 46 × 35¾ in. (116.8 × 90.8 cm).
Hermitage, Leningrad.

achieve renown as one of the Impressionists.

Though painting was clearly at the center of Berthe Morisot's life, she, too, became a mother, and apparently never found the two roles incompatible. Her wealth enabled her to employ a wet nurse to breast-feed her baby, Julie, and otherwise care for the child, while her exceptionally supportive husband encouraged her development as an artist. She found her subjects in everything around her, including little Julie. As the poet Paul Valéry, Berthe's cousin, put it: "Berthe Morisot lives her painting—and paints her life."[2]

In a letter to her sister Yves soon after Julie's birth, Berthe writes that her baby "looks like a boy" and has "a head as flat as a paving stone."[3] Though she is not, of course, the first mother to find her newborn less than cherubic, her delight in her baby quickly surfaces; as she later wrote, the baby is "sweet as an angel" and "she is like a kitten, always happy, she is round as a ball, she has little sparkling eyes, and a large, grinning mouth."[4]

Rembrandt,
The Holy Family with Angels (detail)

Rembrandt was a painter of exceptional compassion, depth of understanding, and insight into human character. He was a master at gazing into the hearts of individuals from all walks of life and telling their individual stories with nonjudgmental sympathy and pathos.

The son of a miller, Rembrandt was a young man in his twenties when he met his beloved wife, Saskia. His exuberant portraits of her and of the two of them together attest to the joyfulness of their love. Saskia died just nine years after their marriage, having given birth to four babies. Only one, born the year before her death, survived.

A man so well versed in the feelings of others and with such a ready sympathy for the general human condition must have felt deeply himself. Many have observed that Rembrandt's painting underwent a substantive shift in style after his loss of Saskia. His interest became more firmly grounded in human feeling, as opposed to the observed external world. This painting of the Holy Family was completed just three years after Saskia's death, and speaks eloquently of the bond of passion and care between a simple peasant mother and her child. As few other paintings before or since, this depiction of the Virgin Mary allows us to see her as a real mother, whose concerned, hushed watchfulness over her sleeping child immediately engages our sympathy. The gentleness of her gesture, and her tentative, absorbed, slightly anxious air enable us to find ourselves in this eminently human woman and mother.

Before baby discovers the exciting physical world beyond mother's secure arms, her lap is a special world unto itself. It is here that a baby experiences the most pleasurable comfort and the happiest play. Later, as a baby starts reaching out for new things, crawling, and finally walking under his or her own steam, mother's lap is a remembered haven of security and contentment. In these images, infants and older children alike enjoy the special refuge and intent interaction experienced in mother's lap, from the tenderness of the ancient Greek *kourotrophos* and the secure comfort Cecilia Beaux's mother provides for her older child, to the uninhibited, spontaneous play of Reynolds's Lady Cockburn and the magical connection shared by Daumier's mother and infant.

5
Mother's Lap

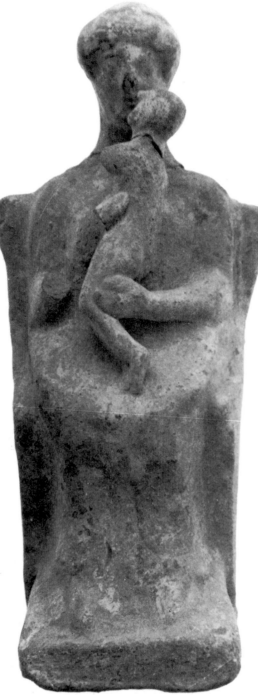

Greece, *Kourotrophos*

*I*n spite of the blocky, unfinished look of this figure, there is a tenderness in the interaction between mother and child not usually found in *kourotrophoi* (see plate 19). In many of these figures, an inert, wooden-looking child is cradled awkwardly in the arms of an expressionless mother. Here, a far more believable child seems to reach up and kiss the mother, whose face holds just the ghost of a smile. There is a gentleness, too, in her faded features and her protective arms.

The *kourotrophoi* were not singular deities but rather the nursing or mothering aspect of such other goddesses as Athena, Artemis, Demeter, Persephone, Hera, and Aphrodite. Later, male gods, too, became *kourotrophoi*, called upon for assistance in the successful upbringing and educating of children.[1]

The Greek concept of the *kourotrophos* has parallels in the ancient world's many goddesses of pregnancy and childbirth in cultures as divergent as the pre-Columbians of western Mexico and the ancient Egyptians. Western culture has also continued the tradition. Christian women from the Middle Ages to the present are likely to call upon the Virgin Mary much as the ancient Greeks did the *kourotrophoi*, for special assistance in matters related to their shared experience of motherhood.

36. Greece, artist unknown. *Kourotrophos*, n.d., dimensions unknown. Museum of Casts and Archaeological Collections, Department of Archaeology and Art History, University of Thessaloniki, Greece.

India,
Balarama Playing with Yashoda

This fond, playful pair, fanned and waited upon by a smiling servant, represents an adoptive mother and child of rather special circumstances. In Indian mythology, Balarama was the older brother of Krishna, the popular Hindu deity, and the seventh child of Devaki, cousin of the tyrannical King Kamsa. Because of the prediction that one of Devaki's children would kill the king and usurp the throne, Kamsa ordered that each child born to Devaki be killed. Having lost her first six children to the evil king's wishes, Devaki, pregnant for the seventh time, heard a celestial voice directing her to transfer the baby in her own womb to that of Rohini, her husband's second wife. She duly performed this obstetrical marvel, and Balarama was born to Rohini.

The birth of Devaki's next child, Krishna, also escaped the king's notice, presumably by some equally remarkable but unrecorded subterfuge, and the two children were smuggled out of the palace and into the country, where they were placed in the care of the cowherder Yashoda and her husband, Nanda. If our painting is any evidence, Yashoda took great joy in her motherhood. Balarama, like any real child, is captivated by his mother's face and reaches curiously for her hair and her jewelry.

Balarama and Krishna grew up as constant

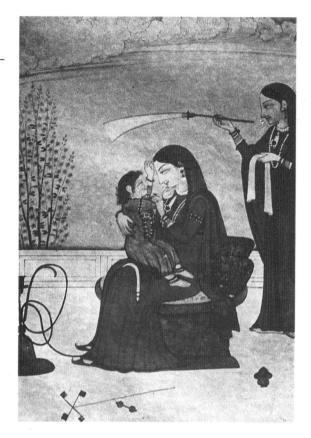

37. India, artist unknown. *Balarama Playing with Yashoda,* 18th century. Watercolor on paper, 6½ × 4½ in. (16.5 × 11.4 cm). Bharat Kala Bhavan, Banaras Hindu University, Banaras, India.

companions. True to prediction, Krishna eventually murdered the tyrannical King Kamsa.

Ghana,
Female Figure with Twins

Representations of mothers and children abound in African sculpture. While the majority are made by male artists, the creator of this piece was female.

The half smile of this contented-looking

mother, and her columnar body, short arms, and high, flat forehead are similar to those of fertility dolls carried by pregnant African women to assure a safe birth and healthy, beautiful offspring.[2] It is likely, however, that this piece had a different purpose. Because the mother is seated on a traditional Akan stool, she is probably of royal lineage.[3] Akan men and women of royal descent near death would often ask a woman sculptor to fashion a clay figure in their likeness. This figure would then be left in a forest shrine in hopes of securing a favorable afterlife.

Although Akan culture is matrilineal, the relative status of women can be confusing. As in most parts of Africa, men fill the more visible leadership roles in the community in a political sense. Women, however, can hold important positions in the areas of religion and economics and enjoy respect and authority in most facets of day-to-day life. An oft-quoted Akan proverb says: "The hen knows very well when it is dawn, but she leaves it to the cock to announce."[4]

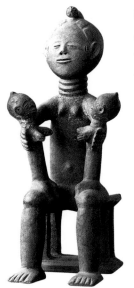

38. Ghana, artist unknown. *Funerary Figure: Female Figure with Twins,* 19th century. Terra-cotta, 18¼ × 7¾ × 9 in. (46.4 × 19.7 × 22.9 cm). Seattle Art Museum; Katherine White Collection.

Sir Joshua Reynolds,
Lady Cockburn and Her Children

The eminently aristocratic Lady Cockburn epitomized the cream of late-eighteenth-century British nobility, but she is found here in less decorous circumstances, literally engulfed by her three little boys. The inclusion of these rambunctious babes clinging and climbing over their tolerant mother like so many Italian putti makes this as different as possible from early-eighteenth-century portraits, where children, if they appeared at all, were depicted as stiff, well-behaved little adults.

This break in the conventions of portraiture corresponds to the late eighteenth century's dramatically different view of the family, and of mothers and children in particular. Marriages had previously been arranged not around notions of love or compatibility but for more weighty considerations like consolidating family interests of wealth, property, and social position. Children were viewed with some indifference as necessary encumbrances, whose care among the upper classes was most appropriately managed by paid help, including wet nurses.

Starting about mid-century, this attitude changed dramatically. Jean-Jacques Rousseau in particular challenged these conventions, espousing a return to nature, where women not only breast-fed their own babies but delighted in close, affectionate bonds with their children.[5] The consequences, Rousseau stressed, would not be just increased health and happiness for mothers and babies, but also a more far-reaching restoration of the family as an important social unit.

Though there were quibblers, like one Mme

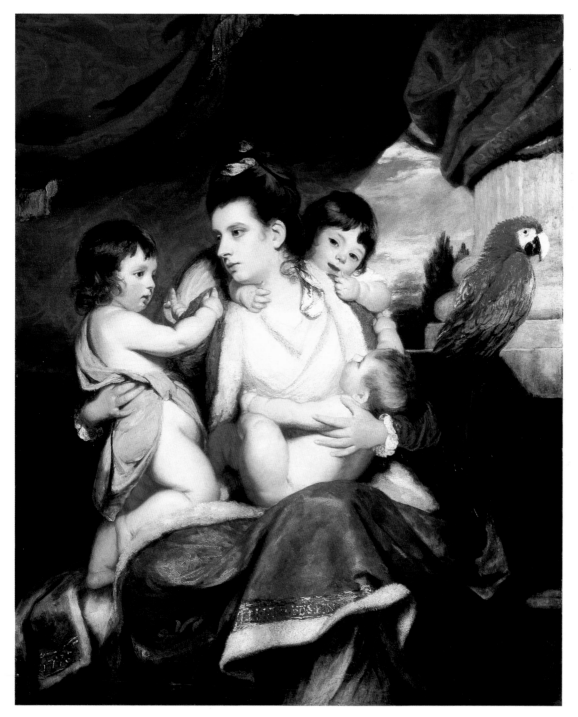

39. Sir Joshua Reynolds.
*Lady Cockburn and
Her Children*, 1773.
Oil on canvas,
44¼ × 55¼ in.
(112.4 × 140.3 cm).
National Gallery, London.

40. Mrs. Samuel Glover Haskins. *Crazy Quilt,* 1870. Pieced, appliquéd, and embroidered cotton, 69½ × 83 in. (176.5 × 210.8 cm). Courtesy Shelburne Museum, Shelburne, Vermont.

de Genlis, who foresaw that the practice of breast-feeding might interrupt the social round of balls and receptions,[6] the upper classes for the most part greeted these innovations with enthusiasm.

Mrs. Samuel Glover Haskins, *Crazy Quilt* (detail)

One of the most intriguing aspects of needlework is its ability to chronicle the lives and times of women whose stories might otherwise be lost to history. This pieced quilt is a detailed autobiographical narrative of its maker, telling a colorful story of life on the Haskins family farm in the mountains of Vermont in the midnineteenth century. Scattered over the quilt in appliquéd cottons are the farmhouse itself, the various animals of the farmyard, several of the region's native wild animals, and many people who were probably either family members or neighbors.

In this detail, we find a mother and her naked, playful child absorbed in characteristic communication: Each stares into the other's eyes, and baby explores mother's face with an outstretched hand. Surrounded by other pieced quilt blocks showing many different aspects of farm life, this little vignette stands out, emphasizing the importance of the mother-child relationship.

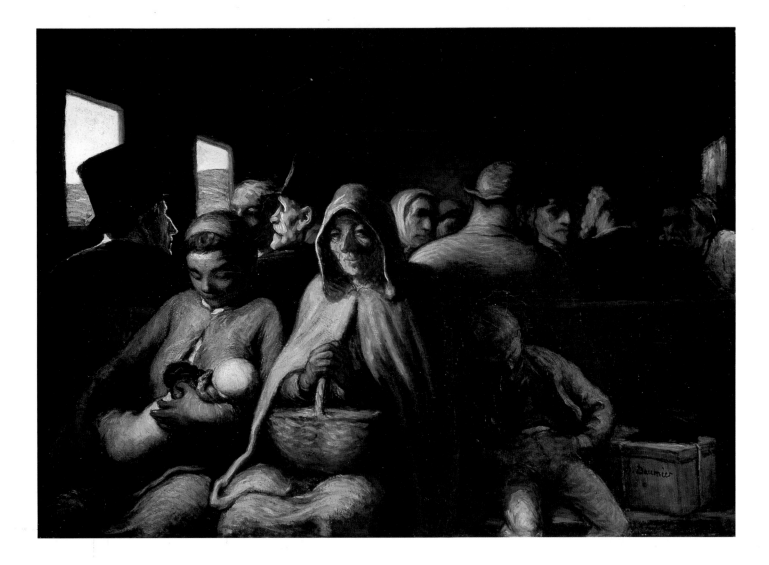

Honoré Daumier,
The Third-Class Carriage

———————————————————

onoré Daumier, the great
political satirist, depicted reality
as he saw it. And since he was
living in the very center of the Industrial

Revolution, reality could be grim indeed.

Loathing travel, Daumier rarely found him-
self aboard a train, but when he did he made
sketches of both self-satisfied-looking first-
class passengers and more forlorn third-class
riders. In this sensitively observed sea of lonely
faces, the artist has picked out a working-class

41. Honoré Daumier.
*The Third-Class Car-
riage,* 1863. Oil on
canvas, 25¾ × 35½ in.
(65.4 × 90.2 cm).
National Gallery of Canada,
Ottawa.

mother and her child. In contrast to the stoic isolation of most of the other travelers (familiar to anyone who has ridden the subway in a large city), the artist gives us a glimpse into this pair's special world, the magical connection between a mother and her child that survives even in the crowded train car.

Life for women such as the one seen here could not have been easy. The poorer neighborhoods of Paris were teeming with life; large families routinely crowded into one-room apartments with minimal cooking facilities and no running water or safe water supply. Raising a family in this setting was a challenge indeed, and contemporary visitors commented particularly on the heroic efforts of working-class mothers.[7] Since a husband's wages alone were usually insufficient to support a family, women like Daumier's subject had to struggle to earn money in addition to performing the everyday rigors of maintaining the household. A few who could arrange child care with neighbors or relatives worked in the factories, but most could only choose work at home. They earned money by piecework, making gloves and hats or sewing dresses for outrageously low wages, burning their candles long into the night.

Daumier's awareness of the harsh lot of his third-class riders comes through clearly in this painting. And although perhaps not quite heroic, this mother, and the weary older woman beside her, obviously earned the artist's compassion and respect.

Cecilia Beaux,
The Last Days of Childhood

*E*very mother will recognize this moment of childhood when an energetic toddler, who has been busily exploring the world on his own two legs, retreats to mother's lap for a refueling of security and comfort. Cecilia Beaux's sensitive painting shows us a child, tired from a full day's falls, bumps, mishaps, and adventures, giving himself up to the familiar comfort of this circle of safety. The child's mother seems happy to provide this quiet interlude for her weary adventurer; she lightly encircles his waist and makes room for him to lean into her shoulder and sprawl over her knees. Her wistful expression suggests that she is also nostalgic, perhaps reminiscing about her baby's infancy—the hours he spent contentedly cradled in her arms—and how quickly it has passed. Her look hints at the contradictory emotions many mothers have felt: As much as a mother celebrates her child's growth and increasing independence, it is difficult to approach the end of each special stage.

This mother and child happen to be the artist's older sister, Aimée Ernesta, with her firstborn son, Henry. Always concerned with capturing something of the character of her sitters, Cecilia Beaux was at her best in paintings like this one, where her knowledge of her subject's inner feelings and sensibilities

42. Cecilia Beaux. *The Last Days of Childhood*, 1883–85. Oil on canvas, 45¾ × 54 in. (116.2 × 137.2 cm).

Courtesy Pennsylvania Academy of the Fine Arts, Philadelphia; Anonymous Partial Gift.

43. Mary Cassatt. *The Child's Caress,* c. 1891. Oil on canvas, 25½ × 19¾ in. (64.8 × 50 cm). Honolulu Academy of Arts; Given in memory of Miss Wilhelmina Tenney, 1953.

enabled her to capture a poignant moment of motherhood.

Mary Cassatt,
The Child's Caress

Mary Cassatt always painted what she knew best and was a great chronicler of the private lives of women. But where her male contemporaries, and so many men artists before her, typecast women according to sentimentalized clichés—portraying them as graceful maidens, pure Madonnas, or sensual, yielding odalisques—Cassatt emphasized women's thoughtfulness, their absorption in their own lives and experiences, and most of all, their dignity.

She is best known for her many paintings of mothers and children, which were highly innovative in their time. They were daring not only in their embrace of radical Impressionist techniques and the earlier example of Japanese woodblock prints, but also in their refusal to idealize an often sentimentalized subject.

The Child's Caress is a good example of Cassatt's refusal to prettify. Mother and child here are ordinary, even plain individuals, with blunted features, unsmiling expressions, and a somewhat leaden mien. Yet both possess a thoughtful dignity, and the painting's real subject—the pair's special connection and shared private sphere—is elegantly expressed. Mother's arms encircle her child, who completes their physical intertwining with her own grasp of her mother's hand and playful exploration of her face. The two are locked in an inquisitive, mesmerized stare that effectively embodies the intimate bond they share.

Erastus Salisbury Field,
Mrs. Paul Smith Palmer and Her Twins

Mrs. Palmer and her twins are at first glance only mildly interesting subjects of a stiff, formalized family portrait. The absence of strong feeling in these sitters is due largely to the relative skill of the artist and the conventions of early American portraiture. Although we can't really guess if this woman was as restrained in her affection as her high collar, rigid posture, and reserved though gentle expression suggest, we do know that there is more to her story than the untutored artist's brush could convey: The roughly painted hands of this mother hold her children in hope and fear. She was to lose them both to illness soon after this portrait was painted.

Mrs. Palmer gave birth to her children at a time when attitudes toward motherhood were undergoing some distinct changes. Where earlier generations of women believed the welfare of their children was by and large in the hands

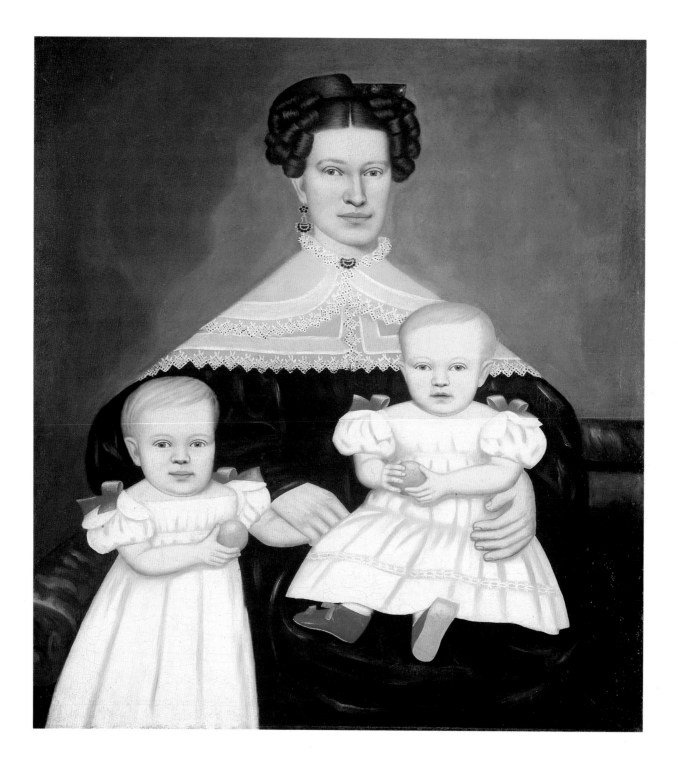

of divine providence, trusting to "mothers' intuition" to guide their actions, early-nineteenth-century women were encouraged to believe that it was their own competence in child rearing that would ensure the physical, emotional, and spiritual well-being of their children.[8] Advice from self-appointed child-care experts abounded in this period, and caused no small degree of anxiety in mothers. Thus one Abigail Alcott, not unlike a modern mother, wrote anxiously to her brother in 1833: "It seems to me at times as if the weight of responsibility connected with these little mortal beings would prove too much for me—am I doing what is right? Am I doing enough? Am I not doing too much?"[9]

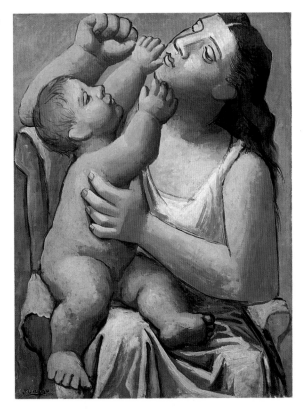

44. Erastus Salisbury Field. *Mrs. Paul Smith Palmer and Her Twins,* 1835–38. Oil on canvas, 38½ × 34 in. (97.8 × 86.4 cm). National Gallery of Art, Washington, D.C.; Gift of Edgar William and Bernice Chrysler Garbisch.

45. Pablo Picasso. *Mother and Child.* 1921–22. Oil on canvas, 38¼ × 28 in. (97.2 × 71.1 cm). Private collection.

Pablo Picasso,
Mother and Child

*P*icasso's *Mother and Child* very effectively conveys the exclusivity of the pair's special relationship. The two figures are tightly isolated within the frame and engage in dreamy, self-absorbed play that almost makes the viewer feel like an intruder upon their intent interaction. The figures have an exaggerated weightiness, a sculptural solidity that gives them the monumentality of ancient statuary.

Picasso was an especially gifted observer, and real life was always the inspiration for even his more abstract art. He must have been an uncommonly discerning new father as well. His wife, Olga, had given birth to their first child, Paulo, in 1921, the year of this painting, and it is clear that the artist was struck by the intensity of the bond between the two.

Every so often, a work of art achieves special success in capturing the emotional intensity of the bond between mother and child; thus the artwork in this chapter strikes a slightly higher emotional pitch than in other chapters. In works like Sargent Johnson's *Mother and Child*, Paula Modersohn-Becker's *Reclining Mother and Child*, and Milton Avery's *Maternity*, we feel the primordial strength of an archetypal mother who sustains and protects her vulnerable child. William Blake makes the child's dependence on the mother more literal in his prelude to *Urizen*: This mother guides her angel child in his tentative first flight, supporting his airborne glide with her steadying arm. Mary Cassatt effectively conveys a small child's unbounded trust in her mother's comforting arms, while Elisabeth Vigée-Lebrun and the unknown tenth-century Indian sculptor give us a glimpse of the spontaneous joy a child feels in a mother's embrace.

6
Close Bonds

India,
Mother and Child

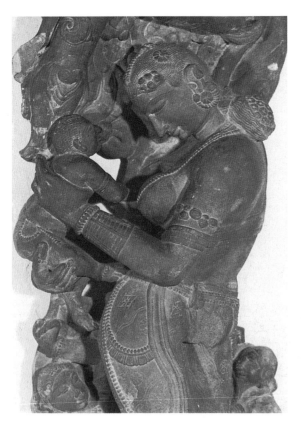

46. India, artist unknown. *Mother and Child*, 10th century. Medium and dimensions unknown. Indian Museum, Calcutta.

In this sculpture, surprisingly naturalistic for its early date, sensual charm combines with mother and child's obvious delight in each other to great effect. Mutual smiles speak eloquently of this pair's special bond. It is difficult to know if this mother represents a Hindu goddess—perhaps the river goddess Ganga with her child Karttikeya—or simply a secular mother and child. Either way she is captivating, with her bejeweled hair, braceleted arms, feminine curves, and especially her obvious pleasure in the infant she holds.

Indian art holds an unexpected charm in its many representations of women. Over and over again one finds a particular brand of femininity, a soft, voluptuous sensuality and grace of gesture unlike anything found in Western art (see plates 10 and 97).

Motherhood in Indian culture has always been held in the highest esteem, which contrasts with the lowly legal, public, and social position of women in other aspects of life. Early civilization worshiped mother goddesses and revered real mothers as a creative life force, the mainstay of life in the community. Vestiges of this reverence survive in the many female goddesses that have found places within Brahmanic society, and in the continued esteem for the role of the mother in society.

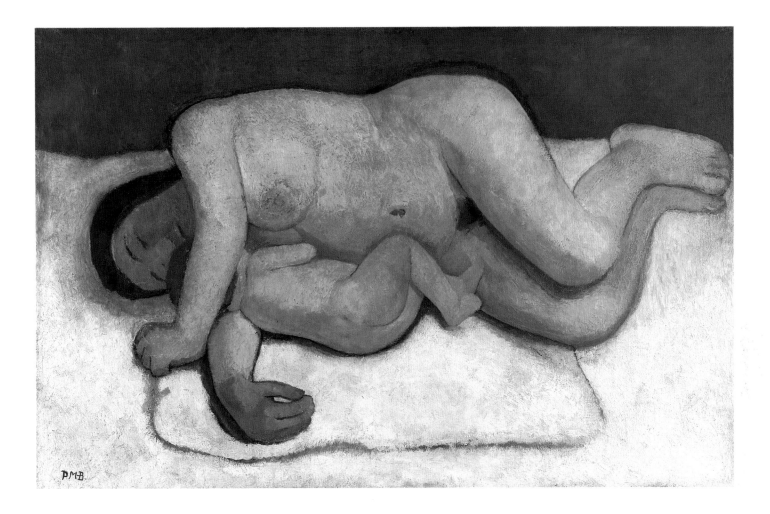

Paula Modersohn-Becker,
Reclining Mother and Child

*A*fter watching a peasant mother nurse her child, German artist Paula Modersohn-Becker wrote admiringly: "The woman was giving her life and her youth and her strength to the child in all simplicity, without realizing that she was a heroic figure."[3] Influenced by the late-nineteenth-century's nature-oriented "earth mother" ideal for women, Modersohn-Becker often chose rural peasant mothers as her subject, endowing them with heroic simplicity. The woman in this painting is monumental, with an essential dignity and primitive, life-sustaining strength. Heavy and somnolent, mother and child are peacefully turned in on

47. Paula Modersohn-Becker. *Reclining Mother and Child*, 1906. Oil on canvas, 32¼ × 49 in. (82 × 124.7 cm). Ludwig-Roselius Sammlung Bottcherstrasse, Bremen, Germany.

one another, perhaps after a midnight feeding.

Modersohn-Becker herself was caught in an all-too-familiar gender conflict. As a young woman she wrote: "I know that I could be somebody, but with petticoats what do you expect one to do? Marriage is the only career for women."[4] After her marriage to landscape painter Otto Modersohn, however, she periodically isolated herself from him and everyone else, going to Paris to devote herself to her art. From there she wrote to her sister: "I am becoming something—I am living the most intensely happy time of my life."[5] She was turning out hundreds of paintings and drawings, and though he longed for her return, her husband appears to have been remarkably supportive and understanding.

Just over a year later, in 1907, Modersohn-Becker rejoiced at the birth of her first child, Mathilde. Only four weeks later, the artist died of a heart attack. She was just thirty-one.

Elisabeth Vigée-Lebrun,
*Madame Vigée-Lebrun and Child
(in Greek Toga)*

This painting of the artist and her daughter, Julie, is one of about twenty self-portraits by Elisabeth Vigée-Lebrun. She is wearing the classically simple white muslin dress she favored over the stiff, corseted, ornate fashions of the day.

The costume enhances the soft mood of the painting and the relaxed, uninhibited closeness between mother and daughter. An overall effect of naturalism and humanity, rare in the work of her contemporaries, was important to Vigée-Lebrun. Prodigiously talented, Vigée-Lebrun was one of the most celebrated women artists of her own or any time. She constantly strove to go beyond mere appearances in her portraits, and in her best paintings she achieves a sparkle and freshness for which she is deservedly famous.

Vigée-Lebrun's self-portraits, in the words of one twentieth-century critic, were "almost outrageously flattering."[1] She was, however, a beautiful woman by anyone's estimation, and purportedly something of a coquette. Her detractors called her vain and egotistical and spread malicious rumors of her extravagant parties and rafts of lovers. What is more certain is that she was devoted to her work, completing hundreds of portraits in the course of her career, and would have been a wealthy woman had she not had the misfortune of having married, at age twenty, a handsome rake who pocketed her profits to finance a compulsive gambling habit.

One wonders what sort of mother she was to little Julie. She reportedly took her impending motherhood in stride, continuing to paint energetically throughout her pregnancy. On the day of Julie's birth, the artist's closest friend, Mme de Verdun, came to see her in her studio and

48. Elisabeth Vigée-
Lebrun. *Madame Vigée-
Lebrun and Child (in
Greek Toga)*, 1789. Oil
on canvas, 51 × 37 in.
(129½ × 94 cm).
Musée du Louvre, Paris.

found her working, as the artist remembered, "between the throes." Urged to take to her bed, the artist replied that this was simply not possible, she had a sitting for a portrait the next day. The artist did, however, take her friend's advice, and her daughter was born that night.[2]

Sargent Johnson,
Mother and Child

This powerful drawing tellingly conveys the elemental, almost archetypal strength of the mother, and the close bond she and her child share. The mother's massive figure, with feet planted wide, forms a stable, weighty triangle. To her small child she is a beacon of security and comfort, a physical haven, and he opens his arms wide to hold her close. But while the mother's body communicates strength, safety, and dependability, her full eyes and her sorrowful expression convey hardship: There are two weary souls here, and as the mother comforts her child with her embrace, so must she comfort herself, one hand wearily cradling her face.

Johnson himself was a child of a racially mixed marriage: His father was a Swedish-American, his mother part Cherokee, part African-American. While his five siblings were variously accepted as whites or Indians in a community intolerant of racial differences, Johnson chose instead to identify himself as an African-American. Sensitive from his earliest experience to problems of identity, he perennially directed his art to his fellow African-Americans in hopes of influencing their struggle. As early as the mid-thirties, long before the civil rights movement gathered its momentum in the sixties, Johnson said of his art: "I am . . . aiming to show the natural beauty and dignity in that characteristic lip and

49. Sargent Johnson.
Mother and Child, 1932.
Chalk on paper,
32⅝ × 20¼ in.
(82.9 × 51.4 cm).
San Francisco Museum
of Modern Art; Gift of
Albert M. Bender.

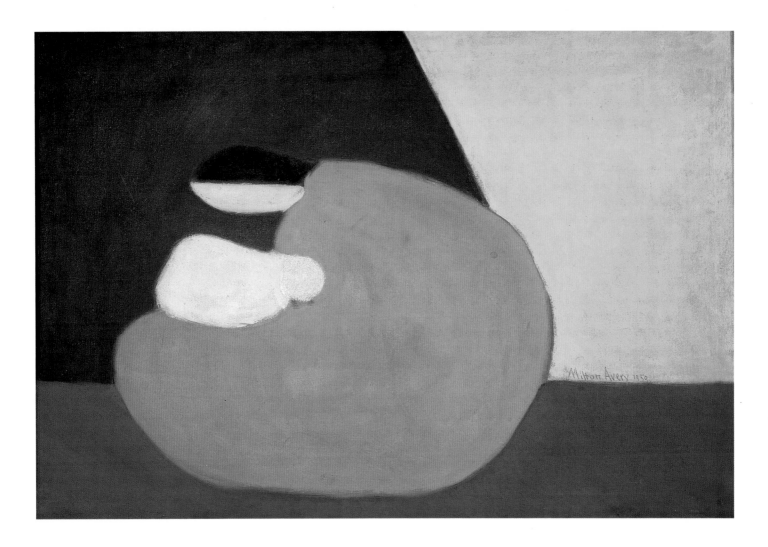

50. Milton Avery. *Maternity,* 1950. Oil on canvas, 32 × 46 in. (81.3 × 116.8 cm). Milton and Sally Avery Arts Foundation.

that characteristic hair, bearing and manner; and I wish to show that beauty not so much to the white man as to the Negro himself. Unless I can interest my race, I am sunk."[6] This mother and child have both beauty and dignity in abundance, and effectively communicate some of the anguish of the early African-American experience.

Milton Avery,

Maternity

By all reports, Milton Avery was a quiet, gentle man who enjoyed a tranquil existence, rather distanced from the turbulence of twentieth-century New York City life around him. In his

art, one critic writes, "there was no place for the anxiety of urban life . . . there were no machines, no massive city structures, no storms, no winter landscapes, no illness and no death, only a genial, friendly world of leisure."[7] Yet the work that emerged from within the protracted universe of this tranquil man was anything but trifling. Avery is renowned as a purveyor of universal truths on canvases resounding with lyrical beauty and inventiveness, an artist with, in Hilton Kramer's estimation, "the finest eye for color in the entire history of American painting."[8]

Avery often found his subjects in his immediate family—his wife, Sally Michel, and daughter, March. Milton Avery met Sally in 1924, when she was just out of high school and he was nearly forty. It was a fortuitous meeting: Sally not only freed him from the necessity of earning a living, supporting them both with her work as an illustrator so he could paint, but also created a kind of buffer between the artist and all the mundane chores of living. When Sally was out of the house, Milton reportedly did not even trouble to answer the telephone.[9] More important, Sally was a fellow artist. Their shared drawing classes, Saturday museum and gallery visits, and evenings spent in the company of other artists made for a marriage filled with exceptional harmony.

At the time of this painting, Avery's daughter was already a young woman. But it had been her birth that occasioned Avery's exploration of the theme of maternity. He executed hundreds of drawings of Sally with March as a baby and chronicled his daughter's life in drawings and paintings so many times that the Durand Ruel Gallery in New York could mount an exhibition of the artist's work titled simply *My Daughter, March*.

Mary Cassatt,
Maternal Kiss

Mary Cassatt excelled at portraying intimate, everyday moments between mothers and children (see also *The Child's Caress,* plate 43). In this pastel sketch she has unerringly caught the small drama of a little girl's distress, when tears seem to have just been dried by the comfort of mother's embrace. The artist communicates all the charm of the child's chubby cheek, brimming eyes, and downturned mouth, as well as her trust in her mother's comforting presence and unconditional love. Although her back is to the viewer, the mother radiates competence and calm, and we sense an independent personality beyond her maternal role.

Cassatt was never satisfied, as were some of her fellow Impressionists, with superficial treatments of women that emphasized mere prettiness or stereotype. Rather, she gave them the dignity of individuals—thoughtful, intelligent, and absorbed in their own lives. She

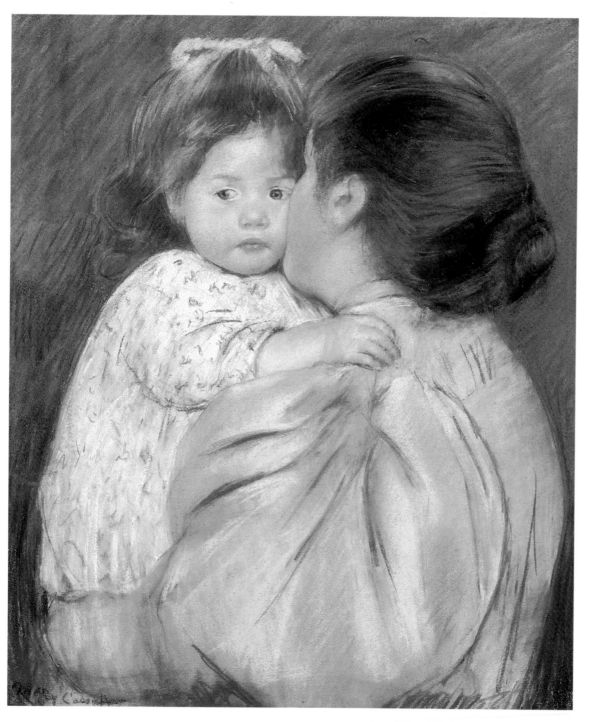

51. Mary Cassatt. *Maternal Kiss*, 1896. Pastel on paper, 22 × 18¼ in. (55.9 × 46.4 cm). Philadelphia Museum of Art; Bequest of Anne Hinchmann.

52. William Blake.
*Preludium to the First
Book of Urizen,* c. 1795.
Etching and watercolor,
6⅝ × 4 in. (16.8 ×
10.2 cm).
Yale Center for British Art, New
Haven; Paul Mellon Collection.

endowed their pursuits—sewing, reading, caring for children—with seriousness and respect.[10]

William Blake,
Preludium to the First Book of Urizen

———————————————

*H*ere William Blake portrays an angelic mother gently teaching her infant to fly. Every mother will recognize the tender, difficult balance being struck here—how much independence to give a child? A good mother wants to give her child the confidence to take off on his or her own but is at the same time painfully aware of the dangers involved. This angel floats easily through the air, bending her muscular body gracefully back to guide her still-wobbly child. The mother's face conveys concern and love as the fearful child reaches out to her.

The world's dangers are even more evident in the flames swirling around the two figures, echoing the graceful curves of the mother's gown. In the text below this picture Blake speaks of the "dark visions of torment" he is about to unfold. This dramatic narrative is Blake's vision of mankind's fall from grace "in trembling and howling dismay." In such a world, the mother's guidance is clearly of paramount importance. Perhaps Blake had this picture in mind when he wrote:

*The Angel that presided o'er my birth
Said, "Little creature, form'd of Joy & Mirth,
Go love, without the help of any Thing on
 Earth."*

Scholars disagree over whether Blake himself gave one version of this picture the caption "Teach These Souls to Fly." It is appealing to think that he did, especially since he reused virtually the same picture in his illustrations to Edward Young's *Night Thoughts* two years later. In that version the mother points with her free hand to a clear, calm sky, illustrating a text that speaks of immortality.

7
First Steps

A baby's first steps are a pinnacle in the on-going drama of childhood accomplishments. It is a heady time of independence, excitement, and joyful pride for the child that can occasion a variety of feelings for parents. There is the excitement and delight of this long-anticipated triumph, certain pride in the child's new abil-ity, the inescapable humor of those wide-eyed wobbles and comically unsteady staggers, and an anxious awareness of the child's new vul-nerability. For some mothers, too, there is a bittersweet quality to this latest milestone, a tinge of sadness as the child moves from infancy to the relative independence of toddlerhood.

The three artists in this chapter have caught some of the varied emotions of this wondrous event of childhood. In Vincent van Gogh's *First Steps*, the father's joy and pride are palpable as he shares the special moment with his wife. Rembrandt honors the magnitude of the event with the participation of three generations—child, mother, and grandmother—each totally absorbed in the task at hand. Picasso has won-derfully caught the humor of the child's com-bined awkwardness and elation as well as the mother's intent, anxious focus.

Rembrandt,
Two Women Teaching a Child to Walk

*H*ad Rembrandt never lifted a brush to canvas, his genius would be thoroughly evident in quick studies like this one. His power of observation, his deep interest in the most minute yet telling of human moments, and his uncanny ability to capture the essence of human feeling are all evident in his fresh, economical sketches.

This stunning little drawing captures with a few quick marks all the drama and emotion of a child's first steps. We have the stooped posture of an older woman, perhaps a grandmother, on the left, and the more lithe and energetic movements of the mother on the

right. Each member of this little trio is thoroughly involved in the moment—the women as they bend to the child's level to encourage and reassure their anxious charge, and the little one, who looks straight ahead rather apprehensively and holds on tightly.

Pablo Picasso,
First Steps

*P*icasso has infused the subject of a baby's first steps with comedy, drama, and emotion. His entire canvas is taken up by the exhilarated, awkward child, as if to emphasize his fresh feeling of elation and omnipotence at this moment of triumph. Mother, who is squeezed into the painting's periphery, wears an anxious expression, but her participation is complete as she bends over uncomfortably to share the moment with her child in cheek-to-cheek proximity.

The artist was sixty-two years old when he painted this canvas depicting his maid Inez and her son. His two children from his marriage to Fernande Olivier were already young adults. He was, however, about to embark upon a new romance with Françoise Gilot, a woman "young enough to be his granddaughter," with whom he would have two more children, and perhaps in anticipation of new beginnings he returned to themes of maternity in his art.[3] In this powerful canvas, the viewer sees be-

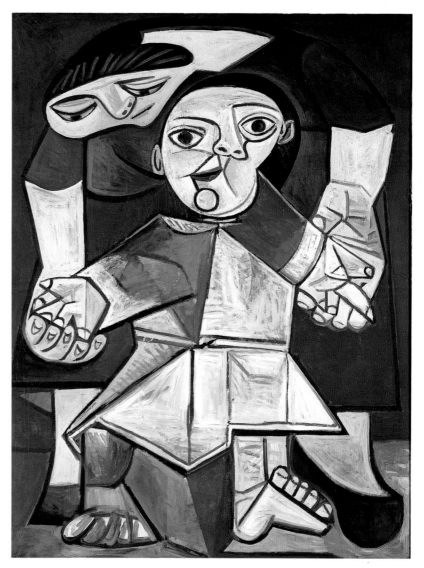

54. Pablo Picasso. *First Steps*, 1943. Oil on canvas, 51¼ × 38¼ in. (130.2 × 97.2 cm). Yale University Art Gallery; Gift of Stephen C. Clark, B.A., 1903.

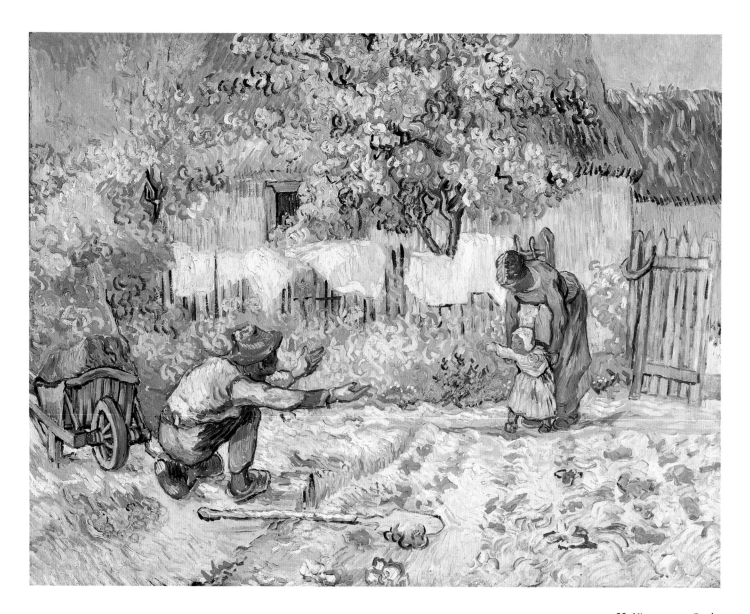

55. Vincent van Gogh. *First Steps,* n.d. Oil on canvas, 28½ × 35⅞ in. (72.4 × 91 cm). The Metropolitan Museum of Art, New York; Gift of George N. and Helen M. Richard, 1964.

yond the nonsensical, cubist distortions of the painting to grasp instead the emotion of the moment between mother and child.

Vincent van Gogh,
First Steps

Vincent van Gogh was recovering at the asylum at Saint-Rémy when he painted this famous work. His brother, Theo, had sent him a photograph of Millet's *First Steps*, and Vincent was struck by its beauty and pathos. Copying from other artists was a consoling exercise for him, and he quickly set about interpreting the Millet.

This painting stands apart from mother-and-child images of its own or any time in giving us such a poignantly involved father. At work in the cottage garden, he seems to have hastily laid down his shovel, crouched down to the child's level, and thrown his arms open wide, alive to the wonder of his child's latest accomplishment.

The painting's subject must have had particular significance for both brothers in the winter of 1890. Theo and his wife, Johanna, were expecting their first child, and Vincent shared their happiness and anticipation. Vincent wrote to his brother: "I think the emotion which must move the future father of a family, the emotion which our good father so liked to talk about, must be with you, as with him, strong and fine. . . . After all, it is something to get back one's interest in life, as when I think that I am about to become uncle to this boy your wife plans for; I find it very droll that she feels so sure it is a boy."[1]

It seems clear that the birth of the child in January—indeed a boy, and named after Vincent—had a powerful impact upon the artist, infusing him with new hope.

Van Gogh had, in paintings like *First Steps*, an effective way of expressing love that otherwise eluded this troubled man. "One may have a blazing hearth in one's soul," he once wrote, "and yet no one ever comes to sit by it. Passersby see only a wisp of smoke rising from the chimney and continue on their way."[2] This glimpse of the artist as someone with few outlets for the love in his heart makes his portrayal of this little family even more poignant.

Combining child care with additional work—whether the work is done within or outside the home—is an age-old proposition that has inspired a variety of coping measures. Most of the mothers in this chapter carry out their work—grinding corn, peeling apples, carrying water, hanging laundry, selling butter, or making lace, pottery, or boots—with their child more or less by their side. Such an arrangement is not without its challenges: The classical Greek mother shows her impatience as her toddler slows his steps in proportion to her hurry (plate 61), the Mesoamerican mother using *metate* and *mano* must contend with small thefts of finished tortillas (plate 56), and the seventeenth-century lace maker is surely about to have her intricate work interrupted (plate 63). While many mothers over the centuries have relied on neighbors or members of the extended family to care for children while they went off to field or factory, only from our own century did an example present itself of a mother in art whose workplace is clearly incompatible with the presence of her baby. Marisol's *Working Woman* (plate 68) apparently cannot, like the other mothers in this chapter, work at her office with her child by her side. Instead, like so many mothers today, she makes use of the day-care options available to her. In this particular instance, the mother does not seem pleased with the arrangement.

Mexico,
Woman Using a Metate, with Child

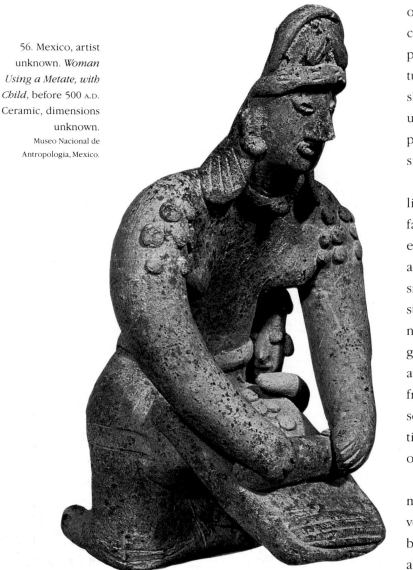

56. Mexico, artist unknown. *Woman Using a Metate, with Child*, before 500 A.D. Ceramic, dimensions unknown. Museo Nacional de Antropologia, Mexico.

From the mountainous northwest coast of ancient Mexico, fifteen hundred years before the arrival of Cortés and the Spanish conquistadores, came this convivial terra-cotta sculpture. This powerfully built mother, with strong facial features and exaggeratedly massive arms and shoulders, bends over her *metate* (stone slab), using a *mano* (cylindrical grinding stone) to prepare her tortillas. Her child has crept to her side, mischievously about to steal a tortilla.

The Pacific coast area has yielded many such lively, anecdotal, naturalistic pieces. We find fathers dandling babies on their knees, women engaged in lighthearted gossip, self-conscious adolescent boys studying their reflections in small mirrors, dancers, lovers, musicians, and, strikingly, an abudance of pregnant women, nursing mothers with children, and family groups. Though it is difficult to piece together an accurate sketch of Mesoamerican society from such artifacts alone, these lively portraits seem to hint at a cheerful, humanistic civilization where a high value was placed on the lives of women, children, and family.

This image of a busy mother using a *metate* must have been pervasive, since the largely vegetarian diet of the Mexican Indians was based upon corn. It has been estimated that about six pounds of corn was eaten daily by

the average Indian family, which required about five or six hours a day in preparation with *metate* and *mano*. Perhaps this woman's muscular arms and shoulders are not so exaggerated after all.

José Orozco,
Mother and Child

*F*ifteen hundred years later, we find the same image of a Mexican mother bent over her *metate,* here with her dark-eyed child wrapped closely to her bare back. While her body bends effectively and surely to its work, her dark eyes seem to hold a certain melancholy. Over the centuries, peasant women of Mexico found little respite from lives of endless toil and a debilitating subordination to domineering men, which led foreign observers to dub them "champions of suffering."[1]

José Orozco had an unusual sensitivity to the plight of humanity and created many moving portraits of women caught in lives of hardship. His portraits of prostitutes, which underscored both their degradation and their humanity, were considered radical and greeted with scorn. In this later image the artist has created a moving testament to the timelessness of Mexican women's unswerving dedication to their hearth and family through the turbulent events of the centuries. During the period of this

painting, the violence of the Mexican revolution and its aftermath changed the situation of women but little. Hardworking, pious peasant mothers of traditionally large families toiled at a round of familiar labors and lived lives not so different from those of their Indian ancestors.

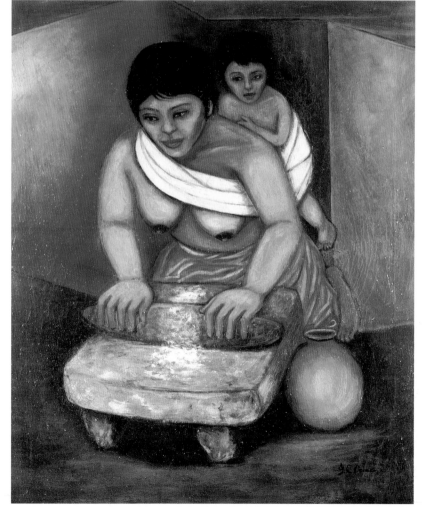

57. José Orozco. *Mother and Child,* 1919. Oil on canvas, 31 × 25 in. (78.7 × 63.5 cm). Arthur Spitzer.

Peru,

Ritual Vessel

This mother-and-child vessel dates from the great Inca civilization in the days before the Spanish conquests of Peru. The mother carries a large pot, or *aryballos,* probably to fetch water in her course of household chores, while simultaneously nursing a small child. This industrious doubling up of tasks, as well as the

imaginable weight of the full *aryballos,* suggests something of the hard, pragmatic life within Incan culture. The mother's resolute, happy expression suggests, however, that she did not resent her lot.

When pregnant, a woman continued her heavy work in the fields, at her hearth, and at her spinning wheel or loom. She was very likely to deliver her baby herself in the fields, sever the umbilical cord with her teeth or fingernails, and proceed to the nearest river to wash her baby. After the birth, the baby's father fasted and spent the first two days with his wife, to ward off evil spirits. On the third day, both returned to work, mother accompanied by her new infant.

Tenderness to babies was frowned upon, since it was thought this would interfere with their growing up to be hearty, productive workers. Mothers therefore were not encouraged to indulge newborns by holding them in their arms; babies were instead strapped into a wooden board cradle that the mother could take with her to work or to bed. Even nursing was to be accomplished without hazarding a physical embrace: Mothers bent over the cradle to suckle their children and were admonished not to nurse a child more than three times a day.

Despite this harsh-sounding pragmatism there is evidence that Incan society was not without its softer sentiments. Surviving love songs, poetry, and folktales clearly indicate

that deep feelings were hardly irrelevant or unknown to the Incas. And then, too, there is the wonderful smile playing across this Peruvian woman's proud features, suggesting life was more than an uninterrupted round of hardships.

Conclucy Nayoumealook Inukjuak,
Woman Stretching and Shaping Boot

eet widely planted, as solid and strong-looking as the stone from which she is carved, this Inuit mother exudes confidence and satisfaction as she bends to her task of shaping a sealskin boot while her child rests comfortably and securely on her broad back.

The lives of Inuit men and women in the Canadian Arctic varied but little, determined by clear necessities of survival in so extreme a climate. Men were primarily responsible for hunting, women for cooking, sewing furs and skins into clothing, and, most important, bearing and raising children. While most of their time was spent within the home, Inuit women also assisted in the hunt. Through all her daily activities, she carried her children on her back, as in this carving, in a specially designed pouch that was a part of each woman's fur parka, or *amautik*. The *amautik,* with its broad back and roomy design, allowed a mother to transfer her child from back to front for nursing with just a twist of her shoulder, without the baby leaving the warmth of the parka. Inuit children were carried about in this way from infancy until the age of two or three, and as a result enjoyed a close physical and emotional bond with their mothers.

59. Conclucy Nayoumealook Inukjuak. *Woman Stretching and Shaping Boot,* c. 1962. Stone, 8¾ × 5¼ × 7¼ in. (22.2 × 13.3 × 18.4 cm). The Winnipeg Art Gallery; Twomey Collection, with appreciation to the Province of Manitoba and Government of Canada.

Japan,

Fan with Hand-Colored Genre Scene

In this delicate fan we glimpse a peasant woman going about her work with a dallying, naked child in tow. This woman would have enjoyed far more relative freedom than her counterpart in the period that followed, with its feudal order and strictly held neo-Confucian beliefs. In contrast, this was a time when women could own, con-trol, and inherit property, be in charge of their own households, and keep their own children in the event of divorce. Although husbands could have more than one wife, love between a married couple was considered important, and there was, in general, less of a sexual double standard than would exist in years to come.[2]

Even with her relative freedoms, however, life for this peasant woman would not have been easy. She would have worked alongside the men, spending long days planting or har-

vesting rice, in addition to shouldering the responsibilities of home and child care. Yet her shared labor with men probably brought her relative equality, with decision-making ability within the family, a far cry from later Confucian doctrines of strict obedience for women.

Interestingly, the further back one ventures in Japanese history, the greater the relative status for women. From the dawn of Japanese history through the seventh century, women held positions of prestige and authority in the family, in religion, and in government. Legends of free-spirited goddesses, powerful empresses at court, and lusty women samurai all date from this time. Earliest records of Japanese culture, which are Chinese, refer to Japan as the "queen country" because of frequent female rule. It was early in the eighth century that Buddhist and neo-Confucian thought, which reached Japan through China, began to erode women's status.

Greece,
Woman with a Hydria Leading a Little Boy

The Greek woman on this vase, like her Japanese counterpart, goes about her work while leading a naked child by the hand. In the time-honored manner of most children, this little boy seems to slow his steps in proportion to his mother's hurry, her tug and over-the-shoulder grimace reveal-

ing her dwindling patience as she rushes to complete her chore. An anonymous Greek artisan's recognition and rather humorous depiction of a typical moment between a mother and child create a bridge over the thousands of years between our time and that of the ancient Greeks.

This woman appears to be on her way to the community well to fill the jug, or hydria, with water. This errand might provide a rare opportunity for social mingling—perhaps some gossip at the fountain among neighbors—since women of all social classes were by and large confined to work within the home: spinning, weaving, preparing food, and caring for children. Because any outing that involved social

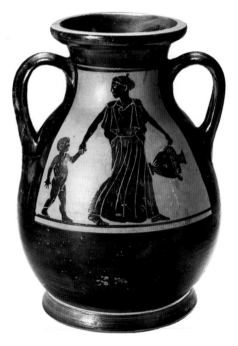

61. Greece, artist unknown. *Woman with a Hydria Leading a Little Boy,* 5th century B.C. Terra-cotta, 9⅜ in. high (23.8 cm).
The Metropolitan Museum of Art, New York; Rogers Fund, 1964.

62. Italy, artist un-
known. *Selling Butter,*
from *Tacuinum
Sanitatis,* c. 1385.
Parchment, 13⅛ × 9 in.
(33.5 × 23 cm).
Oesterreichische National-
bibliothek, Vienna.

mingling would have been deemed particularly improper for upper-class women, this is either a wife of modest status or a servant to a more prosperous household dispatched on such an errand.

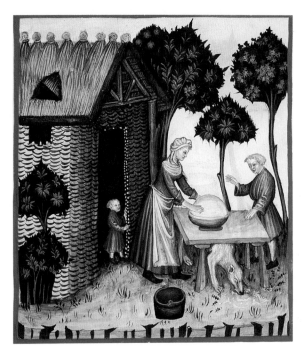

Italy,
Selling Butter

This book illustration shows a medieval woman in one of her many varieties of work. She appears to be selling fresh butter from her thatched cottage while her child looks on shyly from the doorway.

In addition to raising children, rural peasant women throughout medieval Europe performed a daunting round of work with their husbands. Besides the shared work of plowing, sowing, reaping, gleaning, binding, threshing, raking, and winnowing a crop, women also cooked, cleaned, made clothing, milked the cows, fed the farm animals, sheared sheep, cultivated vegetables, and soaked, beat, and combed out flax, in addition to making cheese and the butter we see here.

These labors, combined, of course, with child care, made for a work-filled life, though the little scene depicted here, with lively trees, a household pet scavenging under the table, and the shy child, is portrayed with considerable charm.

Nicolaes Maes,
The Lacemaker

Lace making is one of the most intricate and demanding forms of needle-work. Taxing and tedious, it requires great skill, concentration, and patience. Small wonder, then, that this working mother has resorted to the seventeenth century's less athletic version of our "Johnny Jump Up," walker, or playpen. This small child is safely confined, giving his mother the needed respite to focus on her work. He hardly seems satisfied with the arrangement, however—all of his toys have landed on the floor around him, and one

63. Nicolaes Maes. *The Lacemaker,* n.d. Oil on canvas, 17¾ × 20¾ in. (45 × 52.7 cm).

The Metropolitan Museum of Art, New York; Bequest of Michael Friedsam, 1931.

wonders how long his mother will be able to continue her work uninterrupted.

This chair has some advantages over our contemporary infant chairs: The lower compartment opens to enclose a small stove to warm the child; this can be exchanged for a potty, should the occasion require. These accessories obviously meant more in the days before central heating and modern plumbing.

Seventeenth-century Dutch culture placed enormous value on the role of the mother for raising well-behaved children and maintaining scrupulously clean, pleasant homes. Although women's subordination to men was well established in this century, one visitor, Sir John Reresby, was impressed not only by the characteristic household order effected by Dutch women, but by the way they seemed to dominate their husbands.[3] Then, too, there were radical voices like Johan van Beverwijk's that had begun challenging the established social order. "To those that argue that women are fit only to manage the household and no more," he declared, "I say . . . only let a woman come to the exercise of other matters and she will show herself capable of all things."[4]

This woman may be simply making lace for her own home, but she could also be one of the seventeenth century's enterprising craftswomen who earned additional household income through piecework. Traditionally low paying, piecework (the making of lace, hats, gloves, dresses, or other goods for a fee per piece completed) had the advantage of enabling the woman to work at home around the needs of children and other household responsibilities.

India,
Genre Scene (detail)

This northern Indian mother combines her craft of pottery making with child care. Sitting near an outdoor kiln, she holds a finished pot ready to be stacked with towers of others. She is assisted in her work by a man in the foreground, who appears to be mixing clay, and another figure, who fills a large jug with water. In the midst of all this activity her small child presses close, wrapping his arms around her while observing the village life moving freely through the courtyard.

Traditionally, it was not considered appropriate for Indian women to work outside their homes for wages. In most families, it was the province of men to obtain employment and support their wives and children. Women's sphere was the home, where they were responsible for cooking, cleaning, sewing, and child care. Indeed, upper-class Muslim and Hindu women observed *purdah,* an extreme degree of seclusion of women within the home that often included ritual veiling of face and body when out of doors. However, it would not have

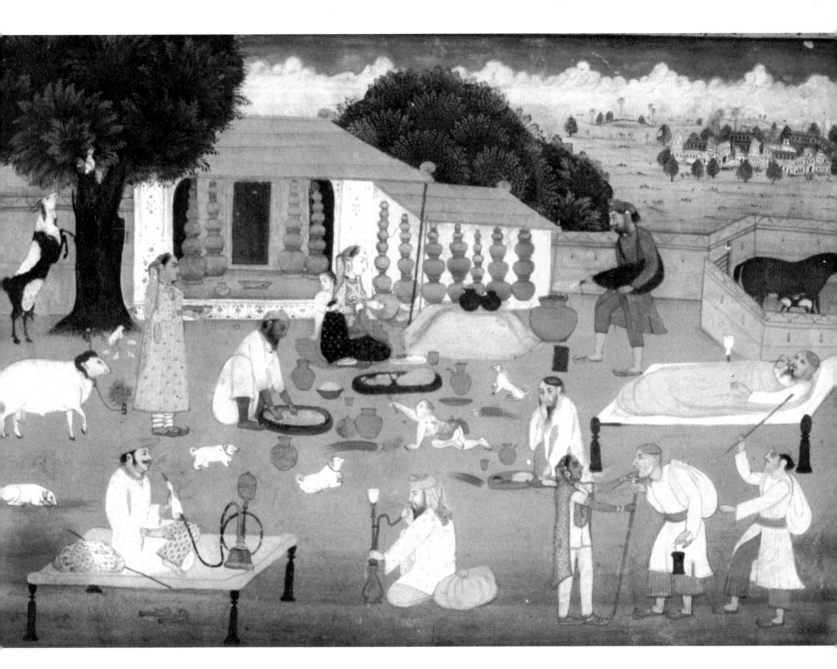

64. India, artist
unknown. *Genre Scene*
(detail), c. 19th century.
Painted miniature,

7¾ × 11 in.
(19.9 × 27.9 cm).
Dr. and Mrs. William Ehrenfeld,
San Francisco.

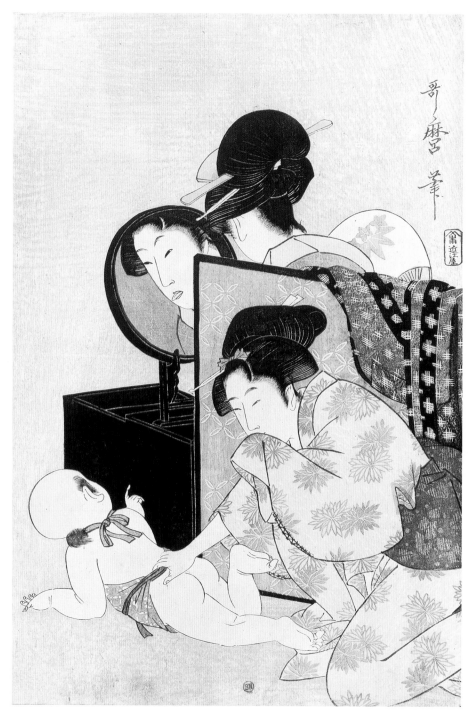

been uncommon for lower-class women of the smaller villages, for whom such niceties were beyond practical reach, to work in the fields, at the market selling produce, at various village and cottage industries, and, like this potter, at handicrafts, which were a traditionally female province.

Kitagawa Utamaro,
Mother Playing with Her Child, and Nurse

As we have seen in plate 24, Kitagawa Utamaro was a remarkably sensitive chronicler of the lives of women. Though his work draws upon women from all walks of life, he is best known for his portraits of beautiful courtesans in the pleasure quarters of the late-eighteenth-century Japanese city of Edo, present-day Tokyo. Within this body of work are many prints of mothers and children like this one. These are gentle, often humorous depictions of the joys and tribulations of being a single parent while working for a living, though these women's occupation as prostitutes may be a little unsettling to Western sensibilities.

In this print we find an obviously mobile, willful little boy scooting away from his nurse to engage his mother's attention. Nurse places a kimono-sleeved hand over her mouth (a polite custom when speaking) to scold or to giggle, while with the other hand she attempts to reel the child in by the back of his biblike garment. Mother's attention is caught by her mischievous child as she sits before her mirror. Her back is to the viewer, but her reflection in the mirror shows her playfully sticking her tongue out at her child.

This mother's elaborate coiffure, and especially the view of her nape, which would have been considered quite risqué—the Japanese regarded the nape as one of the most seductive of feminine attributes—confirm her profession. Sticking out the tongue, usually considered a flirtatious, coy gesture in Japanese art, would have scandalized a proper Edo matron.

Although a high-ranking courtesan in Japan, as elsewhere, could be purchased for her services, and was likely to be a farmer's daughter indentured to the trade to save her family from financial ruin, she was not without dignity. She was renowned not only for her beauty and mastery of her craft but for marks of refinement that combined sensual charm with elegant deportment, witty conversation, and knowledge of poetry, classical literature, and the arts.

Camille Pissarro,
Woman Hanging up Laundry

This airy painting by French Impressionist Pissarro shows a comfortable scene of a working mother and a well-behaved child who seems

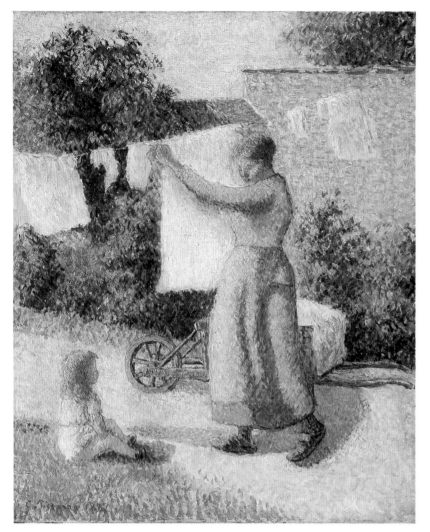

content to watch her mother complete her morning chore. Both are free, for a moment at least, to enjoy the mild morning, the surrounding countryside, and the freshness of the clean laundry snapping in a gentle breeze.

Father of seven children, Pissarro must have been inspired by many such moments. His obvious pleasure in such unpretentious subjects surfaced in spite of his perpetual concern with the difficulty of supporting his large family on a painter's meager earnings.

The artist was, however, clearly delighted when his children followed his example to pursue lives as artists, while his wife, Julie, ever a realist, could less easily forget the hardships of their artistic life. Their life of poverty must have been trying for her in particular, especially since her husband was often absent from home, painting in other places or trying to sell his work, leaving to Julie the lion's share of the responsibility as a parent. When her husband was at home, he reportedly fell into the guilty parent's habit of overcompensating for his absence from the children by spoiling them.

66. Camille Pissarro. *Woman Hanging Up Laundry*, 1887. Oil on canvas, 16⅛ × 12¾ in. (41 × 32.4 cm). Musée d'Orsay, Paris.

Pieter de Hooch,
A Woman Peeling Apples

*P*ieter de Hooch's *A Woman Peeling Apples* epitomizes the seventeenth-century Dutch household ideal: She is mistress of a spotless, well-

ordered home, where the hearth burns warmly and sunshine streams in through polished windows. As important, she demonstrates her devotion to what would have been viewed as her most meaningful task—the instruction of children through setting an appropriate example. We find this mother placidly completing one of her innumerable kitchen chores—peeling apples—enlisting the "help" of her neatly dressed little girl, who watches soberly, apparently in charge of catching the peels before they land on the floor.

All forms of Protestantism in Dutch society decreed that mothers should play a large role in the instruction of their children within the home, and Dutch painters were fond of depicting women fulfilling this duty. We find well-behaved little boys and girls not only sharing household tasks with virtuous mothers but also receiving instruction in reading, writing, saying their prayers, and learning the Scriptures.

This well-ordered state of affairs conformed to Calvinist doctrines favored at this time, which eschewed luxury and extravagance of every kind, even to the point of banning, for a time, organ music and hymns in the churches as too riotous and self-indulgent. Instead, Calvinist doctrine advocated sobriety, simplicity, and reserve.

While many Dutch visitors commented on the cleanliness and harmony of Dutch households at this time, it is interesting to note one French visitor's reaction to Dutch children in 1678. Jean-Nicolas Parival wrote that the Dutch had a habit of excessively indulging children, creating what he called a shocking degree of "disorder" in their conduct.[5] He was, however, quick to backpedal, remarking: "It is nevertheless surprising that there is not more disorder than there is, and there is perhaps no better proof of the natural goodness of the

67. Pieter de Hooch. *A Woman Peeling Apples*, 1660. Oil on canvas, 27¾ × 21⅜ in. (70.5 × 54.3 cm).

68. Marisol. *Working Woman,* 1987. Wood, charcoal, and plaster, 96½ × 28 × 20 in. (245.1 × 71.1 × 50.8 cm). Courtesy Sidney Janis Gallery, New York.

inhabitants of this country and the excellence of their disposition."[6]

Marisol,
Working Woman

Wide-eyed, rigid, and rooted in place, Marisol's late-twentieth-century working mother is very different from her earlier counterparts. On her way to an office, she will presumably drop her child off at a separate day-care location, unable, like her ancient Greek, Mexican, Chinese, and Indian sisters, to work with her child by her side.

Imprisoned in plywood and plaster, this mother stands stiffly, one straight arm clutching a briefcase, the other holding a crudely carved, dour-looking child in a tight, businesslike grip. In spite of the rough edges of the materials, there is poignant emotion in these figures—tension in the lines of the mother's mouth and the set of her shoulders, and a glimmer of sadness and confusion behind her wide eyes. Though her straight posture and businesslike uniform make her appear capable and tenacious, there is a hint of brittleness that threatens to give way to despair. Clearly, this woman is not at all easy with her dual role of mother and executive, and in her discomfort she speaks to many contemporary women's frustrations with the imperfections of combining family and career. The child, too, appears unhappy. Though well-nourished and much less likely to die in infancy than children of earlier times, this baby seems as grim as the mother.

From her debut as a pop artist in the late sixties, Marisol has created consistently witty and incisive art. Her recent work seems even more focused on social comment, illustrating individual struggle symptomatic of larger social problems (see plate 105). *Working Woman* encourages a look at how our own culture values—or devalues—the lives of children and the predicament of mothers, the majority of whom work outside the home. In most instances, neither enjoy the benefits of extensive parental leave, flexible work time, or thoughtfully designed and adequately supported child-care programs; indeed, most mothers are not able to exercise real choice in the decision to work outside the home but work because they must.

9
Mothers and Children at Play

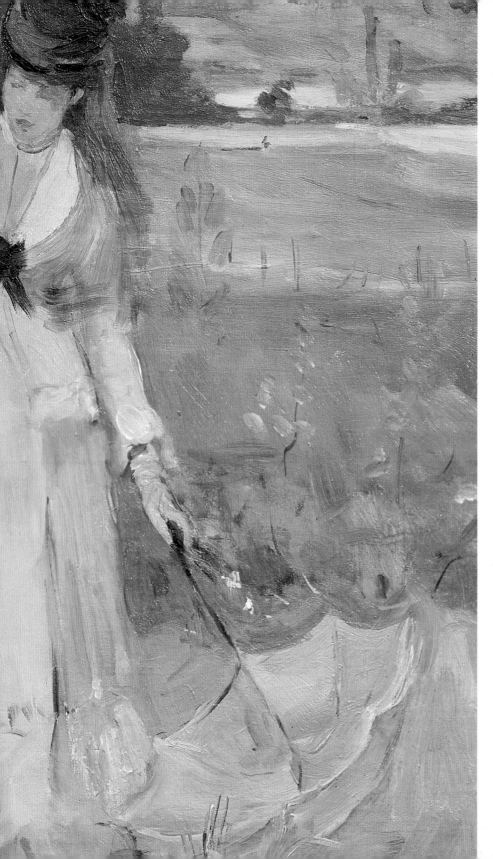

Whether it involves rococo splendor, as in Gerard's *The Beloved Child,* or the quieter delights of Choki's *Catching Fireflies,* Picasso's *Games and Reading,* or Berthe Morisot's *Hide and Seek,* the artwork in this chapter captures some of the happiest hours of mothers and children as they share moments of lighthearted play.

It is interesting to note that while images of mothers and children at play abound in Chinese art (see plates 70 and 71) and Japanese art (see plates 65 and 69), they are exceedingly rare in Western art before the eighteenth century. With the exception of the Christ Child and a smattering of royal heirs, children make few appearances throughout the art and literature of the Middle Ages, the Renaissance, and through the seventeenth century. When they are the subject of a painting, they are treated more like miniature adults than believable children. Not until the Enlightenment and the influence of writers such as Denis Diderot, Jean-Jacques Rousseau, and John Locke was interest focused on children and a more sensitive understanding developed of their nature and their need for affection, approval, and unhampered play. These new attitudes made it possible for artists not only to find children an appropriate subject for art, but, like Sir Joshua Reynolds, to finally depict them acting like children (see plate 72).

Eishosai Choki,
Catching Fireflies

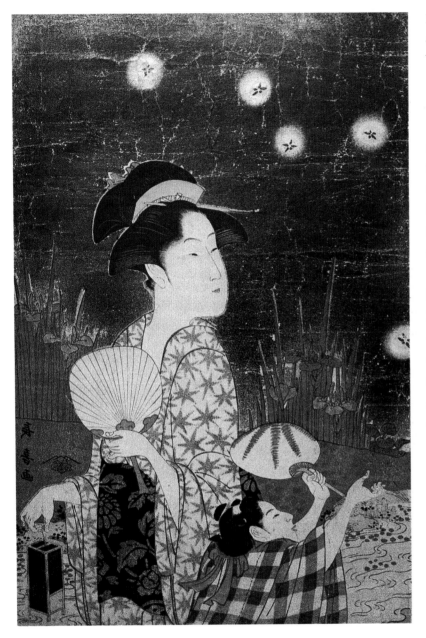

69. Eishosai Choki. *Catching Fireflies*, c. 1790s. Oban, nishiki-e, mica ground, 14⅞ × 9⅝ in. (37.8 × 24.4 cm). Collection Mr. and Mrs. Edwain Grabhorn, San Francisco.

*T*his wonderfully evocative print shows a mother and her child at a favorite summer night's pastime. The dark sky is lit with magical orbs of light from the fireflies, and blooming irises stand like evening sentinels at the river's edge. The little boy excitedly pursues the elusive sparks of light while his graceful mother enjoys a mood of peaceful reverie.

Choki was a colleague of Utamaro, and in breathtaking prints like this one he is every bit his equal for grace of line and the evocation of poignant, fleeting moments. Like Utamaro, Choki suppresses reality in favor of compositional grace, rhythm, balance, and pattern; the results are spare, uncluttered compositions of exquisite decorative elegance.

This woman's elaborate coiffure, her *yukata* (informal summer kimono) patterned with a soft blue-green hemp leaf, and her dramatic black-and-green obi, or sash, suggest she may be a courtesan rather than an ordinary mother. Not surprisingly, these glamorous women fascinated popular imagination in late-eighteenth-century Japan. But whether this mother is a glamorous courtesan or an ordinary Edo matron matters little; Choki's evocation of the shared pleasure of a soft summer evening completely transcends the specifics of time and place.

70. Style of Chou Fang (c. 780–805). *Play with Infants,* Sung Dynasty (960–1280). Painted silk, 12 × 19¼ in. (30.5 × 48.9 cm). The Metropolitan Museum of Art, New York; Fletcher Fund, 1940.

Style of Chou Fang, *Play with Infants*

*I*n handsome tones of crimson and brown, this delightful handscroll offers assorted vignettes of placid mothers at play with chubby-legged, bald-headed infants.

This subject, that of mothers at play with their babies, is relatively rare in Western art and suggests some cultural differences between Western and Chinese attitudes toward children. Even the earliest visitors to China commented on that nation's great fondness for children, which they thought was "spoiling" them. This suggests that by Western standards children in China were accorded what seemed an unusual degree of indulgence. One modern American observer, eminent Asian art historian Alan Priest, noted that although his American friends "go to considerable trouble to get babies," they then proceed to subject them to a "Spartan discipline" that "no grown-up would put up with for a moment." American babies, he observed, "are forcibly fed when they do not want to eat; they are consigned to solitary confinement when they do not want to sleep; and when they scream to high heaven in

anguish their placid mamas say that it is good for their lungs. Is it possible," he wonders, "that as a people we are convinced that life at best is a horrid business and feel that we should start making our children miserable at the earliest possible moment?"[1]

Chinese mothers, Priest continues, "approach the baby problem differently. Never is a Chinese baby left alone. If he yells, it is assumed, quite properly, that he wants something. If he wants something he should not have, he is diverted with something harmless. If he is hungry, he eats; if he is sleepy, he sleeps. . . . There is," he concludes, "no doubt in my mind at all as to which system the babies would choose."[2]

Whether or not the Chinese approach constitutes indulgence is an individual judgment, but what is evident in this work is at least one artist's charmed observation of mothers and babies involved in simple everyday activities.

China,
Famille-rose

*P*layful images of mothers and children abound in Chinese ceramics, supporting the previous observation about this culture's marked fondness for children (see plate 70). This lovely vase shows a placid mother and three happy, playful boys. Each child has had his head

shaved, a custom that began for little boys at one month and continued until about age eight, sometimes as late as sixteen. After the first ceremonial shaving, hair was allowed to grow on a small part of the top of the head, as we see here. The prerevolutionary Chinese themselves seemed to have been at a loss to explain exactly why this tuft was traditionally left on the head, though it was generally held to be a charm that brought the child good luck.

From an eighteenth-century Chinese viewpoint, this mother has had her own share of good luck in having sons rather than daugh-

71. China, artist unknown. *Famille-rose,* Qianlong period, 1735–95. Porcelain, dimensions unknown. Private collection.

ters. Before the Cultural Revolution (1966–76), the Chinese regarded boys very differently than they did girls in the family. Since it was believed that male descendants alone could propitiate ancestral spirits, a woman who did not give birth to at least one son was in an unenviable position. It was a son who assured a parent's spiritual happiness in the afterlife through ceremonies of ancestor worship. It was a son who would support his parents in their old age, having inherited his father's property and prestige. A daughter, on the other hand, was expected to live wih her husband's family after marriage, with no ability to give her parents comfort either in old age or in death through ceremonial ritual. These distinctions resulted in different treatment of the two sexes, stated rather baldly in the following traditional poem:

> When a son is born
> Let him sleep on the bed,
> Clothe him with fine clothes,
> And give him jade to play with.
> How lordly his cry is!
> May he grow up to wear crimson
> And be the lord of the clan and the tribe.

> When a daughter is born,
> Let her sleep on the ground,
> Wrap her in common wrappings,
> And give her broken tiles for playthings.
> May she have no faults, no merits of her own,
> May she well attend to food and wine,
> And bring no discredit to her parents.[3]

Sir Joshua Reynolds,
The Duchess of Devonshire and
Lady Georgiana Cavendish

The vivacious Georgiana, duchess of Devonshire, shown at play with her daughter Georgiana, was one of the most celebrated women of her day. She was renowned not only for her beauty and charm, but for her generous nature and an intelligence that made her the confidante of important men like Richard Brinsley Sheridan and the Prince of Wales (later George IV). She was married to William, fifth duke of Devonshire, one of England's wealthiest men, who was thought to be "the only man in England not in love with her."[4]

Children were of paramount importance among the British aristocracy in assuring the family a male heir. Once this was accomplished, however, daughters were in some ways more desirable to women like the duchess of Devonshire. In the absence of emotionally satisfying marriages, a bond with children, especially girls who might remain lifelong companions, often provided sorely missed emotional gratification.

The duchess's marriage was not unusual in not having been based upon romantic love. A

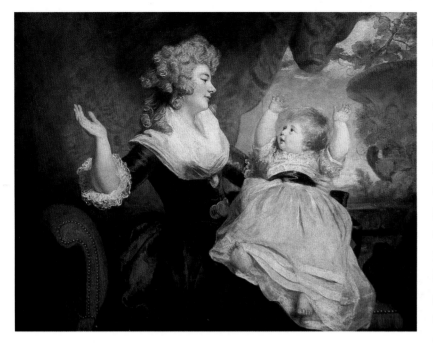

There is good evidence, aside from the spirited game the two share in this picture, that the duchess took particular delight in little Georgiana. Where many women of her station procured wet nurses for their babies, the duchess, influenced by the naturalism of Rousseau, was completely taken up in nursing her little girl herself, much to the annoyance of her in-laws. Her pleasure and emotional gratification in this closeness is evident in her experience of finally weaning the child at one year. "I do miss my Dear little girl so I do not know what to do—I have been twenty times going to take [her] up in my arms and run away and suckle her—I would give the world for her dear little eager mouth at my breast. This is the first night of my sleeping away from her for months and my room looks so dreary."[5]

72. Sir Joshua Reynolds. *The Duchess of Devonshire and Lady Georgiana Cavendish*, 1784. Oil on canvas, 44¼ × 55¼ in. (112.4 × 140.3 cm). Devonshire Collection, Chatsworth, England.

modicum of regard was all that was required in aristocratic engagements to enable the pair to get on with the more weighty business of providing an heir and consolidating family fortunes. The duchess's predicament was, however, less happy than many. At the time the marriage was arranged the duke's affections were thoroughly engaged by his mistress, a comely milliner he saw no reason to forsake. During their marriage this liaison produced one illegitimate child, and an affair with the duchess's best friend, Lady Elizabeth Foster, produced two more, all of whom were brought up in the duchess's household with her own children. There are no records of how the duchess felt about raising her husband's illegitimate children.

Marguerite Gerard with the possible assistance of Jean-Honoré Fragonard, *The Beloved Child*

*L*ike her brother-in-law and teacher Jean-Honoré Fragonard, Marguerite Gerard made rather a specialty of paintings of idealized motherhood. Her affluent domestic scenes are replete with the boundless joys of family life.

A new ideal of motherhood and childhood was afoot in eighteenth-century France, promulgated by Enlightenment writers such as

73. Marguerite Gerard, with the possible assistance of Jean-Honoré Fragonard. *The Beloved Child,* c. 1780. Oil on canvas, 17½ × 21⅝ in. (44.5 × 55 cm). Courtesy The Fogg Art Museum, Harvard University, Cambridge, Mass.; Gift of Charles E. Dunlap.

Denis Diderot, Jean-Jacques Rousseau, and English philosopher John Locke. This new ideal rejected earlier notions of children as a necessary nuisance, a debilitating, even coarsening responsibility that upper-class women gladly dispensed to others.[6] Now mothers and fathers alike were being urged to become involved, loving parents. Harsh discipline of children, who were once viewed as little barbarians in need of fierce, civilizing restraint, gave way to a recognition of children's special need for affection, approval, and unhampered play, and the family itself took on the luster of a harmonious social unit, an emotionally rewarding haven from the outside world.

74. Henry Moore.
Rocking Chair No. 1,
1950. Bronze, 12¾ in.
high (32.4 cm).
Henry Moore Foundation,
Hertfordshire, England.

This new view of mother- and childhood and the family was tirelessly extolled in literature, popular prints, and paintings like Gerard's and Fragonard's, and while many of its effects were undoubtedly positive, the extreme nature of the sentiment contained some pitfalls as well. Motherhood, if no longer a matter of indifference, was now energetically put forward as the only true and proper vocation for women. Women who chose other interests were viewed as unnatural in their deviation from their role of wife and mother. Contraceptive practices, just coming into widespread use at this time by women who wanted to avoid the sometimes devastating physical and economic demands of large families, also came under fire. That women might exercise choice in the matter of motherhood seemed scandalous to many civic-minded gentlemen, who produced an alarmed flurry of moralizing tracts on the joys of motherhood.[7]

Henry Moore,
Rocking Chair No. 1

T he first sculpture that Henry Moore ever made was of a mother and child, carved of Portland stone in 1922, and the theme would occupy him all his life. During the bombing of London in World War II he was particularly struck by the tenderness, endurance, and courage of the mothers

with infants he observed in the bomb shelters, and brought some of their quiet dignity to his treatment of the theme. But it was the birth of his daughter, Mary, named after his own esteemed mother, that brought new vitality and intimacy to the subject.

There are several similar versions of this sculpture, obviously inspired by his wife, Irina, and then-three-year-old Mary enjoying a favorite ladderback rocking chair. The delight of both is evident in the mother's spirited, high lift of her child and in baby's airborne swoop as she playfully reaches for her mother's face. The sculpture's simple lines suit this light-hearted theme, as does the note of whimsy in the mother's body becoming part of the chair.

Pablo Picasso,
Games and Reading

75. Pablo Picasso.
Games and Reading,
1953. Lithograph,
18⅞ × 24⅝ in.
(47.9 × 62.5 cm).
Private collection.

sensed their inevitable parting, and Picasso seems here to savor the quiet presence of his family, perhaps knowing how soon it would be lost to him.

This portrait of Picasso's young mistress Françoise Gilot and the pair's two children, Claude at six years old and Paloma at four, shows a tranquil period of play. Both children and mother seem self-absorbed—Paloma with her tricycle, Claude with his truck, and mother with her book. The still mood carries a touch of melancholy sentiment: This is one of a number of family pictures Picasso made of Gilot alone with the children just before the pair's breakup a few months later. At the time of this work both parents

Berthe Morisot, *Hide and Seek*

*L*ike Choki's magical evocation of a soft, summer evening (see plate 69), this painting by Impressionist Berthe Morisot shows us a mother and child on a meandering stroll through a midsummer meadow. The little cherry tree creates an attractive spot for a quick round of hide-and-seek (with mother obligingly feigning befuddlement at her child's "disappearance" behind its scant branches) before the two continue on their way, enjoying the tall grass, the occasional wildflower, and a mood of quiet reverie.

76. Berthe Morisot. *Hide and Seek*, 1873. Oil on canvas, 17¾ × 21⅝ in. (45.1 × 54.9 cm). Mrs. John Hay Whitney.

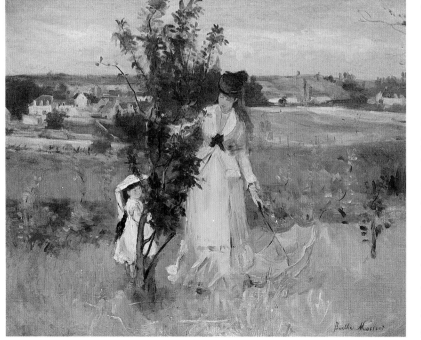

In this painting Morisot has once again depicted her sister Edma, this time with her daughter Jeane at age three (see also plate 34). One of the founders of the Impressionist movement, Morisot developed a painting style characterized by fragile, feathery brushstrokes that impart a light-saturated atmosphere. Her handling of paint always seems delicate and fresh, giving her pictures the fleeting, evanescent quality valued by the Impressionists. Her style perfectly suits this moment of serenity between a mother and daughter, in their summer hats and crisp white dresses.

Guler style, *Krishna on the Swing*

*C*hildren usually delight in being pushed high in the air on a swing, and Krishna, the popular Hindu deity, appears to be no exception. Like any child, he holds on tightly and looks back at his accomplice, eagerly anticipating his heady rise into the air. This play, however, appears to garner a greater audience than usual: Two young women and one child guide the swing, while a man and an elderly woman look on.

One of the young women is probably Yashoda, and the man Nanda, foster parents to Krishna, and the little boy could be Balarama, Krishna's older brother, who was his constant companion (see plate 37).

Krishna's audience, and their rather serious mien, suggest the greater significance the childish play of the young god held for Hindus. The world, Hindus believe, is unstable, precarious, and unpredictable, controlled by frivolous gods who take equal delight in creation and destruction. As a child plays with his toys, so the gods play with the universe. Hence Indian art and legend portray the young Krishna engaged in many forms of self-absorbed play.

Krishna is perhaps the most charming and joyful of Indian deities. His prankish and amorous exploits as both a child and an adult have been chronicled and elaborated on by generation after generation. Most show him to be winsome and affable, an endearingly human focus of worship. This image of Krishna as a child at play is typical in its recognizable humanity.

77. Guler style. *Krishna on the Swing*, c. 1750–60. Medium unknown, 7⅞ × 6¼ in. (20 × 15.9 cm). British Museum, London.

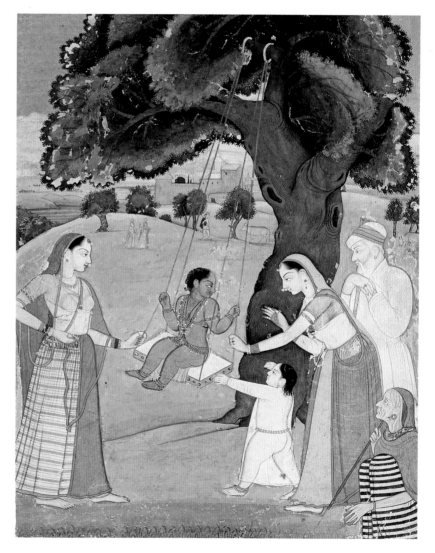

10
Other
Moments

There is endless variety in the kinds of
moments between mothers and children in
the course of a day, not all of which have been
documented in art. In this chapter, some of
the perennial activities of parenting are rep-
resented. There is William Merritt Chase's
nineteenth-century mother taking her baby out
for a walk in the park in a wicker perambulator,
and in a contrasting style of "carriage," an Afri-
can mother carrying her child on her back.
Auguste Renoir and Suzanne Valadon each pre-
sent women dressing their children, and in
Renoir's case, encountering some resistance
from a little boy far more interested in playing
with his cat. Mealtime is the subject of Claude
Monet and Janet Fish, the former taking place
with far greater formality than the latter.
Claudine Stella contributes a welcome allusion
to everyday experience with her depiction of a
diaper change, and Kitagawa Utamaro gives us
a wonderful note of humor with his one-of-
a-kind moment about to be experienced by a
sleeping mother.

Gabriel Metsu, *The Sick Child*

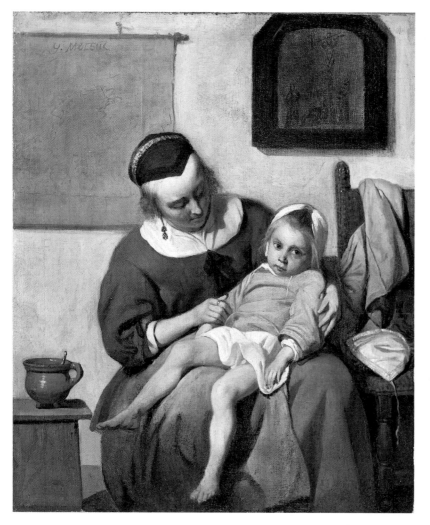

78. Gabriel Metsu. *The Sick Child,* n.d. Oil on canvas, 12⅝ × 10¾ in. (32.1 × 27.3 cm). Rijksmuseum-Stichting, Amsterdam.

This masterpiece by Gabriel Metsu depicts a moment that mothers of any time or place know only too well: the onset of a child's illness. Her expression touched by concern, this capable-looking mother gently cradles her drooping, listless child as she watches closely for symptoms, offering the sure comfort of her lap and perhaps a hoped-for remedy from the cup at her elbow. This quiet, simple moment speaks eloquently of a mother's love and watchful care.

Mothers and children were a favorite subject of seventeenth-century Dutch genre artists, who made a specialty of chronicling the humble moments of everyday life in the northern Netherlands. No household moment was too small to be portrayed on canvas, and we find mothers rocking or nursing babies, combing their children's hair, teaching an older child to read or to learn by example any number of everyday chores: peeling apples or parsnips, filling a linen closet, ironing clothes, or making lace (see plates 63 and 67). This attention to seemingly insignificant subjects underscores the vital role mothers came to play in Dutch life. They were viewed as guardians of the physical and spiritual well-being of their children and preservers of the sanctity of the home. And since home and family achieved

prominence in this century as the building block for the new Calvinistic society, these roles were granted real stature.

Kitagawa Utamaro, *Child Upsetting a Goldfish Bowl*

This print by Utamaro is part of a series entitled Elegant Set of Darling Children. The "darling" pictured here is enjoying a moment of unsupervised play. Taking advantage of his mother's exhaustion—caused, one suspects, by her darling child—he grasps a potted plant in one hand and, with methodical concentration, neatly overturns a goldfish bowl with the other. The flood of water, the displaced fish, and the soon-to-be-uprooted plant promise further fascination for this curious, thoroughly absorbed child, and an interesting tableau for his mother to encounter when she awakens.

In eighteenth-century Edo (present-day Tokyo), mothers were seldom separated from their children. In addition to sharing their mother's bed, babies often spent the better part of a day carried on their mothers' backs, secured with an arrangement of wrapped bands of fabric. And while babies rarely left their mothers, mothers seldom left the confines of the home.

It follows from these strictures and the precepts of Buddhist and neo-Confucian thought that education for women was extremely narrow. "A woman does not need to bother with learning," Matsudaira Sadanobu (1758–1829) stated categorically. "She has nothing to do but obey."[1] From the daughters of the highest samurai to those of the farmer and merchant, women were usually educated at home by other women. With appropriate class distinctions, they learned the practical skills of being a good wife and mother. They were taught housekeeping, etiquette, and the social graces and were given such indispensable advice

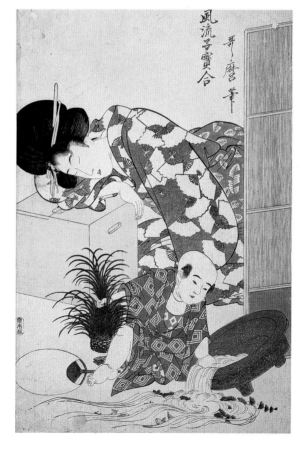

79. Kitagawa Utamaro. *Child Upsetting a Goldfish Bowl*, c. 1800. Woodblock print, dimensions unknown. British Museum, London.

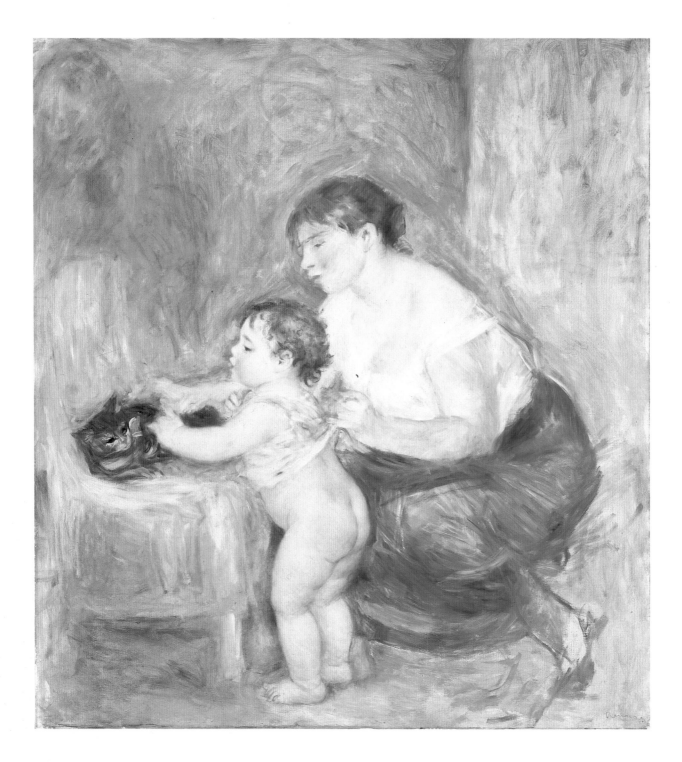

regarding childbirth as not to eat crabs when pregnant lest the child be born sideways.

Pierre-Auguste Renoir, *Mother and Child*

*I*n this airy, sunlit painting Renoir has caught his plump, redheaded son Jean in one of those undignified moments of childhood. Like any self-respecting one-and-a-half- or two-year-old child, Jean has inclinations of his own and obviously prefers discomfiting a sleepy pet cat over submitting to a change of clothing.

Renoir delighted in painting the myriad fleeting moods of his children and produced a number of such canvases between 1895 and 1900. In 1895, the year of this work, Renoir wrote excitedly to a friend: "At the moment I'm painting Jean pouting. It's no easy thing, but it's such a lovely subject, and I assure you that I'm working for myself and myself alone."[2]

The patient young woman in this picture is Gabrielle, Jean's mother's cousin, who joined Renoir's family to help with the children just before Jean's birth and stayed for almost twenty years. Her rosy-cheeked countenance appears frequently in Renoir's paintings, many showing her solicitous care of the children. Mrs. Renoir, who would trust no one else with her babies, had in Gabrielle an enviable helper, and Jean, who grew up to become the famous film director, fondly pronounced himself spoiled by her many indulgences.

William Merritt Chase, *Prospect Park, Brooklyn*

A mood of serenity pervades Chase's vista of Prospect Park, Brooklyn. The broad expanse of open meadow, the wide carriage path, the stately trees, and the distant view of the square tower of Litchfield Villa convey a sense of a tranquil refuge, precisely the intention of the park's creators, Frederick Law Olmsted and Calvert Vaux, when they began their work over a century ago.

In this painting Chase has created a characteristic broad sweep of open foreground with the dramatic diagonal of the walking path slicing through it, leading us into the heart of the picture. Here, graciously attired pedestrians enjoy the park's amenities. In nearest view, a mother has paused at a park bench to attend to her baby in its wicker perambulator. Small figures against the sweep of a calm, ordered landscape, this mother and child are striking in their imperturbable leisure suggestive of an era slower-paced and far more tranquil than our own. Like Berthe Morisot's contemplative mother in plate 35, this pair typifies the nineteenth century's new romanticized vision of motherhood.

80. Pierre-Auguste Renoir. *Mother and Child,* c. 1895. Oil on canvas, 46 × 41 in. (116.8 × 104 cm). The Fine Arts Museums of San Francisco; Mildred Anna Williams Collection.

81. William Merritt
Chase. *Prospect Park,
Brooklyn,* c. 1886. Oil
on canvas, 17⅜ ×
22⅜ in. (44 × 56.8 cm).
Colby College Museum of
Art, Waterville, Maine; Gift
of Miss Caroline R. and Miss
Adeline F. Wing.

A painter of little or no artifice, Chase was a realist adept at crystallizing a sense of time and place in his art. At the time of this painting, Chase was living near Prospect Park with his parents and wife of less than a year. In candidly painting what he saw in his own neighborhood, he has immortalized a particular slice of nineteenth-century urban life.

Kwaku Bempah,
Mother and Child

In many non-Western cultures, mothers continue the centuries-old practice of transporting their children not in elaborate carriages but on their backs, as we see in this beautifully patinated West African sculpture. The custom, of course, has recently found favor in North America and Europe, and many contrivances are now available to Western parents for securing baby to mother's or father's back or front in this practical, time-honored convention. Though the usual African practice is to secure the baby with wrapped cloth, this child seems to ride piggyback atop his solemn-looking mother's beaded hip.

This sculpture comes from the Ashanti tribe in Ghana on Africa's west coast and was carved for one of its paramount chiefs. Like the majority of African carved wood maternity images, it is not a portrait of an actual mother and child but was made for ritual use in a cult shrine.

It is difficult to know the precise significance of these maternal figures, which exist in abundance in many African countries, but their prevalence surely attests to the importance of motherhood in African life and thought. Scholars suggest the sculptures carry several levels of meaning—fertility figures for much-needed agricultural plenty, female deities (which include earth, forest, or river spirits), and an archetypal supreme goddess, a primordial mother of a tribe who gives birth and life to the entire culture. These are, of course, only simplified explanations and do not do justice to the richness and complexity of African traditions.

Mary Cassatt,
Gathering Fruit

While the thoughtfulness and sensitivity of Mary Cassatt's portrayals of women and children is amply demonstrated in plates 43 and 51, this print adds the new element of allegory to her otherwise true-to-life subjects.

In this and several similar prints and paintings, Cassatt explores the theme of women plucking fruit from an allegorical tree of knowledge. Traditionally forbidden to women, this fruit is customarily associated with female sinfulness: Eve's acquisitiveness serves to cast

82. Kwaku Bempah. *Mother and Child*, c. late 19th–early 20th century. Wood and blackened and patinated beads, 17⅝ in. high (44.8 cm). Michael and Rosemary Roth.

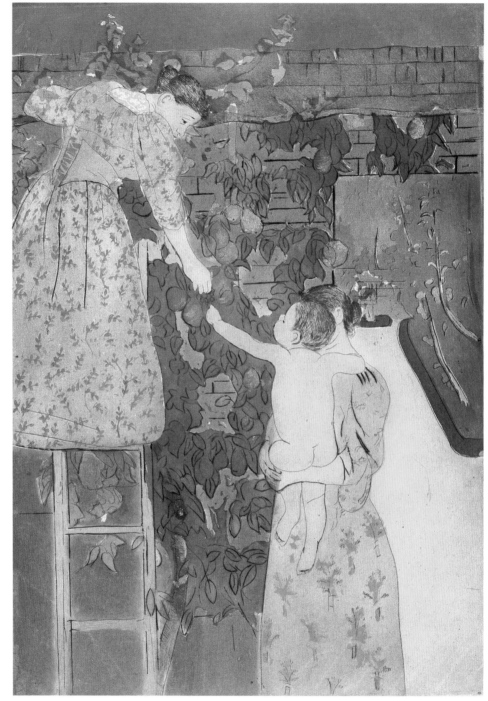

83. Mary Cassatt.
Gathering Fruit, 1895.
Etching with drypoint
and aquatint, 16⅞ ×
11¾ in. (42.8 × 29.7 cm).
Library of Congress,
Washington, D.C.

all of humanity from Paradise. In her own artwork Cassatt sets a different stage, creating a case instead for modern, independent women pursuing knowledge by and for themselves and passing it down to future generations, just as the woman here hands the fruit she has picked down to a child.

This print was inspired by the mural Cassatt painted for the Women's Building of the World's Columbian Exposition in Chicago in 1893. Although the original mural is lost, the artist noted in her letters the brilliant colors she used to convey a sense of celebration. "The occasion," she wrote, "is one of rejoicing, a great national fete." In this print, the bright blue sky and light colors convey some of this elation. Cassatt herself was a champion of the rights of women, advocating their participation in any profession or endeavor of their own choosing. At a time when women's choices were severely restricted by the conventions of the Gilded Age, Cassatt's own life as a dedicated artist is a testament to her advocacy of the rights of women.

Claudine Bouzonnet Stella,
Pastoral No. 16

No compendium of "other moments" in the art of mothers and children would be complete without the inclusion of that perennial parental

activity, the diaper change. It seems fitting that this rarely depicted moment is brought to us by a woman artist, whose personal experience might have prompted this note of undaunted realism.

Claudine Stella moved with her family from the Netherlands to France, where the family established a thriving print shop. Trained as an engraver by her uncle, Claudine and her sister Antoinette were kept busy in the family trade. This print portrays a peaceful domestic scene no doubt typical of its time. While a group of men sit around a table drinking, a circle of women and children gather around a wide hearth, where a large kettle boils and a roast is cooking. One child clutches a doll, another plays with a puppy, and a third minds the roast.

84. Claudine Bouzonnet Stella. *Pastoral No. 16*, 1667. Etching, 9½ × 12½ in. trimmed (24.1 × 31.7 cm).
Museum of Fine Arts, Boston; Bequest of William P. Babcock.

Mother calmly tends to her baby, while a young couple converse in the shadows and an older woman looks on from her chair.

Suzanne Valadon,
Two Children Dressing in a Garden

The illegitimate daughter of a laundress, Suzanne Valadon had little formal education. It was a disadvantage she more than made up for with her talent, her self-confidence, and her audacity. A lively participant in the free-spirited, Bohemian life of Paris's Montmartre, she was by turns a waitress, a circus acrobat, and an artist's model. After posing for such artists as Puvis de Chavannes, Renoir, and Toulouse-Lautrec, she began making her own bold, energetic drawings, and won the admiration of so fastidious a critic as Degas, who was one of the first to buy her work. She was soon sharing an artistic spotlight with Degas, Renoir, Gauguin, and van Gogh. She was, according to Degas, "one of us," though she followed her own intuition rather than painting according to prescribed theories.

In this print we find two women engaged in bathing and dressing two children in a garden. While one woman tends the tub, the other dresses a young boy on her lap, and a little girl dresses herself in the foreground. The scene is quiet, unpunctuated with drama of any kind, and there is no sense of a direct appeal to the viewer. Rather, the women and children seemed engrossed in their own thoughts and their own activity, much like Cassatt's mother and child in plate 51.

In contrast to male artists, who often interpreted women according to generalized notions of femininity, Valadon's women remain refreshingly true to subjective female experience. Her nudes, for example, are unidealized, earthy, and powerful rather than pretty and passive. In this print, as in her later oils, she rejects qualities of timelessness and monumentality in favor of distinct individuals and the specifics of time, place, and physical action.[3]

Like Mary Cassatt, the context for her figures is most often believably domestic, and the women themselves are distinct individuals absorbed in their own moods and activities.

Claude Monet,
The Luncheon

*M*onet's painting of his wife, Camille, and son Jean is a testament to a peaceful interlude in the artist's life. A patron's financial assistance enabled the Monets to leave the bustle of Paris and spend a quiet year in the country. "I am surrounded here with everything that I love," the artist wrote to a friend. "My desire would be to continue always this way, in a quiet corner of nature like this."[4] He could spend his days drawing and painting at the beach or in the woods and fields surrounding Etretat, and return in the evening to "a good fire and a cozy little family in my cottage."[5]

In this painting we find Camille and Jean sitting down to a midday meal, with a visitor standing by the window and a maid peeking through the door. Mother looks on attentively as Jean wields his spoon, both apparently waiting for Monet to join them at his place, which anticipates his momentary presence: His chair is pulled out, and his place is set with boiled eggs, the heel of a crusty loaf of bread, a bottle of wine, and copy of *Le Figaro*.

86. Claude Monet. *The Luncheon*, 1868. Oil on canvas, 90½ × 59 in. (230 × 150 cm). Stadtische Galerie, Stadelsches Kunstinstitut Frankfurt.

87. Janet Fish. *Feeding Caitlin,* 1988. Oil on canvas, 54¼ × 70¼ in. (137.8 × 178.4 cm). Robert Miller Gallery, New York.

Jean was a year old at this time, and a delight to his father. "How sweet he is at present," Monet wrote. "It's fascinating to watch this little being grow, and, to be sure, I am very happy to have him."[6]

Janet Fish,
Feeding Caitlin

Whether the subject is a kitchen table scattered with teacups, sparkling glassware, eccentrically patterned dishes, and lavish flowers, or a landscape of spring trees and bright blue sky, Janet Fish's paintings have an intense shimmer and vibrancy. Painted in vivid, jewellike colors touched by brilliant light, these objects finally appear almost intertwined, and the busy surface of the paintings fairly jumps with the animation of gesture and color, pattern and light.

This outdoor scene, splashed by the glare of a high summer sun, is no exception. Lush irises and poppies vie with rosy watermelon, the lemon yellow cloth, a sun-drenched meadow, and the three animated, colorfully clothed figures on the right. Amid the flicker of color and bright light that is the real subject of the painting, we find a true-to-life narrative of a child's mealtime.

This outdoor feeding of a slightly squirmy infant is accomplished jointly, with an intrigued older child wielding spoon and baby food jar. Abandoned toys and a teething ring sit on the table in the foreground, and mother in a sun hat and red shoes hovers nearby with a dampened cloth at the ready.

11

*Special
Mothers*

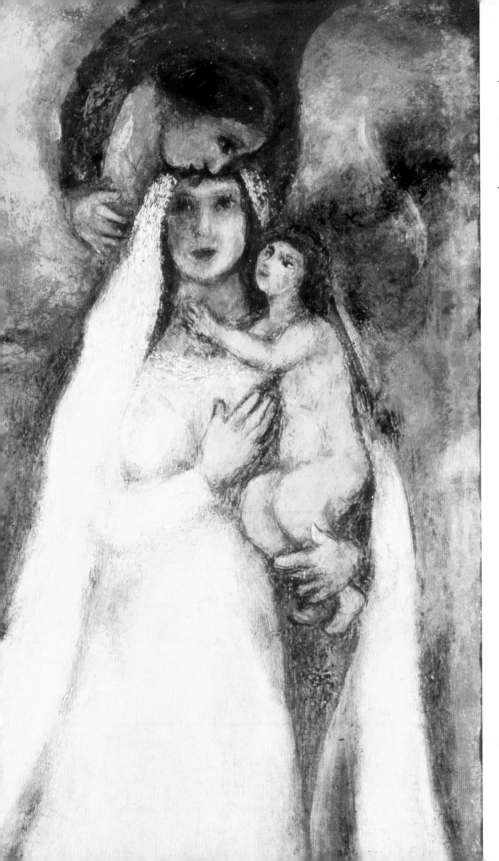

"Special mothers" refers to deified and mythological mothers. Some form of mother goddess was worshiped as the supreme creator before the advent of the male-god religions of Judaism, Islam, and Christianity. Like the Egyptians' Isis, these goddesses date from as early as 25,000 B.C. The power and divinity of mother goddesses is often supposed to have arisen out of early civilizations' perception that women, not men, were endowed with the miraculous ability to create life by giving birth. It would then follow that the creator of the universe would be female. Since men's role in conception was not readily apparent, it may have been unknown, enhancing women's mystery and power.

In addition to mother goddesses, India's Parvati and the *mātrkās* and Christianity's Mary are included here. For centuries, Mary's representation has comprised the most pervasive image of maternity in the Western world. Though her saintly perfection conflicts with our humanness, and her placid self-abnegation runs counter to our "modern" concept of ourselves as fully realized individuals, she is yet, in the hands of many artists, a strong, heroic woman. In her image we can read not simply religious veneration, but mankind's appreciation for the devotion and care of ordinary mothers for their own precious, loved children.

Detail from Chagall's *Madonna of the Village*

Greece,
Two Women and a Child

88. Greece, artist unknown. *Mycenaean Ivory Three-Figure Group: Two Women and a Child (Demeter and Kore with Ploutos?)*, c. 1400 B.C. Ivory, 3 × 2¾ × 2⅛ in. (7.8 × 7 × 5.5 cm). National Archaeological Museum, Athens.

This tiny, exquisite grouping of two women with a child between them puzzles as much as it captivates scholars. Carved of Syrian ivory, it is almost without precedent in ancient Greek art in its portrayal of human affection. The identity of the two women is unknown, and scholars disagree as to whether they are goddesses or mortals.

If they are goddesses, their close bond suggests Demeter—the ancient Greek mother goddess whose worship was well established at Mycenae in the thirteenth century B.C.— and her daughter Kore, who are sometimes depicted wrapped in one shawl, as they are here.[1] They are linked as well by arms and held hands, and the woman on the right rests a free hand on the little boy's shoulder. Since the child moves toward her, she may be his mother. Both women's jewelry and heavily pleated, flounced skirts are known as traditional Cretan costume, but the beaded shawl they share is an anomaly.[2]

Like the much later Christian "holy trinity," Demeter was a triple goddess existing in three separate forms: mother (Demeter), virgin daughter (Kore), and "crone" or creator/destroyer (Persephone). Kore and Persephone were often confused and eventually came to be seen as the same goddess.[3]

The child's identity is a matter of conjecture. He could be Ploutos, god of wealth and abundance, who in classical myth is Demeter's child by the mortal Iasion. Or he may be Triptolemus, Demeter's divine child, who, like Christianity's Jesus, was believed to be the savior of mankind. Or he may simply be a well-loved little boy in the company of his mother and grandmother.

Identity aside, this trio conjures up a familiar Christian grouping, the Madonna and Child with Saint Anne (see plate 89). Both show a gentle affection between two women—possibly mother and daughter—and for the small boy between them.

Leonardo da Vinci,
Virgin and Child with St. Anne

Leonardo's famous painting of the Virgin and Child with Saint Anne immediately calls to mind this artist's most renowned work, the *Mona Lisa.* Saint Anne in particular has something of this celebrated lady's inscrutable smile, and each woman possesses a similarly remote, mysterious beauty. Both paintings seem suffused in a veiled, misty atmosphere that lends an air of warmth and intimacy.

Like the ancient Mycenaean trinity in plate 88, these two women display a strong sense of affection, and a shared emotional connection

89. Leonardo da Vinci. *Virgin and Child with St. Anne,* 1508–10. Oil on panel, 66⅛ × 51¼ in. (168 × 130.2 cm). Musée du Louvre, Paris.

to the child. Their equally gentle but quali-tatively different facial expressions correspond to their roles of mother and grandmother. Mary's gaze is the more passionate: She reaches for her baby with a face full of maternal love. Saint Anne, Mary's own mother, is tempered by her comparative emotional distance—instead of passion, we read fondness and the grand-motherly pleasure of observing her own daughter in the role of mother.

Interestingly, the concept of Saint Anne as the grandmother of God has ancient prece-dents. Long before the Bible was written, Anna was a "grandmother goddess," the mother of the Middle Eastern mother goddess Mari.[4]

Freud, among others, has remarked on Mary's and Saint Anne's apparent nearness in age in this painting: Saint Anne doesn't really look old enough to be Mary's mother. Freud's interpretation of the picture has less to do with ancient or biblical history and, predictably, more to do with his own view of the artist's psychology. Leonardo was a "love child" of his then-bachelor father, Ser Piero, and a peasant woman named Caterina. One year after Leonardo's birth, the artist's father mar-ried another woman, who, it turned out, was unable to have children. Ser Piero eventually brought a very young Leonardo to his wife to be raised by the pair as their own. Leonardo, Freud reasoned, therefore had two mothers, the first equally beloved but only dimly re-membered. This unconscious memory, Freud

speculated, took shape in this painting, where two women tenderly care for the small child.[5]

Saint Anne became crucially important in Christianity only when Mary's immaculate conception was adopted as an article of faith in 1854, after seven centuries of theological dispute.[6] Since Mary had to have been born free of original sin, Mary's mother, Church leaders reasoned, had to be free of any taint of sexuality. One zealous fifteenth-century theologian, Johannes Trithemius, pragmatically proclaimed that Anne, like her daughter, had conceived "without the action of man."[7] Two virgin mothers, however, proved too much even for amenable churchmen, and Saint Anne was henceforth allowed to have conceived her daughter in the usual way.

Post-Hittite citadel,
Cybele

Smiling, majestic Cybele, Great Mother Earth throughout the Mediter-ranean from 6000 B.C. to early Chris-tian times, looks appropriately sovereign here, standing with all the majesty and beneficence proper to the acknowledged creator of all things. There is something jubilant, almost boisterous in her smile.

Cybele was brought to Rome from Phrygia in a triumphal procession in 204 B.C., where she became, as she was in Asia Minor and

Greece, a supreme deity. Her temple stood on the Vatican, where Saint Peter's basilica stands today. The Roman emperor Augustus was careful to build his own home to face this citadel, and was fond of seeing his wife, Livia, as Cybele's earthly incarnation.[8]

Much to the chagrin of the early Church fathers, Cybele was for centuries widely known and accepted as the mother of the gods, indeed, mother of all things. Through the energetic efforts of the likes of Saint Augustine, who scornfully dismissed her as "a harlot, mother not of the gods, but of the demons,"[9] she was ousted by the fourth century A.D., when Christians took over her temple at the Vatican and made it their own.

Cyprus,
Colossal Head from a Votive Statue

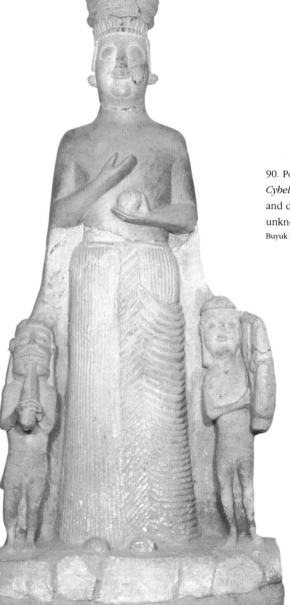

90. Post-Hittite citadel. *Cybele,* n.d. Medium and dimensions unknown.
Buyuk Kale, Bogaskoy, Turkey.

*T*his colossal head of a goddess, with its serene expression, must have been impressive indeed when united with its larger-than-life-size body. The graceful sweep of her prominent brows, her Egyptian eyes, and her strong, straight nose, elaborate tresses, and Mona Lisa smile are entrancing, while her crown of riotous satyrs, maenads, and floral rosettes adds grandeur and mystery.

Although we do not know the identity of this goddess, she probably represents the Great

91. Cyprus, artist unknown. *Colossal Head from a Votive Statue,* c. 500 B.C. Limestone, 20 × 13¾ × 16¼ in. (50.8 × 34.9 × 41.3 cm). Worcester Art Museum, Worcester, Mass.

Mother goddess who takes so many forms throughout early civilizations. By the sixth century B.C. the Greek pantheon was well established on the island of Cyprus, and because worship of Aphrodite was especially popular it is tempting to identify this goddess as such.

Though we tend to think of Aphrodite as a goddess of love, she was to the Cyprians and the rest of Greece and Rome a supreme mother goddess, like the Egyptian Isis, who was "older than time"[10] (see plate 20). She governed love and marriage, fertility, pregnancy, and childbirth, and not only had power over the sea but also ruled life, death, time, and fate. It makes sense that this principal deity would be honored on the grand scale of this sculpture, which is as original and lively as much of the art of Cyprus.

in the company of Eros, or Love, and Himeros, or Desire, and was dressed by celestial nymphs in rich clothing and precious jewels. She was, legend tells us, feminine beauty incarnate, with pure features, golden hair, a voluptuous figure, and a graceful demeanor.

Although she is included in this chapter for her role as a mother goddess (see plate 91), this sculpture emphasizes her more familiar sensual aspect as a goddess of love and sexuality. In this sensual aspect Aphrodite could wreak havoc. She had the ability to fill the hearts of women with destructive passion, causing them to betray their fathers, abandon their homes, and, like Helen of Troy, follow a stranger.[11] Yet she could also inspire legitimate marriages, and Spartan mothers were known to appeal to Aphrodite on behalf of their unwed daughters.

Greece,
Aphrodite Poised on the Shell

*U*nlike the somewhat enigmatic Cyprian head of a goddess, this lovely figure is easily identified by her graceful perch upon a seashell, which could refer only to Aphrodite's singular birth.

According to Greek myth, Aphrodite emerged from the foam of the sea, over which she would reign as queen. Borne upon her shell, she was carried over the tumultuous waves by Zephyrus, the West Wind. She reached the shore of Cyprus

92. Greece, artist unknown. *Aphrodite Poised on the Shell*, early 3rd century B.C. Terra-cotta, 8¼ in. high (21 cm). Musée du Louvre, Paris.

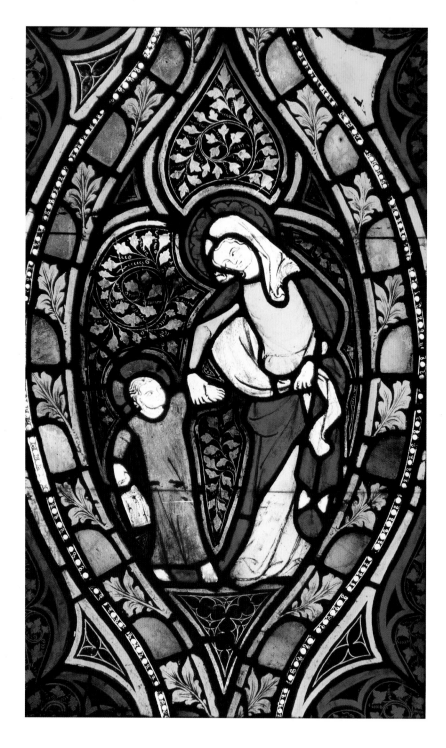

France,
Virgin and Child

This exquisite ivory is remarkable in its naturalistic treatment of the relationship of mother and child, more so given its thirteenth-century date. There is a fineness of sentiment in the child's playful gesture of chucking his mother under the chin, and in the pair's smiles and mutual absorption. In contrast to the stiffness and severity of paintings of the Virgin Mary by Cimabue, and even later by Duccio and Giotto, this sculptural pair appears joyful and merry, with a lovely, fresh innocence about the young mother, Mary.

It is interesting to note that Church-supported veneration of Mary came relatively late, dating only from the ninth century. While Mary was always immensely popular with the laity, the early Church strongly opposed her worship, seeing in Mary a composite of all the ancient pagan manifestations of the culturally ubiquitous Great Mother goddess. The early Church made it its business to stamp these out. Yet in common with them, Mary fulfilled an apparently powerful need for an archetypal mother figure in religion. Mary was not simply the mother of God, but a humane, sympathetic, and accessible mother to all, who understood worldly pain and could provide comfort.

Rather than allow this powerful, exalted mother-to-all image to compete dangerously with Church-approved doctrine, Mary was simply incorporated into the faith, albeit uneasily, with the aim of thereby controlling her pre-eminence. Periodically, when her popularity threatened to become too great, the Church would stem the tide with pronouncements like that of Pope John XXIII: "The Madonna," he hazarded, "is not pleased when she is put above her son."[12]

Esslinger Werkstatt,
The Virgin Holding the Child by the Hand

This late Gothic stained-glass window shows the Virgin and Child in an eminently human moment unusual at this early date. Where fourteenth-century representations often portray Mary as stiff and magisterial, surrounded by a celestial court of angels and saints, we find her here looking very much like the ordinary mother of a believably childlike little boy. Like the ancient Greek mother in plate 61, Mary encounters a willful child seemingly dragging his feet in proportion to her own hurry. With the same gesture—and slightly more patience—she pulls the child along with a glance of gentle remonstrance.

By the mid-fourteenth century, veneration of Mary was well established. While Christians of the Middle Ages and Renaissance tended to view God as a vengeful persecutor of impious

93. France, artist unknown. *Virgin and Child,* c. 1260–70. Ivory, 8 in. high (20.3 cm). The Metropolitan Museum of Art, New York; Gift of J. Pierpont Morgan, 1917.

94. Esslinger Werkstatt. *The Virgin Holding the Child by the Hand,* pane from the Mary Window, c. 1330. Stained glass, 29¾ × 16½ in. (75.6 × 41.9 cm). Frauenkirche, Esslingen, Germany.

95. Raphael. *Madonna della Sedia,* 1514–15. Oil on panel, 28 in. diameter (71 cm). Galleria Palatina di Palazzo Pitti, Florence.

humanity, punishing man with floods, famines, war, and pestilence, they regarded Mary as a kindly mediator between God and mankind, able to soften his harsh judgments and grant mercy and forgiveness. "When we have offended Christ," wrote one fourteenth-century Franciscan, "we should go first to the Queen of Heaven. . . . She, like a mother, will soften the king's anger against us."[13]

Raphael, *Madonna della Sedia*

Over the course of his brilliant career, Raphael made rather a specialty of Madonna and Child paintings, completing over forty variations on the theme. Though there are many masterpieces among them, this one is perhaps the most revered of all.

This painting owes much of its appeal to its departure from traditional representations of the Madonna and Child. Most obviously missing are such familiar trappings as the imposing, high-backed throne and contingent of adoring angels and saints of medieval tradition. Gone, too, is the Virgin's customary modest, hooded blue robe. Raphael has instead clothed his Madonna in a vivid, richly embroidered shawl, with a bright red sleeve daringly paired with the vibrant orange of the child's dress. As arresting as this almost Venetian color is this

mother's direct, compelling gaze. Gone are the demure, downcast eyes that characterize so many reposeful Madonnas, which led writer George Eliot to wonder in 1860 whether these mothers, "with the blond faces and somewhat stupid expression, kept their placidity undisturbed when their strong-limbed, strong-willed boys got a little too old to do without clothing."[14]

In contrast, this gaze holds our attention and evidences a thoughtful intelligence that does not preclude emotion or activity. Mary's expression has some of the fathomlessness and mystery of Leonardo's *Mona Lisa.* The atmosphere she inhabits, too, has a veiled, misty, dreamlike quality that recalls Leonardo and gives the portrait warmth and intimacy.[15] And where other Madonnas may seem aloof and unapproachable, we respond at once to her obvious love for the child she tightly clasps.

The child, like the mother, is delightfully free of deified convention, particularly the tradition of portraying him as a miniature adult. Here instead is a real child—plump, tentative, and shy, abstractedly playing one naked toe against heel, taking comfort in the enveloping embrace of a protective mother.

This is an intimate, human portrait, one that perhaps admits the viewer into a private realm. Although Raphael never married, there was, according to the sixteenth-century biographer Vasari, "a certain lady" to whom Raphael was

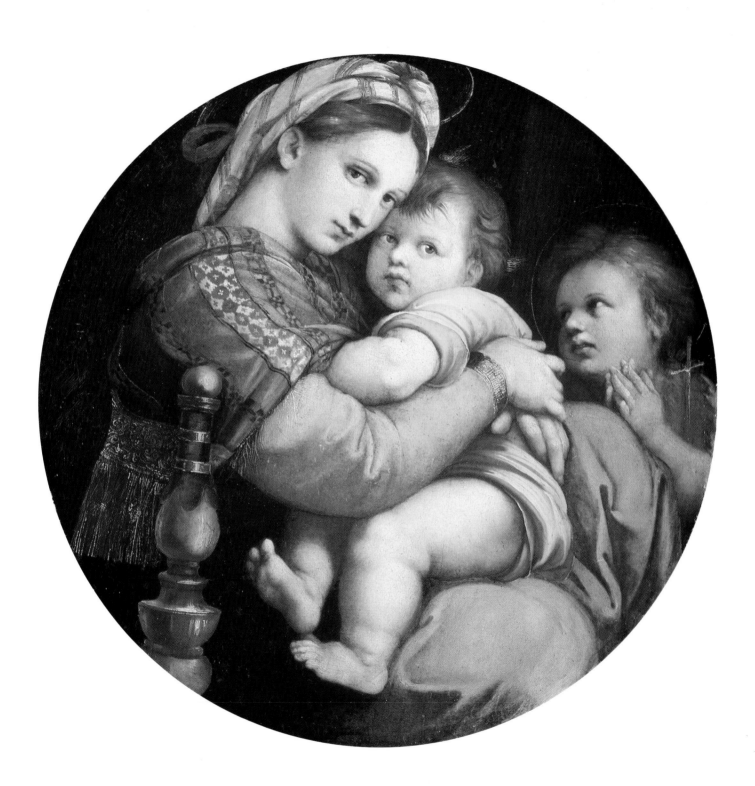

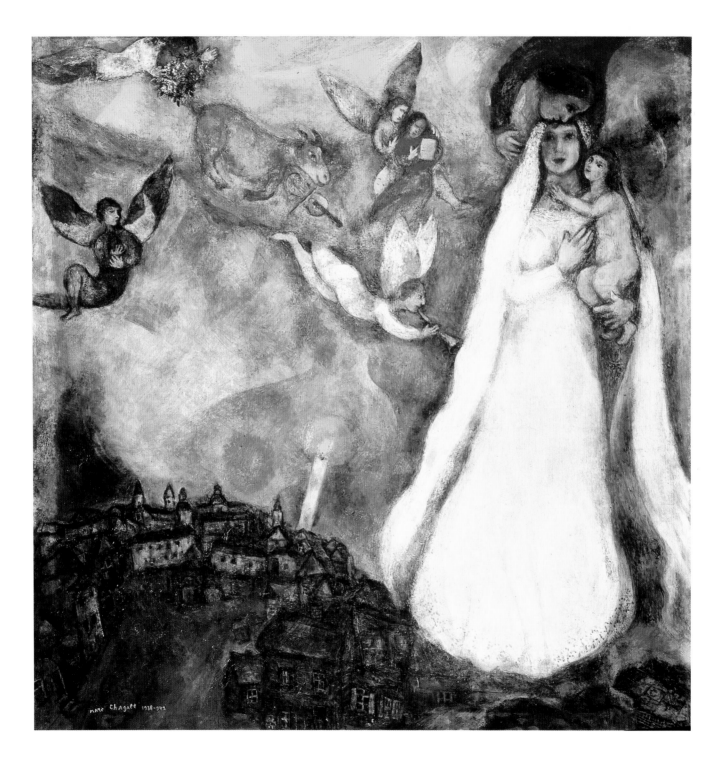

attached until the day he died. This woman, known as La Fornarina ("the baker's daughter"), is believed to have been the model for this and other Raphael Madonnas. Certainly it is easy to believe that the woman portrayed so intimately in *Madonna della Sedia* was loved by the painter.

Marc Chagall,
Madonna of the Village

Chagall's lyrical Madonna and Child is of a piece with this artist's emotion-filled, highly imaginative approach to painting. As is clear from his *Pregnant Woman* in plate 5, Chagall painted from the heart, using vivid color and dreamlike imagery to communicate a quixotic personal vision that leaves conventional reality far behind.

In this painting the artist once again hearkens back to his native Russian village of Vitebsk. The small town slumbers in the glow of a large candle representing the native Jewish faith, while a wide, brilliant sky is charged with exuberant fancy and a radiant Madonna—in full bridal splendor—and Child receive a celestial embrace from the artist himself.

Chagall was emphatically a man who loved women. From his earliest youth he idolized his lively, industrious mother, who raised eight children and created a home of sparkle and warmth. Given the silence and inaccessibility of the artist's father, his mother and his six sisters must have imbued the household with a powerful femininity. Later his wife, Bella, filled the role of adored archetypal female: mother, bride, muse, and angel. In light of this idolization of women as mothers, and because the Jewish faith has no parallel to Christianity's Madonna, it is not surprising that Chagall found a special place for Mary in his spiritual life and in his art. Certainly in this picture the Madonna is a powerful vision of goodness and personal salvation, particularly poignant given the menacing political events of the late thirties in Europe. By 1942, when Chagall finally called the painting finished, the Nazis had begun the systematic extermination of just such mothers and children.

India,
Parvati with Ganesa

The Hindu goddess Parvati is a special mother of a very special child, Ganesa, the popular elephant-headed deity. Married to the powerful god Siva, who is known for his rigorous asceticism and indifference to worldly pleasure, Parvati has historically been given the role of coaxing her husband away from spiritual preoccupations into the enjoyment of beauty, sensuality, marriage, home, and family. In her devotion to

96. Marc Chagall. *Madonna of the Village,* 1938–42. Oil on canvas, 40¼ × 38½ in. (102.2 × 97.8 cm). Thyssen-Bornemisza Collection, Lugano, Switzerland.

the household and her tolerance of her husband's idiosyncrasies, she represents an ideal wife in Indian thought. In spite of their differences and occasional quarrels, the pair enjoy a mostly harmonious, frequently passionate relationship. Their opposition—Parvati's worldliness and Siva's spiritualism—complement each other. Each tempers the other's excesses, and together they forge an interdependent, harmonious ideal.

Be that as it may, Parvati often wearied of her husband's perennial absences and austerities and longed for a child to ease her loneliness. Out of this desire she creates the child Ganesa from her own body without conventional assistance from Siva. Parvati was delighted with her creation and doted upon her son. As is made clear in this painting, Ganesa in turn adores his beautiful mother. Their mutual devotion personifies the ideal mother-child relationship in Indian culture, where mothers take delight in their offspring, dispensing to each a generous measure of maternal comfort and attention.[16]

Ganesa's unusual head deserves some explanation; he was not born this way. One day, instructed by his mother to guard the door to her boudoir, Ganesa overzealously attempted to bar Siva himself from entering. The mistake aroused his father's wrath and Siva promptly sliced off the child's head. Parvati was inconsolable until Siva, in an act of contrition, gave his son the first available head that came along, which happened to belong to a passing elephant.

97. India, artist unknown. *Parvati with Ganesa,* 19th century. Gouache on paper, 15 × 11 in. (38 × 27.9 cm). Mr. and Mrs. John Gilmore Ford.

India,
Saptamatrika

This vivacious chorus line represents a group of Indian mother goddesses known collectively as the *mātrkās*, accompanied by the Hindu god Siva on the far left, and Ganesa, the elephant-headed deity, on the far right.

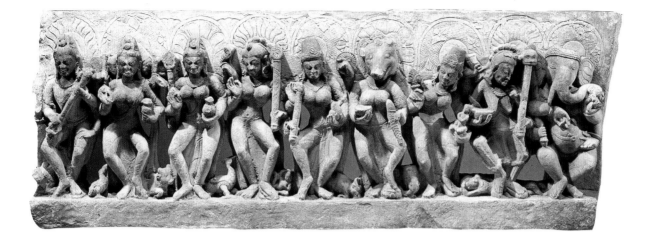

The humor and gaiety of this group notwithstanding, the *mātrkās* have a somewhat sinister history in Indian mythology. Earliest references, dating from the first century A.D., describe them as a malevolent group, disposed to violence and particularly dangerous to babies and young children. They are sometimes portrayed as women who could not have their own children, and hence jealously destroy, or at least torment, the children of other women. Mothers fearfully worshiped the *mātrkās* in order to appease them, forestalling their potential afflictions. Though sometimes described as lovely, youthful, and fair, they are also known in a more terrible aspect that corresponds to their inimical nature, exhibiting large teeth, long nails, and protruding lips, and habituating dark caves or mountaintops.

Sometime after A.D. 400, however, these "bad witches" were transformed into relatively benign goddesses who were the protectresses of children. Though still violent in nature, they came to expend their fury on the forces of evil, valiantly combating all manner of demons who threaten the cosmic order. Fierce warriors, they defeat their enemy and then collectively dance, drunk with the blood of their victim, as perhaps we find them here. But in spite of their efforts as superwomen in the service of truth and justice, something of their terrible aspect lingers, and they have not completely succumbed to domestication—even today they are considered dangerous, and suspect with regard to young children.[17]

98. India, artist unknown. *Saptamatrika*, 8th–9th century. Indian buff sandstone, 20 × 53 in. (50.8 × 134.6 cm).
Richard and Dorothy Sherwood, Beverly Hills, Calif.

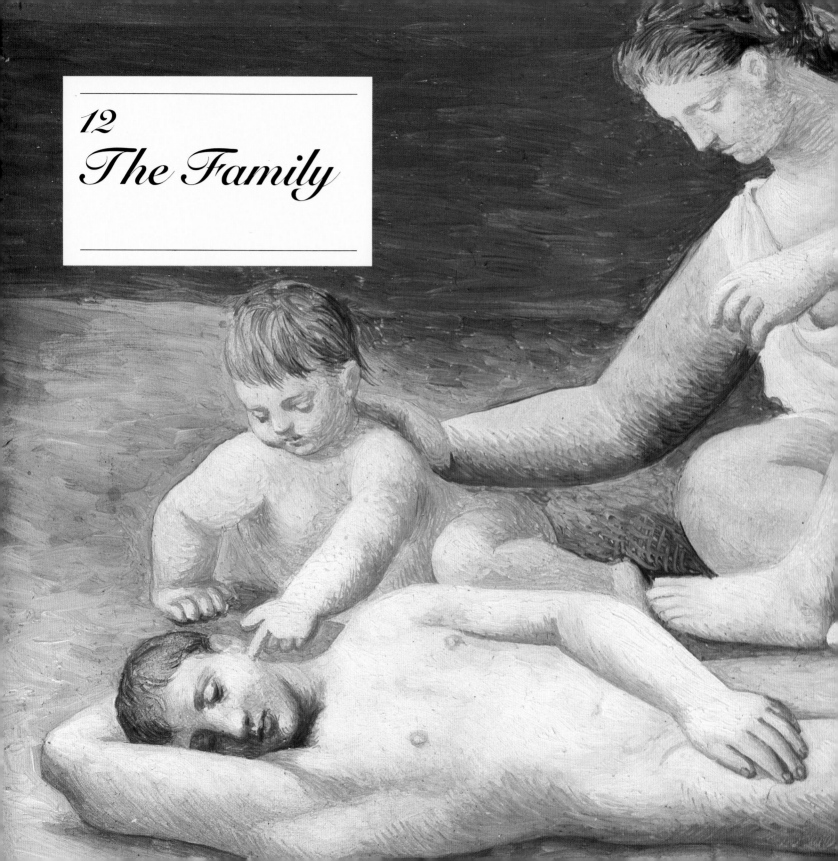

12
The Family

This book's rather exclusive consideration of mothers in art naturally leaves out significant others—namely, fathers and other family members. This final chapter broadens the focus with the inclusion of a small selection of artwork depicting both typical and slightly out-of-the-ordinary family life.

On the extraordinary side, there are Indian god and goddess Siva and Parvati and their sons Ganesa and Karttikeya relaxing beside a campfire, sharing their elephant skin with a dozing tiger. And we find the royal family of Henry IV behaving surprisingly like any ordinary family, with father and children engrossed in alternating rounds of piggyback rides. While Marisol's *Poor Family I* eloquently depicts deprivation and despair, Bonnard's conventional and Utamaro's somewhat unconventional families exude tender, happy feelings. In *Tar Beach* Faith Ringgold, without glossing over the hardships experienced by her Harlem family, presents a magical moment of family harmony and love.

Liberia,
Figures: Dan Tribe

These statues, made by the Dan tribe of Liberia and nearby regions, vividly portray the everyday life of mother and child in this agrarian culture. Since women did the majority of the work in both household and field, it is not surprising to find the child on the way to work hand in hand with mother or riding piggyback. Men typically had several wives, with the "head wife" in charge of all others.

The Dan are known for their brilliant music and dance and beautifully formed artifacts, including impressive carved masks and metalwork figures like these. At one time they made much cast brass jewelry; however, by the twentieth century jewelry was out of fashion among this tribe, and the craftsmen turned to casting brass into these figurines. Called *ze me* (brass person) or *ze ne* (brass child), they were made solely for the enjoyment of the chieftains. Although the figures come in all varieties, women with children outnumber the laborers, craftsmen, soldiers, dancers, and musicians. The number of mothers attests to the culture's esteem for prolific women, desirable in nearly all agrarian societies. The Dan were apparently quite fond of children, lavishing affection on their offspring particularly during the first few years of life.

The features of these mothers are indicative

99. Liberia, artist unknown. *Figures: Dan Tribe,* Bronze, Peabody Museum, Harvard University, Cambridge, Mass.

of the Dan's feminine ideal: Each has a round, symmetrical face with pointed chin, shaved eyebrows, and narrow, half-opened eyes. Hair was plaited in intricate patterns, and well-developed breasts and a degree of corpulence (indicated by the neck rolls on each figure) were highly valued, suggesting physical well-being, wealth, and ideal beauty.

India,
Siva and Parvati with Their Two Sons

Having become acquainted with the Hindu goddess Parvati as the happy mother of Ganesa in plate 97, we find her here in an imaginative mountain landscape, surrounded by her complete family: husband Siva and sons Ganesa and Karttikeya. The scene is peaceful and harmonious; the group reclines upon an elephant skin before a small campfire, Siva's hand lightly resting on Ganesa's sleepy head and Karttikeya snuggled on Parvati's lap. Beside them dozes a tiger (Parvati's mount), the bull Nandi rests by the fire, and Karttikeya's peacock watches the quiet scene from the branch of a flowering tree.

The remarkable humanity of this scene finds parallels in the many myths associated with this family that seem to be modeled on real life. Siva and Parvati's marriage, for instance, in spite of occasional quarrels, is usually char-

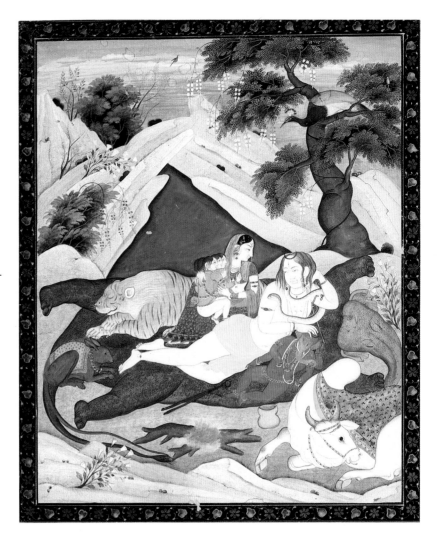

100. India, artist unknown. *Siva and Parvati with Their Two Sons*, c. 1810. Gouache, 9 × 7 in. (22.9 × 17.8 cm).
San Diego Museum of Art; Gift of Edwin Binney III.

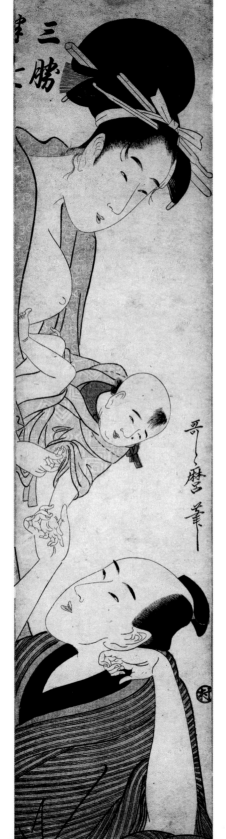

101. Kitagawa Utamaro. *Two Lovers, Sankatsu and Hanhichi, with Their Baby,* c. 1790. Woodblock print, 24½ × 5⅞ in. (62.2 × 14.9 cm). The Metropolitan Museum of Art, New York; Rogers Fund, 1919.

acterized as ideal, but myth allows that the marriage preparations were nearly halted when Parvati's mother, Menā, met Siva for the first time. She could not believe that this odd-looking ascetic was the chosen mate of her beautiful daughter. With time-honored melodrama, Siva's future mother-in-law threatened to kill herself if the marriage went forward, though mother and daughter eventually became reconciled.[1] Parvati remains steadfast in her devotion to Siva, and the entire family can enjoy pleasurable, harmonious moments like the one depicted here.

Kitagawa Utamaro,
Two Lovers, Sankatsu and Hanhichi, with Their Baby

This lively print by Utamaro gives us yet another glimpse of this artist's versatility. Famed simultaneously for his racy images of eighteenth-century Japanese courtesans and for his remarkably sensitive and convivial portraits of mothers and children (see plates 24, 65, and 79), he gives us here a celebration of the pleasures of family life that finds few parallels in Western art.

This simple woodcut captures a languid, serene moment in the life of a young family. Mother, her breast bared by her open kimono, appears to have just finished nursing and

hands the child over to a relaxed and doting father. The baby, clearly a product of their love, is placed between the two figures, compositionally linking mother to father and punctuating their mutual affection.

Utamaro succeeded in revealing such nuances of mood and feeling to a greater degree than usual in Japanese art, albeit through what appears to Western eyes the merest expressive detail: the slight forward incline of the mother's head, for instance, the lifted arch of her brows, and her playful half smile; the father's languorous posture and his gentle clasp of his child's outstretched hand.

Though it is likely that these figures do not represent a traditional Japanese family—the complacent sensuality suggests instead a courtesan and her lover—their unconventional arrangement is no barrier to eloquently expressed feelings shared among the three.

Pierre Bonnard,
Family Scene

*P*ierre Bonnard's portrayal of a young family comes close to Utamaro's in spirit, minus the sensuality. Bonnard was a quiet soul who, even at the relatively young age of twenty-five, was attuned to the pleasures of family life. Fond observations of children were often the subject of his art. He was to meet his own wife three

years later, but in this cheerful lithograph he finds his subject in his sister Andrée, her husband, Claude Terrasse, and their new baby.

Clearly the artist delights in the mild humor of baby's round bald head and the doting parents' attentiveness. The flat, simplified forms and the bold pattern of mother's checked dress lend the composition an air of conviviality

102. Pierre Bonnard. *Family Scene,* 1893. Color lithograph on heavy cream wove paper, 12¼ × 7 in. (31.1 × 17.8 cm). The Metropolitan Museum of Art, New York; Rogers Fund, 1922.

typical of Bonnard in his life as well as in his art. He is remembered not only for the lively visions of his paintings, but for his own carefree good nature.

Bonnard has taken more from Utamaro than similarity of subject. Like many other painters of his circle, he was intrigued by the conventions of the Japanese ukiyo-e print: the flat planes of color, simplified forms, and unconventional compositions that emphasize contours and negative space in the creation of an overall decorative effect. In *Family Scene* the figures are realized with a simple, quirky line, and instead of occupying the center they cling to the picture's outer margins. This unconventional arrangement emphasizes the informal character of the little scene, giving it the freshness of a spontaneous domestic moment.

Edgar Degas,
Carriage at the Races (detail)

Though broad and masterfully painted, Degas's wide open landscape does not eclipse this painting's true subject, the absorbed little family in the open carriage in the foreground, specifically its newest member. The tiny infant is cradled in his nurse's lap, with mother and father looking on attentively, suggesting this may be the first such outing for the little one. Perhaps Degas, a lifelong bachelor, enjoyed contrasting the expansive sweep of countryside and the bustle of the races with the constricted absorption of his friends, the Valpinçons, in their newborn son, Henri. Degas's portrayal seems at once tender and whimsical: Our attention is drawn to the two women and the child by a large white parasol, which shelters the group from the afternoon sun and gives their corner of the open carriage a protective intimacy beneath the broad sky. There is a gentle note of humor in the little dog who, from the top of the carriage box, echoes the solicitous glance of the child's father.

Degas occasionally expressed his longing for a family of his own. He seemed convinced, however, that this was not possible and was reconciled to a certain amount of regret and loneliness. Many have speculated that it was Degas's alleged antipathy toward women that kept him unattached. Much has been made of Degas's iconoclastic treatment of the female nude. His preference for ungainly poses and unidealized faces and figures have earned him the label of misogynist. His acerbic wit fueled the misogynist fires: Berthe Morisot, he once stated, painted pictures "the way one would make hats," and upon viewing an exhibition of Mary Cassatt's etchings, he remarked, "I am not willing to admit that a woman can draw that well."[2] However, few women *or* men of Degas's acquaintance escaped his vituperative remarks.[3] Moreover, there is ample evidence that rather than disdaining women, the artist reveled in

the company of intelligent, spirited women like Mary Cassatt, whom he counted as a close friend, and the free-spirited, abundantly talented artist Suzanne Valadon.[4] Indeed, he was often a champion of women artists, the first to praise and encourage their work and welcome them into the fraternity of men painters. The claim of misogynism can be seen instead as Degas's viewers' discomfort with the artist's penchant for painting women not according to prevailing conventions of feminine charm or beauty, but as distinct individuals.[5]

In this painting, as in so many of his portraits, Degas gives us an insightful glimpse into the preoccupations of the Valpinçon family at this moment in his long friendship with his school friend Paul Valpinçon. Like the family, Degas himself seems taken with the infant Henri, placing him directly in the center of the composition. His own doubts about marriage

103. Edgar Degas. *Carriage at the Races* (detail), 1870–72. Oil on canvas, 14⅜ × 22 in. (36.5 × 55.9 cm). Museum of Fine Arts, Boston; 1931 Purchase Fund.

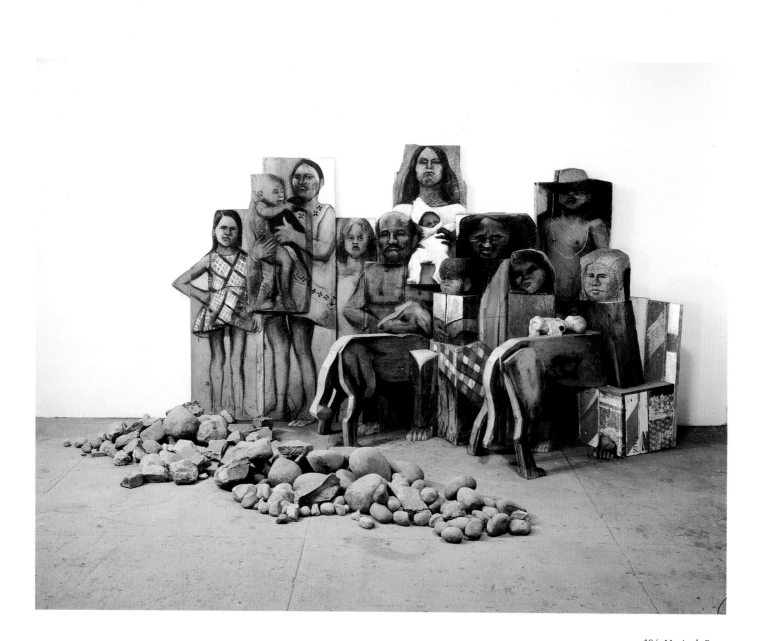

104. Marisol. *Poor
Family I,* 1986. Wood,
charcoal, stones, and
plastic doll, 78 ×
156 × 84 in. (198 ×
396 × 213 cm).
Courtesy Sidney Janis Gallery,
New York.

aside, he seems to have painted this picture out of his finer sentiments about family life.

Marisol,
Poor Family I

As with *Working Woman* (see plate 68), Marisol in this mixed media assemblage takes on the larger ills of contemporary society through an incisive look at individual struggle. *Poor Family I* powerfully confronts the viewer with an array of faces alternately pensive, impassive, truculent, sad, and defiant. Roughly formed of scrap lumber, broken boxes, and carved, weathered beams, figures and faces alike are presented in unadorned monochrome, suggestive—as are the bare feet, broken doll, and stone rubble—of severely restricted lives narrowed to a level of mean subsistence. Given additional depth and character by the battered surfaces and wide wood grain, the faces of these individuals are compelling and unforgettable.

While such tableaux are not new to Marisol (an assemblage of a dust-bowl farm family dates from 1962), her focus on less fortunate families in her most recent work reflects her perception of the urgency of poverty as a pervasive, universal concern. The sobering pathos of these works, with their essential if disquieting message, is occasionally offset by contemporary icons of courage and hope: Marisol has more recently completed a multimedia portrait of Bishop Desmond Tutu, and a group portrait of John Roebling, the designer of the Brooklyn Bridge; his son, Washington, who directed the bridge's construction; and his wife, Emily, who valiantly carried the project through to completion after her husband's injury.[6]

Richard Parkes Bonington,
Henry IV and the Spanish Ambassador

This nineteenth-century family portrait finds Henry IV, king of France from 1589 to 1610, in a less than majestic moment. While his queen, Marie de Médicis, comports herself regally, Henry

105. Richard Parkes Bonington. *Henri IV and the Spanish Ambassador*, 1827–28. Oil on canvas, 15 × 20⅝ in. (38.4 × 52.4 cm). Reproduced by permission of The Trustees, The Wallace Collection, London.

cavorts on hands and knees among three of his children, giving his eldest son, Louis (the future Louis XIII), a piggyback ride. The subject—an unguarded moment rare in the depiction of royalty—was inspired by an eighteenth-century record of an incident dating from 1604. The king was thus occupied among his family when "an Ambassador arrives, to discover the conqueror of the Catholic League and the Monarch of France in this undignified position. The worthy Henri, without getting up, said: 'Have you any children, Ambassador?' 'Yes, Sire.' 'Then I may finish my trip around the room.'"[7]

Henry IV was reportedly an excellent, albeit strict, father, spending a lot of time with each of his thirteen children and loving them all equally. He is not, however, remembered for being a good husband. His thirteen children had five different mothers. Only six were the queen's own; the rest were products of the king's many amorous liaisons, brought up, at his insistence, under his own roof. In a further test of the queen's endurance, several of her husband's mistresses achieved live-in status as well. While she tolerated many of the king's affairs, one pushed the queen to her limit. "This woman," she wrote, "has only one aim in life—to insult and torture me."

Though the state of the royal marriage was not unusual among the seventeenth-century aristocracy, it seems telling that this portrait depicts the queen distinctly apart from the playful group on the floor.

Faith Ringgold, *Tar Beach*

*P*ainter, sculptor, writer, and performance artist Faith Ringgold is known for telling sharp, witty, often lyrical stories in pieced, painted, and tie-dyed quilts like this one. Her subjects are frequently both personal and political, describing her own experiences as a woman and as an African-American.

Tar Beach lovingly describes a gathering of family and close friends on a warm summer evening on a rooftop in Harlem, where the artist was born and has lived all of her life. The narrative in the top and bottom borders tells the story from the point of view of the little girl, for whom the evening is infused with magic. Sharing a makeshift bed with her brother while her parents and their friends play cards under a sky of glittering stars, the child dreams she is soaring above the rooftops, with the power to own all she sees below her. Entranced, she claims the George Washington Bridge—which her father worked on and which was completed the year of her birth—to wear "like a giant diamond necklace," as the narrative reads. Drunk with her powers, she plans next to fly over the new building her father is currently working on and give it to him as a gift, leaving her with a rich daddy and a mother who "won't cry all winter when Daddy goes to look for work and doesn't come

107. Pablo Picasso.
Family at the Seashore,
1922. Oil on board,

7 × 8 in. (17.7 ×
20.2 cm).
Musée Picasso, Paris.

home," but instead "can laugh and sleep late like Mrs. Honey, and we can have ice cream every night for dessert."

Like the little girl's blissful dream, this quilt, with its exuberant border of floral patchwork, evokes the romance of the summer evening and celebrates a happy, trouble-free interlude among family and friends. Certainly children can find magic almost anywhere on a summer's night, but the faces of the adults indicate that they, too, are touched by the enchantment of the star-filled sky.

Pablo Picasso,
Family at the Seashore

A mood of deep calm and timelessness prevails in this family by the sea. There is an introspective air and a touch of melancholy about the mother, a similar pensiveness in the child, and a further extreme of remove in the father, who is secluded from the group in peaceful slumber.

At the time of this painting Picasso's first child, Paulo, would have been about the same age as the child here. Although Picasso was popularly believed to be a doting father, at least one biographer has pointed out that there is little evidence that he ever spent much time with his children. Picasso's well-known practice of painting until dawn and sleeping until late morning might indeed have limited the time he spent in their company, leading one writer, Mary Mathews Gedo, to suggest that this image—with mother and child awake and ready for play but father unavailable for company—may have closely paralleled real life.[8]

Though each of these three figures is isolated in varying degrees from the others, the group is nonetheless physically connected: Mother reaches out to her child to caress his back, and the child in turn fondles his sleeping father's ear. This contrast between individuality and elemental, familial unity may reflect the artist's perception of the nature of family, where there is inevitably both detachment and connection.

Notes

1 PREGNANCY (pages 12–21)

1. Quoted in Pat Getz-Preziosi, *Sculptors of the Cyclades: Individual and Tradition in the Third Millennium B.C.* (Ann Arbor: University of Michigan Press, 1987), p. ix, from A. Malraux, *Picasso's Mask* (New York, 1976), p. 136.

2. Patricia Hills, *Alice Neel* (New York: Harry N. Abrams, 1983), p. 162.

3. Ibid., p. 100.

4. Martha Kearns, *Käthe Kollwitz: Woman and Artist* (Old Westbury, N.Y.: Feminist Press, 1976), p. 107.

2 GIVING BIRTH (pages 22–35)

1. Quoted in Christine Mitchell Havelock, "Mourners on Greek Vases: Remarks on the Social History of Women," in *Feminism and Art History: Questioning the Litany*, ed. Norma Broude and Mary D. Garrard (New York: Harper and Row, 1982), p. 46, from Aristotle, *Politics*, vol. 1, trans. William Ellis (London: Everyman Library, 1948), p. 8.

2. Diana Y. Paul, *Women in Buddhism: Images of the Feminine in Mahayana Tradition* (Berkeley, Calif.: Asian Humanities Press, 1979), p. 63.

3. Ibid., p. 63.

4. Elizabeth Lyons and Heather Peters, *Buddhism: History and Diversity of a Great Tradition* (Philadelphia: University Museum, University of Pennsylvania, 1985), p. 5.

5. Paul, *Women in Buddhism,* p. 60.

6. Lorraine Dong, "The Many Faces of Cui Yingying," in *Women in China*, ed. Richard W. Guisso and Stanley Johannesen (New York: Philo Press, 1981), pp. 79–80.

7. Shulamith Shahar, *The Fourth Estate: A History of Women in the Middle Ages* (London and New York: Methuen and Company, 1983), p. 103.

8. Ibid.

9. Ibid., p. 104.

10. Burr Cartwright Brundage, *The Fifth Sun: Aztec Gods, Aztec World* (Austin: University of Texas Press, 1979).

11. Ferdinand Anton, *Women in Pre-Columbian America* (New York: Abner Schram, 1973), p. 17.

12. Ibid., p. 17.

3 NURSING MOTHERS (pages 36–55)

1. Theodora Hadzisteliou Price, *Kourotrophos: Cults and Representations of the Greek Nursing Deities* (Leiden, The Netherlands: E. J. Brill, 1978), p. 1.

2. Ibid., p. 199.

3. Ibid., p. 210.

4. Ibid., p. 219.

5. Merlin Stone, *When God Was a Woman* (New York: Harcourt, Brace, Janovich, 1976), pp. 22–23.

6. Barbara G. Walker, *The Woman's Encyclopedia of Myths and Secrets* (New York: Harper and Row, 1983), p. 453.

7. Sir E. A. Wallace Budge, *Gods of the Egyptians* (New York: Dover Publications, 1969).

8. Nancy Luomala, "Matrilineal Reinterpretations of Some Egyptian Sacred Cows," in *Feminism and Art History: Questioning the Litany*, ed. Norma Broude and Mary D. Garrard (New York: Harper and Row, 1982), p. 19.

9. Stone, *When God Was a Woman*, p. 36

10. Diane Kelder, *Pageant of the Renaissance* (New York: Frederick A. Praeger, 1969), p. 114.

11. Rudolf Wittkower, *Idea and Image: Studies in the Italian Renaissance* (London: Thames and Hudson, 1978), p. 166.

12. Nathan Leites, *Art and Life: Aspects of Michelangelo* (New York: New York University Press, 1986), p. 2.

13. Ibid., p. 1.

14. Robert S. Liebert, *Michelangelo: A Psychoanalytic Study of His Life and Images* (New Haven: Yale University Press, 1983), p. 13.

15. Marianna Shreve Simpson, *Arab and Persian Painting in the Fogg Art Museum* (Cambridge, Mass.: Harvard University, 1980), p. 58.

16. Ibid.

17. Julie Bailey and Afsaneth Najmabadi (Fogg Art Museum, Cambridge, Mass.), telephone conversation with author.

18. Charles Stuckey, "The First Tahitian Years," in *The Art of Paul Gauguin* (Washington, D.C.: National Gallery of Art, 1988), p. 210.

19. Paul Gauguin, *Noa Noa: The Tahitian Journal*, trans. O. F. Theis (New York: Dover Publications, 1985), p. 20.

20. Ibid.

21. Ibid.

22. Whitney Chadwick, *Women, Art, and Society* (London: Thames and Hudson, 1990), p. 268.

23. Ibid.

4 BY THE CRADLE (pages 56–61)

1. E. About, review of an 1855 Millet exhibition, quoted in Griselda Pollack, *Millet* (London: Oresko Books, 1977), p. 5.

2. Baroness Frances Pellenc, *Mother and Child*, ed. Mary Lawrence (New York: Crowell, 1975), p. 174.

3. Denis Rouart, ed., *Berthe Morisot: The Correspondence* (Mount Kisco, N.Y.: Moyer-Bell, 1987), p. 115.

4. Ibid.

5 MOTHER'S LAP (pages 62–75)

1. Theodora Hadzisteliou Price, *Kourotrophos: Cults and Representations of the Greek Nursing Deities* (Leiden, The Netherlands: E. J. Brill, 1978), p. 199.

2. Pam McClosky (Seattle Museum), telephone conversation with author, August 31, 1989.

3. Ibid.

4. Herbert M. Cole, *The Mother and Child in African Sculpture* (Los Angeles: Los Angeles County Museum of Art, 1985), p. 10.

5. Robert Rosenblum, *The Romantic Child, from Runge to Sendak* (London and New York: Thames and Hudson, 1988), p. 9.

6. P. D. Jimack, "The Paradox of Sophie and Julie: Contemporary Response to Rousseau's Ideal Wife and Ideal Mother," in *Woman and Society in Eighteenth-Century France* (London: Athlone Press, 1979), p. 162.

7. Bonnie S. Anderson and Judith P. Zinsser, *A History of Their Own: Women in Europe from Prehistory to the Present*, vol. 2 (New York: Harper and Row, 1988), p. 236.

8. Sylvia D. Hoffert, *Private Matters: American Attitudes Toward Childbearing and Infant Nurture in the Urban North, 1800–1860* (Chicago: University of Illinois Press, 1989), p. 142.

9. Ibid.

6 CLOSE BONDS (pages 76–87)

1. Ann Sutherland Harris and Linda Nochlin, *Women Artists, 1550–1950* (New York: Alfred A. Knopf, 1984), p. 192.

2. Karen Petersen and J. J. Wilson, *Women Artists: Recognition and Reappraisal from the Early Middle Ages to the Twentieth Century* (New York: Harper and Row, 1976), p. 51.

3. Gillian Perry, *Paula Modersohn-Becker* (New York: Harper and Row, 1979), p. 57.

4. Ibid., p. 10.

5. Ibid., p. 2.

6. *Sargent Johnson: Retrospective* (Oakland, Calif.: Oakland Museum, 1971), p. 17.

7. Burt Chernow, *The Drawings of Milton Avery* (New York: Taplinger Publishing Company, 1984), n.p.

8. Ibid.

9. Barbara Haskell, *Milton Avery* (New York: Harper and Row, 1982), p. 26.

10. Griselda Pollock and Rozsika Parker, *Old Mistresses: Women, Art and Ideology* (London and New York: Routledge and Kegan Paul, 1981), p. 41.

7 FIRST STEPS (pages 88–93)

1. Metropolitan Museum of Art, *Metropolitan Children* (New York: Metropolitan Museum of Art, 1984), p. 21.

2. Robert Wallace, *The World of Van Gogh, 1853–1890* (New York: Time-Life Books, 1969), p. 8.

3. Mary Matthews Gedo, *Picasso: Art as Autobiography* (Chicago: University of Chicago Press, 1980), p. 203.

8 MOTHERS AT WORK (pages 94–111)

1. Anna Macias, *Against All Odds: The Feminist Movement in Mexico to 1940* (Westport, Conn.: Greenwood Press, 1982), p. 3.

2. Marjorie Wall Bingham and Susan Hill Gross, *Women in Japan: From Ancient Times to the Present* (St. Louis Park, Minn.: Central Community Center, 1987), p. 57.

3. Christopher Brown, *Images of a Golden Past: Dutch Genre Painting of the Seventeenth Century* (New York: Abbeville Press, 1984), p. 58.

4. Ibid.

5. Ibid.

6. Ibid.

9 MOTHERS AND CHILDREN AT PLAY (pages 112–23)

1. Alan Priest, "Play with Infants," *Metropolitan Museum of Art Bulletin* 37 (May 1942): 130.

2. Ibid.

3. Beverly Birns and Dale F. Hay, eds., *Different Faces of Motherhood* (New York: Plenum Press, 1988), p. 121.

4. Judith Schneid Lewis, *In the Family Way: Childbearing in the British Aristocracy, 1760–1860* (New Brunswick, N.J.: Rutgers University Press, 1986), p. 21.

5. Ibid., p. 210.

6. Carol Duncan, "Happy Mothers and Other New Ideas in French Eighteenth-Century Art," in *Feminism and Art History: Questioning the Litany*, ed. Norma Broude and Mary D. Garrard (New York: Harper and Row, 1982), p. 206.

7. Ibid., p. 215.

10 OTHER MOMENTS (pages 124–37)

1. Joyce Ackroyd, "Women in Feudal Japan," *Transactions of the Asiatic Society of Japan*, 3d series, vol. 7 (November 1959), p. 56.

2. Michael Raeburn, ed., *Renoir* (London: Arts Council of Great Britain, 1985), p. 264.

3. Whitney Chadwick, *Women, Art, and Society* (London: Thames and Hudson, 1990), p. 268.

4. William C. Seitz, *Claude Monet* (New York: Harry N. Abrams, 1960), p. 80.

5. Ibid.

6. Ibid.

11 SPECIAL MOTHERS (pages 138–53)

1. Alan J. B. Wace, *Mycenae: An Archaeological History and Guide* (Princeton, N.J.: Princeton University Press, 1949), p. 83.

2. Ibid., p. 84

3. Barbara G. Walker, *The Woman's Encyclopedia of Myths and Secrets* (New York: Harper and Row, 1983), p. 786.

4. Ibid., p. 39.

5. Kenneth Clark, *Leonardo da Vinci* (New York: Viking, 1988), p. 217.

6. Walker, *Woman's Encyclopedia*, p. 39.

7. Ibid.

8. Ibid., p. 201.

9. Ibid., p. 202.

10. Ibid., p. 44.

11. Felix Guirand, ed., *Larousse Encyclopedia of Mythology* (New York: Prometheus Press, 1959), p. 148.

12. Walker, *Woman's Encyclopedia*, p. 606.

13. Ibid., p. 604.

14. George Eliot, *The Mill on the Floss*, quoted in Roger Jones, *Raphael* (New Haven: Yale University Press, 1983), p. 22.

15. H. W. Janson, *History of Art* (Englewood Cliffs, N.J.: Prentice-Hall, 1973), p. 348.

16. Paul B. Courtwright, *Ganesa: Lord of Obstacles, Lord of Beginnings* (New York: Oxford University Press, 1985), p. 107.

17. David Kinsley, *Hindu Goddesses: Visions of the Divine Feminine in the Hindu Religious Tradition* (Berkeley: University of California Press, 1986), p. 151.

12 THE FAMILY (pages 154–67)

1. David Kinsley, *Hindu Goddesses: Visions of the Divine Feminine in the Hindu Religious Tradition* (Berkeley: University of California Press, 1986), p. 43.

2. Roy McMullen, *Degas: His Life, Times and Works* (Boston: Houghton Mifflin Company, 1984), p. 267.

3. Norma Broude, "Degas's 'Misogyny,'" in *Feminism and Art History: Questioning the Litany*, ed. Norma Broude and Mary D. Garrard (New York: Harper and Row, 1982), p. 263.

4. Ibid., p. 259.

5. Ibid., p. 261.

6. Paul Gardner, "Who is Marisol?" *Artnews* 88 (May 1989): 151.

7. John Ingamells, *The Wallace Collection Catalogue of Pictures*, vol. 1 (London: Trustees of the Wallace Collection, 1985), p. 34.

8. Mary Matthews Gedo, *Picasso: Art as Autobiography* (Chicago: University of Chicago Press, 1980), p. 131.

Index

Page numbers in *italics* refer to illustrations.

A

African art, 65–66, *66*, 131, *131*, 156–57, *156*
Akan art, 65–66, *66*
Akbar (emperor of India), 35
Alcott, Abigail, 75
Alphonse the Wise, 29
amautik, 99
Aphrodite, 24, 39, 64, 145
Aphrodite Poised on the Shell, 145, *145*
Ariès, Philippe, 30
Artemis, 64
Art Students' League, 48
aryballos, 98
Ashanti tribe, 131, *131*
Athena, 39, 64
Augustine, Saint, 143
Augustus (emperor of Rome), 143
Avery, March, 84
Avery, Milton, 10, 76, 83–84, *83*
Avery, Sally Michel, 84
Aztec art, 22, 33, *33*, 35
*Aztec Goddess Tlazolteotl Giving Birth to
 Centeotl, the Corn God*, 33, *33*, 35

B

Baby's Slumber (Millet), 57, 58–59, *58*
Balarama, 65, 122
Balarama Playing with Yashoda, 65, *65*, 122
Beaux, Cecilia, 10, 62, 70, *71*, 73

Beloved Child, The (Gerard), 113, 118, *119*, 120
Bempah, Kwaku, 131, *131*
Bernini, Giovanni Lorenzo, 36, 53–54, *54*
Bilder vom Elend (series; Kollwitz), 21
birth, 22–35
 attendants for, 24, 29
 of boys vs. girls, 116–17
 breech, 33
 goddesses of, 24, 33, 39, 64, 139
 miraculous, 25, 26, 27, 139, 152
Birth of Buddha, 26–27, *26*
Birth of Erichthonius, The, 25–26, *25*
Birth of Prince Salim (Dharm Das), *22–23,
 34,* 35
Birth of the Buddha, 27–29, *27*
Birth Project, The (Chicago), 33
Birth Trinity, 24, *24*, 39
Birth Trinity Mola, Q1 (Chicago), 22, 32–33,
 32
Blake, William, 76, *86*, 87
board cradle, 98
Bonington, Richard Parkes, 155, 163–164, *163*
Bonnard, Pierre, 155, 159–60, *159*
Brahmanic society, 78
Brancusi, Constantin, 14
breast-feeding, 36, 42, 44, 66
breech births, 33
Buddha, 10, 22, 26–27, 29
Buddhism, 27, 29, 101, 127

C

Calvinism, 109
Canonical Female Idol, 14, *14*
Cantigas (Alphonse the Wise), 29
Carriage at the Races (Degas), 160–61, *161,* 163
Cassatt, Mary, 9, *72, 73,* 76, 84, *85,* 87, 131, *132,* 133, 134, 135, 160, 161
Catching Fireflies (Choki), 113, 114, *114,* 122
Cavendish, Lady Georgiana, 117–18
Centeotl, 22, 33
Cézanne, Paul, 15
Chagall, Bella, 151
Chagall, Marc, 13, *18,* 19, *138–39, 150,* 151
Charity with Four Children (Bernini), 36, 53–54, *54*
Chase, William Merritt, 125, 129, *130,* 131
Chicago, Judy, 22, 32–33, *32*
Chicago Exposition (1893), 133
children:
 in African society, 156
 in British society, 66, 68, 117–18
 in Chinese society, 115–16
 in Dutch society, 108–9, 111
 female vs. male, 35, 116–17
 first steps of, 88–93
 in French society, 118, 120
 in Greek society, 38–39, 64
 illegitimate, 118
 illnesses of, 126–27
 independence of, 87
 instruction of, 109
 in medieval Europe, 30
 at play, 112–23
 protectresses of, 153
 upbringing of, 30, 39, 64, 75, 94, 111, 113, 115–16, 118, 120
 in Western societies, 115–16
 see also mother-and-child relationship
Child's Caress, The (Cassatt), *72,* 73, 84
Child Upsetting a Goldfish Bowl (Utamaro), 127, *127,* 129
Chinese art, 27, *27,* 29, 115–17, *115, 116*
Choki, Eishosai, 10, 113, 114, *114,* 122
Christianity, 27, 139, 151
Cimabue, 147
Colossal Head from a Votive Statue, 143, *144,* 145
Columbian Exposition (1893), 133
Columbia University, 48
Condivi, 43
Confuscianism, 27, 29, 100–101, 127
contraception, 120
Cooper Union, 48
Cortés, Hernán, 96
courtesans, 97, 107, 114, 159
Cradle, The (Morisot), *6,* 57, 59, *59,* 61, 129
cradles, 56–61, 98
Crazy Quilt (Haskins), 68, *68*
Cretan art, 140
Cultural Revolution, Chinese, 117
Cybele, 142–143, *143*
Cycladic sculpture, 10, 13, 14, *14*
Cyprian art, 24, *24,* 39, 143, *144,* 145

D

Dan tribe, 156–57, *156*
Daumier, Honoré, 10, 62, 69–70, *69*
da Vinci, Leonardo, 16, 141–42, *141,* 148
day care, 94, 111
Degas, Edgar, 134, 160–61, *161,* 163
de Genlis, Madame, 66–67
de Hooch, Pieter, *94–95,* 108–9, *109,* 111
de la Tour, Georges, *8,* 22, 30, *31,* 32

Demeter, 10, 64, 140

Devaki, 65

de Verdun, Mme, 80, 82

Devonshire, duke and duchess of, 117–18

Dharm Das, *22–23, 34,* 35

diaper change, 9, 125, 133, *133*

Diderot, Denis, 113, 120

Duccio, Agostino di, 147

Duchess of Devonshire and Lady Georgiana Cavendish, The (Reynolds), 117–18, *118*

Durand Ruel Gallery, 84

Dürer, Albrecht, *2,* 36, 43–44, *43*

E

Egyptian art, 40, *40*

Elegant Set of Darling Children (series; Utamaro), 127

Eliot, George, 148

Enlightenment philosophy, 118–19

Erichthonius, 25

Eros, 145

Esslinger Werkstatt, *146,* 147–48

F

Famille-rose, 113, 116–17, *116*

family, 154–67
 Afro-American, 155, 164, 167
 depiction of, 154–67
 extended, 94
 in Indian society, 157–58
 unity of, 167

Family at the Seashore (Picasso), *154–55, 166,* 167

Family Scene (Bonnard), 155, 159–60, *159*

Fan with Hand-Colored Genre Scene, 100–101, *100*

Fatehpur Sikri, 35

fathers, 89, 93, 155, 159, 160, 164, 167
 see also family

Feeding Caitlin (Fish), 125, *136,* 137

Female Figure with Twins, 65–66, *66*

fertility goddesses, 14, 33, 66, 131

Field, Erastus Salisbury, 73, *74,* 75

Figures: Dan Tribe, 156–57, *156*

First Steps (Millet), 93

First Steps (Picasso), 89, 91, *91,* 93

First Steps (van Gogh), *88–89, 92,* 93

Fish, Janet, 125, *136,* 137

Fornarina, La, 148, 151

Foster, Elizabeth, 118

Fragonard, Jean-Honoré, 113, 118, *119,* 120

Freud, Sigmund, 142

G

Gaia, 25

Games and Reading (Picasso), 113, 121, *121*

Ganesa, 11, 151, 152, 155, 157

Ganga, 78

Gathering Fruit (Cassatt), 131, *132,* 133

Gauguin, Paul, 36, 48, *50,* 51, 134

Gedo, Mary Mathews, 167

Genre Scene, 104, *105,* 107

George IV (king of England), 117

George Washington Bridge, 164

Gerard, Marguerite, 113, 118, *119,* 120

Giorgione, 40, *41,* 42, 48

Giotto, 147

goddesses, 10, 14, 25, 33, 39, 40, 64, 66, 78, 131, 140, 142, 143, 145

Goddess Isis with the Child Horus, The, 40, *40*

Gravida, La (Raphael), *12–13,* 16, *17,* 19

Great Mother goddess, 142, 143, 145

Greek art, 10, 13, 14, 24, 25–26, *25,* 39, 64, *64,* 101–2, *102,* 140–41, *141,* 145, *145*

H

harems, 35
Haskins, Mrs. Samuel Glover, 68, *68*
Henry IV and the Spanish Ambassador
 (Bonington), 155, 163–64, *163*
Hephaestus, 25
Hera, 64
Herodotus, 40
Hide and Seek (Morisot), *112–13,* 122, *122*
Hideyori, Kano, 11, *36–37,* 47–48, *47*
Himeros, 145
Hinduism, 27, 35, 65, 123
Holy Family with Angels (Rembrandt), 10, *56–
 57,* 59, *60,* 61
"holy trinity," 140
Horus, 40

I

Ilithyia, 24
Impressionism, 51, 84, 122
Incan art, 98–99
Indian art, 10–11, *22–23, 26–27, 26, 34,* 35, 65,
 65, 78, *78,* 104, *105,* 107, 122–23, *123,* 151–
 53, *152, 153,* 157–58, *157*
Industrial Revolution, 58, 69
infant mortality rate, 30
Inuit art, 99
Inukjuak, Conclucy Nayoumealook, 99, *99*
Isis, 10, 40, 139, 145
Islam, 35, 139

J

Japanese art, *36–37,* 44, *45,* 47–48, *47,* 73,
 100–101, *100, 106,* 107, 114, *114,* 127, *127,*
 158–59, *158*
Jesus Christ, 9, 40, 42, 57, 61, 147–48, 151
Jodh Bai (Hindu princess), 35

Johnson, Sargent, 10, 76, 82–83, *82*
John XXIII (pope), 147
Judaism, 139, 151

K

Kamsa, 65
Karttikeya, 78, 155, 157
Kesu the Elder, *22–23, 34,* 35
Kollwitz, Karl, 20
Kollwitz, Käthe, 20–21, *21*
Kore, 140
kourotrophoi, 38–39, *39,* 62, 64, *64*
Kourotrophos, 64, *64*
Kramer, Hilton, 84
Krishna, 65, 122–23
Krishna on the Swing, 3, 122–23, *123*

L

Lacemaker, The (Maes), 94, 102, *103,* 104
Lady Cockburn and Her Children (Reynolds),
 62–63, 66, *67,* 68
landscape painting, 40, 42, 48
Last Days of Childhood, The (Beaux), 10, 62,
 70, *71,* 73
Last Judgment of Christ, The, 20
Leyla and Majnun (Nezāmī), 44
Livia Drusilla (empress of Rome), 143
Locke, John, 113, 120
Louis XIII (king of France), 164
Luncheon, The (Monet), *124–25,* 135, *135,* 137

M

*Madame Vigée-Lebrun and Child (in Greek
 Toga)* (Vigée-Lebrun), 76–77, 80, *81,* 82
Madonna and Child theme, 9, 40, 42–44, *42,
 43,* 57, *60,* 61, *146,* 147–48, *149, 150,* 151
Madonna della Sedia (Raphael), 148, *149,* 151

Madonna Nursing the Baby Christ (Michelangelo), 42–43, *42*

Madonna of the Iris (Dürer), *2,* 36, 43–44, *43*

Madonna of the Village (Chagall), *138–39, 150,* 151

Maes, Nicolaes, 94, 102, *103,* 104

Mahaprajapati, 27

mano, 10, 94, 96–97

Maple Viewers at Mount Takao (Hideyori), 11, *36–37,* 47–48, *47*

Margaret Evans Pregnant (Neel), 11, *15*

Mari, 142

Marisol, 94, *110,* 111, 155, *162,* 163

marriages, arranged, 66, 117–18

Mary, Virgin:
 Christ child and, 9, 40, 42, 57, 61, 147–48, 151
 immaculate conception of, 142
 as mother goddess, 64
 St. Anne and, 141–42
 veneration of, 11, 16, 139, 147

Maternal Kiss (Cassatt), 76, 84, *85,* 87, 134

Maternity (Avery), 76, 83–84, *83*

Maternity II (Gauguin), 36, 48, *50,* 51

matrilineal societies, 66

mātrkās, 139, 152–53

Maya, 10, 26–27

Mead, Margaret, 40

Médicis, Marie de (queen of France), 163, 164

medieval art, *28,* 29–30, *29,* 102, *102, 146,* 147–48

Menā, 158

Mesoamerican art, 10, 94, 96

metate, 10, 94, 96–97

Metsu, Gabriel, 126–27, *126*

Mexican art, 13, 16, *16,* 33, *33,* 35, 38, *38,* 96–97, *96, 97*

Michelangelo Buonarroti, 42–43, *42,* 58

Midwife Hands the Mother Her Baby, The, 29, *29*

midwives, 24, 29, 33

Millet, Jean-François, 57, 58–59, *58,* 93

Modersohn, Otto, 80

Modersohn-Becker, Paula, 10, 76, 79–80, *79*

Momoyama period, 47

Mona Lisa (da Vinci), 16, 141, 148

Monet, Camille, 135

Monet, Claude, *124–25,* 135, *135,* 137

Monet, Jean, 135, 137

Moore, Henry, 10, 120–21, *120*

Moore, Irina, 121

Moore, Mary, 121

Morisot, Berthe, *6,* 11, 57, 59, *59,* 61, *112–13,* 122, *122,* 129, 160

Mother and Child (Bempah), 131, *131*

Mother and Child (India), 11, 76, 78, *78*

Mother and Child (Johnson), 10, 76, 82–83, *82*

Mother and Child (Orozco), 97, *97*

Mother and Child (Picasso), 75, *75*

Mother and Child (Pissarro), 36, 51, *52,* 53

Mother and Child (Renoir), 125, *128,* 129

Mother and Child (Turner), 10, 36, 48, *49*

mother-and-child relationship, 62–87
 day-to-day activities of, 124–37
 depiction of, 9, 76, 113
 intimacy in, 98–99
 nursing and, 43–44, 48, 55
 physical closeness in, 99
 play as part of, 112–23
 as private world, 70, 73, 107–8
 protectiveness of, 70, 82
 unconditional love in, 84

mother goddesses, 40, 78, 139, 140, 142, 143, 145

motherhood, mothers:
 African-American, 82–83
 contemporary, 111
 cultural significance of, 11
 deified, 10–11
 deities of, 152–53
 domestic work by, 102, 104, 126
 in Dutch society, 104, 108–9, 111
 in eighteenth century, 118, 120
 emotional support in, 39
 in Greek society, 94
 as heroic, 79
 historical representations of, 9–11
 idealization of, 9, 16, 118, 129
 in Indian society, 78, 104, 107
 intuition of, 75
 middle-class, 59
 in nineteenth century, 75
 nostalgia of, 70
 peasant, 57, 58, 79, 97
 religious significance of, 27, 139
 responsibility of, 21, 30, 75
 social life of, 101–2
 "special," 138–53
 working, 94–111
 working-class, 69–70
 see also mother-and-child relationship
Mother Playing with Her Child, and Nurse
 (Utamaro), 106, 107, 113
Mrs. Paul Smith Palmer and Her Twins
 (Field), 73, 74, 75
Mycenaean Ivory Three-Figure Group: Two
 Women and a Child (Demeter and Kore
 with Ploutos?), 140–41, 140
My Daughter, March (exhibition), 84

N

Nanda, 65
Nandi, 157
Nanny and Max (Prior), 54–55, 55
Nayarit Indian art, 13, 16, 38
needlework, 33, 68, 102
Neel, Alice, 9, 11, 13, 15, 15, 32
Newborn Child, The (de la Tour), 8, 30, 31, 32
Nezāmī, 44
Night Thoughts (Young), 87
Nike, 25
Noa Noa (Gauguin), 51
Nomadic Encampment (Sayyid Ali), 44, 46,
 47
Nu lunyu (Ruohua), 29
nursing, 36–55
 by bottle, 36, 53
 by breast-feeding, 36, 42, 44, 66
 deities for, 38–39
 depiction of, 36
 intimacy and, 98
 mother-and-child relationship and, 43–44,
 48, 55
 see also wet nurses
Nursing Deity, 38–39, 39
Nursing Mother (Picasso), 53, 53

O

Olmstead, Frederick Law, 129
Orozco, José, 97, 97

P

Parival, Jean-Nicolas, 109
Parvati, 11, 139, 151–52, 155, 157–58
Parvati with Ganesa, 151–52, 152
pastoral literature, 42
Pastoral No. 16 (Stella), 125, 133–34, 133

perambulators, 125

Persephone, 64, 140

Peruvian art, 98–99, *98*

Picasso, Claude, 121

Picasso, Fernande Olivier, 91

Picasso, Françoise Gilot, 91, 121

Picasso, Olga, 75

Picasso, Pablo, 11, 14, 53, *53,* 75, *75,* 89, 91, *91,*
91, 113, 121, *121, 154–55, 166,* 167

Picasso, Paloma, 121

Picasso, Paulo, 75, 167

piecework, 70

Pissarro, Camille, 36, 51, *52,* 53, 107–8, *108*

Pissarro, Julie, 51, 108

Pissarro, Rodolphe, 51

Play with Infants (style of Chou Fang), 113,
115–16, *115*

Ploutos, 141

Poor Family I (Marisol), 155, *162,* 163

pre-Columbian art, 13, 16, 38, *38*

Pre-Columbian Nursing Figure, 38, *38*

pregnancy, 12–21

 anxiety and, 16

 depiction of, 9, 10, 13

 goddesses of, 64

 in pre-industrialized cultures, 13

 serenity and, 19–20

 underrepresentation of, 13

 as vulnerable time, 15

 working and, 98

Pregnant Woman (Beim Arzt) (Kollwitz),
20–21, *21*

Pregnant Woman (Chagall), *18,* 19

Preludium to the First Book of Urizen
(Blake), 76, *86, 87*

Priest, Alan, 115–16

Prior, Scott, 54–55, *55*

Prospect Park, Brooklyn (Chase), 125, 129,
130, 131

prostitutes, 97, 107, 114, 159

purdah, 104

Puvis de Chavannes, Pierre-Cécile, 134

ℛ

Raphael, *12–13,* 16, *17,* 19, 148, *149,* 151

Reclining Mother and Child (Mondersohn-
Becker), 76, 79–80, *79*

Rembrandt van Rijn, 10, *56–57,* 59, *60, 61,* 89,
90–91, *90*

Renaissance art, *12–13,* 16, *17,* 19, 40, *41,*
42–44, *42, 43,* 53–54, *54,* 141–42, *141,* 148,
149, 150

Renoir, Pierre-Auguste, 125, *128,* 129, 134

Reresby, John, 104

Reynolds, Joshua, *62–63,* 66, *67,* 68, 113,
117–18, *118*

Ringgold, Faith, 155, 164, *165,* 167

Ritual Vessel, 98–99, *98*

Rocking Chair No. 1 (Moore), 120–21, *120*

Roebling, John, 163

Roebling, Washington, 163

Rohini, 65

Rousseau, Jean-Jacques, 66, 113, 118, 120

Ruohua, Song, 29

𝒮

Sadanobu, Matsudaira, 127

Salim, Prince, 22

Saptamatrika, 152–53, *153*

Sayyid'Ali, Mir, 44, *46,* 47

Scenes of Childbirth, 28, 29

Selling Butter, 102, *102*

Sheridan, Richard Brinsley, 117

Sick Child, The (Metsu), 126–27, *126*

Siva, 151–52, 155, 157–58
Siva and Parvati and Their Two Sons, 155, 157–58, *157*
Standing Pregnant Woman, 13, 16, *16*
Stella, Claudine Bouzonnet, 9, 125, 133–34, *133*
Suddhodhana, 26
swaddling clothes, 30, 32

T

Tacuinum Sanitatis, 102
Tang dynasty, 29
Tar Beach (Ringgold), 155, 164, *165,* 167
Tasso, Torquato, 42
Tempest, The (Giorgione), 40, *41,* 42, 48
Terrasse, Andrée, 159
Terrasse, Claude, 159
Third-Class Carriage, The (Daumier), 10, 62, 69–70, *69*
Tlazolteotl, 22, 33
Toulouse-Lautrec, Henri de, 134
Trithemius, Johannes, 142
Turner, Helen, 10, 36, 48, *49*
Tutu, Desmond, 163
Two Children Dressing in a Garden (Valadon), 125, 134–35, *134*
Two Lovers, Sankatsu and Hanhichi, with Their Baby (Utamaro), 155, 158–59, *158*
Two Women and a Child, 140–41, *140*
Two Women Teaching a Child to Walk (Rembrandt), 90–91, *90*

U

Utamaro, Kitagawa, 10, 11, 36, 44, *45, 106,* 107, 114, 125, 127, *127,* 129, 155, 158–59, *158*

V

Valadon, Suzanne, 125, 134–35, *134,* 161
Valéry, Paul, 61
Valpinçon, Henri, 160, 161
Valpinçon, Paul, 161
van Beverwijk, Johan, 104
van Gogh, Johanna, 93
van Gogh, Theo, 93
van Gogh, Vincent, *88–89, 92,* 93, 134
Vasari, Giorgio, 148
vase paintings, Greek, 25–26, *25,* 101, *101*
Vaux, Calvert, 129
Vermeer, Johannes, 13, 19–20, *20*
Vigée-Lebrun, Elisabeth, 76–77, 80, *81,* 82
Virgin and Child, 146, 147
Virgin and Child with St. Anne (da Vinci), 141–42, *141*
Virgin Holding the Child by the Hand, The (Esslinger Werkstatt), *146,* 147–48
votive offerings, 24

W

weaning, 43
wet nurses, 16, 19, 35, 36, 42–43, 47, 61, 66, 118
Woman Hanging up Laundry (Pissarro), 107–8, *108*
Woman Holding a Balance (Vermeer), 19–20, *20*
Woman Peeling Apples, A (de Hooch), *94–95,* 108–9, *109,* 111
Woman Stretching and Shaping Boot (Inukjuak), 99, *99*
Woman Using a Metate, with Child, 94, 96–97, *96*
Woman with a Hydria Leading a Little Boy, 101–2, *101,* 147

women:
 African ideal of, 156–57
 as artists, 9–10, 80, 160–61
 in classical Greece, 25–26, 101–2
 depicted as individuals, 84, 87
 in Japanese society, 44, 47–48, 100–101, 107,
 127, 129
 knowledge gained by, 131–33
 leisure time for, 59
 in medieval Europe, 29–30
 in Mexican society, 96–97
 motherhood as vocation for, 120
 "natural feminity" of, 51
 poor, 20–21, 70–71
 seclusion of, 104
 spiritual progress of, 27
 subordination of, 104
 in Tahitian society, 51
 see also motherhood, mothers
Working Woman (Marisol), 94, 110, 111, 163

Y

Yashoda, 65, 122
Young, Edward, 87
Young Woman Arranging Her Hair and
 Nursing Her Distracted Child, A (Utamaro),
 36, 44, 45
yukata, 114

Z

ze me, 156
zenana, 35
ze ne, 156
Zephyrus, 145
Zeus, 25

Photography Credits